Marion
Post
Wolcott

Marion Post by Trude Fleischmann, 1940.

Marion Post Wolcott

A Photographic Journey

F. Jack Hurley

Foreword by Robert Coles

UNIVERSITY OF NEW MEXICO PRESS

Albuquerque

For our spouses,
Lee Wolcott and Nancy Hurley,
who endured this project.

Library of Congress Cataloging-in-Publication Data

Hurley, F. Jack (Forrest Jack)
 Marion Post Wolcott: a photographic journey/F. Jack Hurley;
foreword by Robert Coles.—1st ed.
 p. cm.
 Bibliography: p.
 ISBN 0-8263-1114-8. ISBN 0-8263-1115-6 (pbk.)
 1. Wolcott, Marion Post, 1910–
 2. Photographers—United States—Biography.
 3. Photography, Documentary—United States.
 4. United States—Social conditions—Pictorial works.
 I. Wolcott, Marion Post, 1910–
 II. Title.
 TR140.W64H87 1989
 770'.92'4—dc19
 [B]
 88-20690

SECOND PRINTING, 1990

PRINTED IN JAPAN

Contents

Foreword

Robert Coles

My wife and I were first introduced to Marion Post Wolcott's photographic work during the fall of 1962. We were living in the South then, going back and forth from Louisiana to Georgia, studying school desegregation as it took place in important southern cities, such as New Orleans and Atlanta. We were also becoming involved with the sit-in movement: a number of the black high-schoolers we met in Atlanta were taking a stand against various segregationist practices. One of those youths, a senior at Henry Grady High School, had stumbled into a collection of photographs, which he much wanted to share with us. They were part of the FSA documentary tradition, which Jack Hurley in an earlier book has examined so carefully and intelligently. One evening, as we talked about the quickening social and racial struggle of the early 1960s, which we were witnessing first-hand, the young man, Lawrence Jefferson, made a point of sharing with us his library book, with the FSA photographs. We marvelled at the compelling strength of the photographs—their collective capacity to make us attend a particular world. Lawrence was at pains to remind us that we were not only looking at history, but at what still obtained all over the South, and elsewhere, too: people in great distress—poor, vulnerable, needy, in great social, economic, racial jeopardy.

As we looked at picture after picture, we began to take note of the names of the photographers who had taken them. None of us knew much about the FSA or its photographic efforts. Names such as Walker Evans, Russell Lee, Ben Shahn, and Dorothea Lange were

somewhat familiar to us, but by no means had we the ability to recognize their respective aesthetic styles, their intellectual or moral interests, predilections. Lawrence was less interested in the names of the photographers than the subject matter of the various pictures, but eventually he began to take note of the particular photographs he most liked, or to which he felt most summoned, and eventually, too, he began to associate this or that photograph with one or another manner of pictorial presentation—a way of seeing things and offering them, visually, to others. He was, I suppose, becoming a bit more intellectual in his responses, as we soon began to realize. He declared preferences, described variations in visual arrangement, mentioned different perspectives—and, eventually, told us which photographer had most gripped him: Marion Post Wolcott, because "she has a way of hitting a home run." We knew he was a good baseball player, but we weren't sure what he meant. All the photographers were for us rather successful in conveying the contours of the various worlds they had witnessed—the circumstances, the people caught in and struggling with those circumstances. But in Lawrence's mind Marion Post Wolcott often went a step further. Prodded by us, he tersely explained what he felt: "She's more upset with what's wrong than anyone else."

I'm not at all sure that anyone's moral indignation can be fully ascertained by a perusal of what he or she has written or photographed. Nor do comparisons such as Lawrence made prove necessarily useful. Still, a young viewer was finding his way to a biographical truth, as Jack Hurley makes quite clear in this important and edifying book—the ethical passions that prompted one photographer's extraordinary journey through the America of the late 1930s and early 1940s. Marion Post Wolcott had a lively moral impulse at work as she carried her camera—a sense of outrage that so many should be so vulnerable, while a few lived so extravagantly well. She was no scold and no radical; she was someone of great sensitivity and compassion who ached for those who were down-and-out, who were being given a rough time because of their race or because a society professing high ideals had lost its way economically. She was (she still is, one gathers) part of an American high-minded reformist tradition—a populism that is comfortable with the intellectual and cosmopolitan side of things, as opposed to the xenophobic and racist populism that our nation has also managed to generate.

Today Marion Post Wolcott's career and, too, her life as a wife and mother, prompt our special interest. Jack Hurley tries his best to come to terms with the end of an exceptionally promising and productive career: a photographer who was a woman decides to

forego the camera in favor of the responsibilities of a home life. We may now be tempted to push that decision too far. Surely the Marion Post Wolcott we meet in this book was a sturdy, independent, brave, and sensitive person, not at all inclined to take bullying as her feminine due. She faced down all sorts of prejudice, stupidity, arrogance; she was, in fact, almost fearlessly stubborn and determined as she pursued her work. Moreover, her marriage took place as America was in the midst of a big shift in its life: the boost of a war economy. The FSA would soon enough enter history as an exceptionally instructive moment of collaboration between a government agency and certain gifted members of an artistic community. True, the other FSA photographers went their own ways with the camera; but the decision to put the camera aside for a while need not be seen only as a tragedy, or as an instance of injustice (a woman's surrender to a man, to a culture, to a whole way of seeing and doing things). The one who made such a decision had her own reasons, and they surely deserve our respect—even as we still, today, look at the photographs in this book with a certain awe: the range of life observed; the care and attentiveness of the observation; the dramatic and moral intensity rendered, again and again; the shrewdness and poignancy of vision set before us.

Marion Post Wolcott was *sui generis* an inspired American idealist who, in a brief span of time, gave us a visual feast to keep taking in—those of us who want to know how it can go abroad this land for the many "sorts and conditions" of people who inhabit it. We are privileged, indeed, to have this book among us almost a half-century after her pictures were taken. They offer us an unforgettable glimpse at an aspect of twentieth-century American social history, as does Jack Hurley's text—and, too, lots to think about, even today, as the next century approaches.

Introduction

The first thing I must do is correct a statement made in my first book on the documentary photography of the FSA. In that book I paraphrased Roy Stryker in characterizing Marion Post Wolcott as "a city girl, the product of a fashionable home. She had attended New York University and the New School for Social Research in New York City. To round out her education in proper style, she had studied at the University of Vienna."[1] When I wrote those rather flippant lines in the late 1960s, Marion and her husband, Lee Wolcott, were out of the country, stationed in India, and I had to use facts that were given me by others. In many respects the facts were more or less true. She did spend a considerable part of her formative years in New York, and she did attend good schools. On the other hand, she was never wealthy nor did she have the sort of easy time growing up that my words implied. In fact, important parts of her early years were very difficult, and the story is considerably more complex and interesting than I realized when I wrote *Portrait of a Decade*.

As I have come to know Marion Post Wolcott in the years since that first book was written, I have become convinced that she is one of the most important of the FSA photographers. Few of us have had the opportunity, until now, to see a large number of her pictures, or to appreciate the clarity of her vision, her honesty, her humor, and her anger. Finally, although much has been written about the 1930s, we need to know more about the specific historical context in which the photographs were made and her life was lived.

For without that time matrix, the photographs are all too easily misunderstood.

The context is the Great American Depression, the national trauma that so tried the mettle of the United States in the years just before World War II. Marion Post Wolcott's work documented and commented on the depression in specific parts of the country between 1938 and 1942. As an employee of the Farm Security Administration, a federal agency dedicated to helping the poorest one-third of American farmers, she was witness to terrible squalor, hopeful new beginnings, and frustrating bureaucratic bungling. She enjoyed the advantages of having a federal office behind her, and she also suffered the limitations that the same circumstances imposed.

In some ways, the story of Marion Post Wolcott is very much a modern woman's story, for Marion fought virtually all the battles that women of the recent past and present have faced, and she did so at a very early date and in some very difficult places. She carved out a successful career for herself against powerful odds, and she did it with style and flair. Moreover, her photographic work constitutes a major permanent contribution to the development of our photographic vision as well as our understanding of the past. Yet Marion Post Wolcott's life does not perfectly fit the mold of modern radical feminism. She is too quiet, too retiring, and entirely too likely to defer to the males around her. After an active career as a government photographer, she chose to marry and raise a family, putting down her cameras, at least as far as the public was concerned, for thirty-five years. It is not the way the story is supposed to end, but then Marion Post Wolcott has never been concerned with conforming to some imposed set of standards. Her standards are her own, and they are very high. Her reasons for changing her life are also her own, and they are understandable to those who take the trouble to inspect closely. Her photographs reveal a rich combination of dispassionate observation and passionate advocacy. The pictures make us want to know more about the person who took them. Who is she? How did she become such an effective photographer? Why did she stop taking pictures professionally? Why, in recent years, has she begun again? If this essay does not provide answers, it may at least offer some hints toward understanding this fascinating and complex woman.

Marion
Post
Wolcott

*"Nan," Marion Hoyt Post, right after marriage to Walter Post. Bloomfield,
New Jersey, c. 1905.*

The Early Years

Marion Post was born in 1910 in the classic small town of Montclair, New Jersey. Her parents were Marion Hoyt Post and Dr. Walter Post.[1] As an infant, Marion was very sickly. In fact, she was not expected to survive her first year. As often happens in cases of this sort, this meant that Marion was surrounded by a great deal of attention and love in her earliest years. Her older sister, Helen, who was three when Marion arrived, was both fascinated by and resentful of the new little intruder, and the basis was laid down for a complex relationship between the two girls.[2] Throughout their lives there would be a tension composed of a great deal of love and concern and just a hint of competition in their dealings with one another. Helen quickly developed into an overachiever at school, with easily spotted talents in the arts. Marion's talents emerged more slowly. In fact, during her formative years she tended to be overshadowed by a beautiful mother, a respected father, and a clearly talented big sister. What was Marion's special gift? Everyone told her that she was pretty. Her mother dressed her in ruffles, and her big sister resented her hair. It was not a situation to encourage serious thought, yet serious thought was taking place.

Her early memories include a beloved black cook and housekeeper named Reasie Hurd, whose husband, Charles, took care of the yard and whose daughter, Edna, was a childhood playmate. The Hurds were accepted, at least by the Post children, as equals in the household. Marion loved and, more important, respected the Hurds. They were able people who contributed to the household and to the world

Helen and Marion, c. 1916.

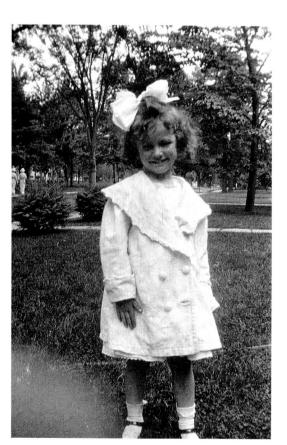

Marion Post, Bloomfield, New Jersey, c. 1916.

that the Post girls knew. Marion remembers her mother and Reasie helping in the doctor's office (which was a three-room wing that had been added on to their home) when emergencies occurred. Her mother was a trained nurse, and she had shown Reasie enough of her skills so that she could give real help when needed. A woman of great self-possession and intelligence, Reasie Hurd was also perfectly capable of administering a solid "love pat" on the bottom of Miss Marion when things got too noisy or too rough in the kitchen. Once, in a moment of anger for being punished for some minor infraction, Marion used the wrong word, a word that she had heard in the streets of Bloomfield but never in her own home. "I don't like you, you Nigger!" she screamed and immediately received a serious spanking from her mother. Mother would not tolerate racism, and Marion never forgot it.[3]

Looking back, Marion saw her relationship with Reasie Hurd as one of the pivotal experiences of her life. In October 1986, she told an audience at the "Women in Photography Conference" at Syracuse University (where she gave the keynote address) that to understand "my empathy with blacks and my ease in relating to their problems, you must flash back sixty-five years." After sketching her relationship with the family cook, Marion recalled:

> Reasie's mother had been a slave; she wasn't sure about her father. But she loved me as her own child, and she talked to me of her life and the life of the black people in the South. As I grew up and my father and mother divorced, Reasie taught me more and comforted me—cared for me—worried about me when I came home on vacations from boarding school. I loved her deeply.[4]

This opportunity to grow up in a household that respected black people was one of the more important lessons Marion learned from her mother. Marion Post senior's intolerance of racism, among other things, made her stand out in the little community of Bloomfield. Most whites of that day used the language of racism as naturally as they used words of polite discourse. In fact, Mrs. Post was regarded by her neighbors as a bit of an eccentric and a radical on a number of social issues. She did not, for example, believe that all labor unions were led by communists, nor did she feel compelled to be at the church every time the doors were opened. These unusual beliefs put her at odds with her husband, a family doctor and a pillar of the community. Walter Post was, in fact, a deeply conventional man who found his wife an increasing trial as the marriage wore on. It may also be that Marion Post senior's behavior was more notice-

able because she was what used to be called "a great beauty." Walter Post felt the need to entertain, and his wife played her role fully but insisted that her opinions were her own. She expressed them whenever she thought appropriate.

By the time Marion was ten she knew that there was trouble in the house. When she was twelve, her parents separated, divorcing when she was thirteen. The year of separation was a very hard time for Marion and her sister. Both girls were under great pressure to choose sides. Helen became close to her father while Marion gravitated to the company of her mother. It was a hard time for their mother too, for during these years she contracted cancer of the uterus. She endured surgery, radiation, and a great deal of gossip. Proud and independent, she refused to accept aid from Walter Post, and somehow she survived, but the last shreds of the marriage dissolved in the anger and recriminations that her illness accentuated. Thirteen-year-old Marion tried to keep her friends from knowing about the separation and impending divorce. When she came home from the movies, or an evening at the ice cream parlor with her "bunch," she would have them leave her at her father's house and then, when they had gone on their various ways, she would run several blocks to her mother's rented apartment. "It was a bitterly contested, nasty divorce," she recalled, "and it really prejudiced me against marriages in general."[5] On the positive side, however, she became very close to her mother, whose courage and integrity she came to admire tremendously.

During the year of separation, Helen, who was perceived by her father as the talented child, commuted to Parsons School in New York City. Eventually she would receive her degree in applied arts from Alfred University.[6] Marion spent one more miserable year at the Bloomfield, New Jersey, high school, listening to the gossip about her parents, and then was sent to a private girl's school in Pennsylvania. It turned out to be a severely regimented place where the lights went out at 10:00 P.M., and the girls were marched to church every Sunday. Marion hated it and begged to be sent somewhere else. Somewhere else proved to be Edgewood, a boarding school in Greenwich, Connecticut, where Marion found friends and teachers who recognized her potential. The previous four years had turned her into a quiet, almost secretive girl, but now she blossomed forth, even showing some leadership abilities. Edgewood was a progressive, coeducational school. Marion loved the climate of open inquiry that was encouraged. Even better were the occasional weekends in New York with her mother.

About the time Marion began to go to boarding school, her

mother got a job in New York City, working with Margaret Sanger, the great advocate of birth control. Marion Post senior felt very strongly about her work and immersed herself deeply in it, traveling all over the country helping to set up health clinics with the Sanger organization. The work did involve long trips, and there were many weekends when mother and daughter could not be together, but whenever possible, fourteen-year-old Marion would ride the train to the city for a lovely long weekend with her mother. Helen was sometimes there, too, though she tended to spend more time with her father and his friends in New Jersey. Summers were particularly wonderful. Mrs. Post had a little apartment on the edge of Greenwich Village and enjoyed the company of creative, talented people. For Marion there were art exhibits and concerts to attend (she learned to go to the rehearsals because they were free), people to meet, and wonderful conversations to listen to. She remembers a cafe in the Village that artists frequented because the owner was sympathetic and let artists run up a long tab. Aaron Copland was there often, as were painters like Stefan Hirsch and George Ault.[7] Always close, Marion and her mother now became much closer. They never had enough money but they became artists at survival, and they learned to suck the juices from the big city without using much cash. Marion was spending considerable time on her own during her visits to New York by the time she was sixteen or seventeen. She had developed a circle of her own friends and also knew her mother's older friends. She was never far from a familiar face in the Village. Eventually she was able to earn a bit of extra cash posing for artists, and she was making friends in the theatrical world. It was an exciting time to be a young woman in New York.

Her schooling was also going well. She heard Marietta Johnson, a student of John Dewey's, lecture on progressive education when she was about fifteen and was fascinated, both with the woman and the subject.[8] After her bad experience in a repressive, highly regimented school, she found that she had strong feelings about the proper way to educate young people. The idea of using education to open up new and exciting possibilities to children rather than forcing them into molds of conformity was immensely appealing to her. As she told a reporter in 1986, "I was a crusader for progressive education."[9]

After graduating from Edgewood she took a job at Caldwell, New Jersey, teaching very young children, getting them ready to read and enjoy the process of learning. At this time, she began taking classes at the New School for Social Research in New York. She studied anthropology with Franz Boaz. She also began to dance at

this time, and dance became important to her.[10] The teaching job at Caldwell was used to help finance studies in the city. After a year at the New School for Social Research she transferred to New York University. There she was able to pursue her studies as well as studying dance with Doris Humphrey and Ruth St. Denis. Marion had come to the dance too late to have much hope of a career (and to complicate matters further, her father was opposed to her interest, considering dancing to be something that improper women did in burlesque houses). Even so, she loved the feeling of her body coming alive and was impressed with the ideas of Ruth St. Denis, one of the leading proponents of dance as a liberating force, both for the dancer and the audience. These ideas fit nicely with the goals of progressive education that Marion had adopted as her own.

For the next year she continued to teach at Caldwell while taking courses in educational psychology at New York University and dancing at studios in the city. She also spent a summer as an intern at Vassar, working with problem children and their parents. After two years at NYU, she apprenticed for a year in Massachusetts at the Shady Hill School, a private boarding school in Cambridge, Massachusetts, where many Harvard professors sent their children. By the time she was twenty-one, Marion was a well-trained teacher with a great deal of knowledge of child psychology and advanced teaching techniques. She did not, however, hold a degree.

While at Shady Hill, she lived for a while with a family that became important to her. Everett Smith and his wife, Hershey, were kind to Marion, and she became attached to them and to their two children. The Smiths were well off and interested in many of the same things Marion was. They introduced her to psychotherapy and some of the most advanced thinking in the field of psychology. Yet with all their positive attributes, the Smiths did not have a happy household; Everett and Hershey were clearly moving apart. Filling in where she could, Marion became close to the children and tried to help stabilize their lives.[11]

While she was an unpaid apprentice at Shady Hill School she learned of a job at a progressive school in Whitinsville, Massachusetts (near Worcester). She applied for the position and, with her strong qualifications, was quickly hired. This particular school had been set up by the owners of the local textile mills for the education of their own children and the children of the area's few professionals. The children of mill workers went to local public schools and took whatever meager educational opportunities were offered. At Whitinsville Marion began to see class distinctions in education and to realize that she didn't like the elitism that was occurring. Marion

lived in a working-class boardinghouse, an experience that was both new and important to her. The longer she stayed in Whitinsville the more she was struck by the sharp distinction between the children of the rich with whom she dealt all day and the hard-pressed mill workers she saw around the table at breakfast and at the evening meal.[12] It was 1932 and the depression was deepening in New England. People either had considerable fortunes (or at least substantial purchasing power) or they were likely to be in real poverty. There was no middle class in Whitinsville. The working-class men in her boardinghouse knew nothing of "progressive education," and the clean, bright children whose minds Marion spent her days stimulating knew nothing, indeed might never know anything, about the necessity of working in order to eat.

To Marion Post the world seemed increasingly out of joint. She began to feel the first pangs of disillusionment with the accepted American system, with its presumed promise of certain reward for individual effort and its emphasis on individual responsibility for any failures that might result, pangs which, in this case, manifested themselves in a strong urge to get away from New England, away from overtrained "interesting" people like the Smiths and overrich children wrapped in cosseted concern, and underpaid mill hands, worried about whether there would be another paycheck. She watched as the depression closed down the town and the school—then she left.

Marion was preparing to leave Whitinsville when she learned of her father's death. Dr. Walter Post died in considerable debt, owing to some unsuccessful land speculations in Florida during the 1920s. But there was some money left when all the claims had been settled, which was set up in trust for the education of the two girls. A small stipend was available to Marion as long as she stayed in school.[13] She was still at least two years away from a bachelor's degree and had been hearing about educational opportunities in Europe. Sister Helen was there, studying photography in Vienna; furthermore, she wanted to attend a friend's wedding in Paris. Best of all, Paris was a long way from Whitinsville and the disturbing problems that she had encountered there. She went to Paris.

After a short stay in Paris, Marion traveled to Berlin. She intended to study dance under the direction of the avant-garde dancer and choreographer Mary Wigman. A contemporary and friend of Doris Humphrey, Wigman was an advocate of *Tanzgymnastik* or gymnastic dancing, a forerunner, in its way, of aerobic dancing. Despite her late start, Marion could do and enjoy this form of dance, and she wanted to learn more about it.[14] She did study dance for a few

months, but Berlin was not a hospitable place for Marion. Unused to northern European weather as well as the lack of interior heat in both her apartment and the dance studio, for her, the winter of 1932 was dark, gloomy, and very cold. At one point she went with friends to a political rally and heard Adolph Hitler speak. She was horrified by the huge crowds and the carefully managed emotionalism.[15] Most of all, she was frightened by his message of hate. Her knowledge of German was far from comprehensive, but she could understand enough to see that Hitler was advocating the creation of a dominant class to rule a dominant race: Supermen ruled by super-supermen, with all other groups relegated to the trash-heap of history. Most frightening was the fact that so many Germans were listening to him. Coming, as this experience did, on the heels of her first real awareness of social class discrimination in Whitinsville, Marion found her political ideology moving sharply to the left.

The cold Berlin winter was too much for Marion, and soon she caught pneumonia. For weeks she hung on grimly in her rented room, hoping to feel well enough to dance again. She did recover, but the thought of going back to the cold rehearsal hall was too much to bear. Besides, she was anxious to leave Berlin. At this point she heard from Hershey Smith. Hershey and Everett had finally separated. While not unexpected, this development upset Hershey. Her two children were with her in Paris, and they wanted to see Marion. Would it be possible, Hershey asked, for Marion to join her and the children for a nice long trip through rural France? Marion could tutor the children and have time to herself as well. Predictably, Marion jumped at the opportunity and never returned to Berlin.[16]

The trip with Hershey and the children was a lovely last interlude before Marion's life began to take a definite direction. They rented a car and drove through the beautiful Loire Valley, exploring villages and looking at the great chateaus. Marion's health returned during their stay at Antibes, where they enjoyed the beaches and the pleasant life-style. After a few weeks, however, it all came to a sudden end. On March 4, 1933, Franklin Roosevelt took office and announced, among other things, the closing of all the banks in the United States. It was a necessary move at the time, but Hershey panicked. Scooping up her children, she returned to the United States to look after her investments. Marion was left to decide what to do next.

The decision came more from necessity and a sense of duty than anything else, yet it proved to be an important move for Marion. Her sister, Helen, had been studying photography in Vienna with Trude Fleischmann, a Viennese woman who had established an

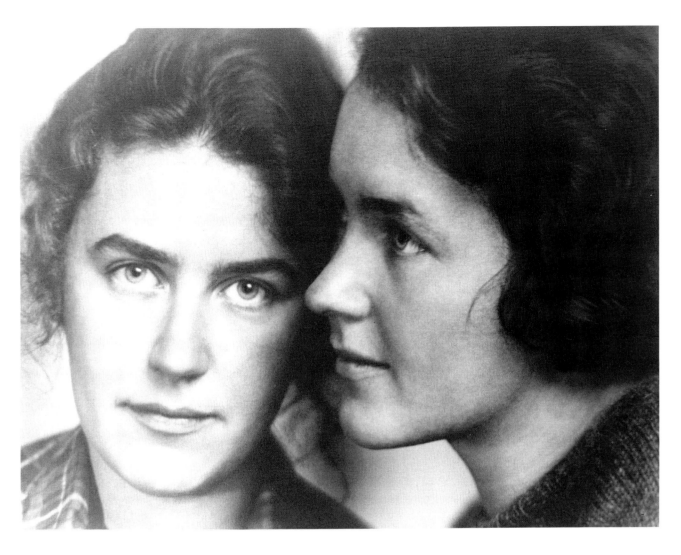

Marion and Helen by Trude Fleischmann, c. 1933.

international reputation for her portrait work. Helen had become ill with a suspected case of tuberculosis, which had interrupted her work. Helen was now convalescing at a farm in the Austrian Alps, where it was thought the clear air would help her lungs. For Marion it was a chance to get to know her sister better and to help her in a time of genuine need. She spent the summer of 1933 nursing Helen.[17]

Marion found her sister in bed in an upper room of the farmhouse, unable to come downstairs. For two months she took her all her meals and cared for her in other ways as well. By late summer it was clear that Helen's lung disease, while serious, was not tuberculosis, and the two sisters were able to leave the house for long walks together. When fall came, they returned to Vienna, Helen to continue her studies with Trude Fleischmann and Marion to take classes in child psychology at the University of Vienna. Helen's friends became Marion's friends, and a warm group developed. Marion had never done any cross-country skiing so several of the better-looking and more interesting young men undertook to teach her when the group went to the mountains on weekend trips. On the surface it was a happy time. Many of these young people were musicians and artists who were delightful companions, yet their light-hearted facades often masked seriousness of purpose. Several within the circle of friends were Jewish; most were considerably to the left of the mainstream of European thought at that time. Many were socialists, and some were communists. All hated and feared Hitler and opposed his rise to power. Marion, who had seen and heard Hitler the year before, found their ideas understandable.

In the Austrian Alps, 1933 was not an idyllic time. Trude Fleischmann and her friend, magazine photographer Otto Skall, had stayed often at the farm where Helen was sent to get well. They were Jewish and the farm family had always welcomed them. Now, however, with Nazism on the rise, neighbors objected. Whispered insults were reported back. The farm family staunchly stood by their Jewish friends and became known as anti-Nazis. Swastikas were burned in front of their house; fields and fences were burned. These nasty and frightening incidents served to remind everyone that Hitler's ideology of hate was never far away.[18]

During the winter in Vienna, Marion's first concern was her classes in child psychology. She found classes in German quite a struggle. Although she had learned some German up in the Alps, she quickly discovered that peasant German was not the same as high-Austrian intellectual German. She reacted to her problem in typical fashion by, as she later put it, "clamming up," getting as much as she could

from the lectures and finding friends who could help her with notes
or translations. This withdrawal into silence was a defense that she
had learned during her parents' separation and one that she would
use again in later life.

Marion's circle of friends now included many of Vienna's brightest
young intellectuals. Hitler's growing influence in Austria in the
winter of 1933–34 was of grave concern to them and to her. When
Austrian Chancelor Dolfuss was assassinated and the apartments of
socialist workers at Floridsdorf, on the outskirts of Vienna, were
bombed, Marion knew that she had to do something.

> I had some friends who were either Jewish or part Jewish and they
> were also *very* [emphasis is Wolcott's] liberal. So I was concerned
> about these people out there [on the edge of the city] and I asked
> what I could do. Well, they said, you can go out to these workers'
> apartments and help with the little Montessori school that they have
> out there. Well I ended up helping there and at another school that
> the local people had started.[19]

Marion spent several months working with the schools for the chil-
dren of Austrian workers, but friends finally convinced her to stop.
As Hitler's power over the region became complete, it was just too
dangerous, even for an American citizen, to engage in such activ-
ities. It is worth noting that Marion's activism at this time was
primarily directed toward helping the children who were innocent
victims. Although many of her friends were socialists or communists,
Marion was not a "joiner," nor was she ever particularly attracted
to the more extreme ends of the political spectrum. She was inter-
ested in freeing minds, not freezing them in political ideology.

By now the University of Vienna had been closed for months.
Marion's bequest from her father's estate had stipulated that the
money was to be paid as long as she stayed in school. Concerned
for her safety as well as her education, her trustee wrote that it was
time for both sisters to come home. Marion stalled for another
month, trying to prolong her stay in Europe as long as possible; then
the trustee made his message crystal clear. Instead of sending a check,
he sent a ticket. Marion had no choice; it was home or hunger.

During her hectic last weeks in Vienna, Marion had an experience
that was to prove pivotal. She had been given a camera, a tiny
twin-lens reflex called a "Baby Rollei," which she took on a weekend
outing in the mountains. Trude Fleischmann developed her first roll
and was impressed. "Sis," [Marion's nickname with Helen's friends]
she said, "you've got a great eye, You must do more of this."[20] The

encouragement from Fleischmann was important. Until this point, Marion had resisted the urge to take up a camera. Photography was something that Helen did and Helen was the artist. Trude continued to nudge and encourage her. At first Marion was little more than pleased at the compliment from an internationally recognized photographer, but she was interested in photography, and as time went on she would become increasingly involved with it. For now, however, her time in Europe had run out. After helping a few other friends leave Vienna for Italy, where antisemitism was thought to be less severe, Marion sailed for New York, following Helen who had left a few weeks earlier.

Back in the United States, Marion gladly accepted a position teaching first and second grade at the progressive Hessian Hills School at Croton-on-Hudson. The children were bright and pleasant, and the director of the school was a woman she respected. The director's husband, an amateur photographer, had built a darkroom which Marion was able to use occasionally. Best of all, Croton-on-Hudson was close enough to New York that she would be able to get to the city often. As usual, Marion found interesting people to live with. She rented a room from Margaret Chase, the ex-wife of social historian and critic Stewart Chase. Margaret was a committed vegetarian, a serious aficionado of the theater, and a full-time eccentric.

> Every morning I would be awakened by a maid with a huge glass of grapefruit juice and then Margaret would cry, "Come out, Marion, you've got to do the bear walk with me!" and so we'd go up and down her corridors on all fours, both as naked as jaybirds, taking our morning exercise. She was a wonderful character. The whole year was just great.[21]

It was a great year but not an entirely satisfying one. By now Marion was active in the League Against War and Fascism which, among other things, helped to sponsor Jewish immigrants from Europe to the United States. She and her sister sponsored Trude Fleischmann's immigration to the United States, guaranteeing her financial solvency as required by the laws of a nervous and often antisemitic nation. Fleischmann opened a studio at 127 West 56th Street in New York and had a very successful career specializing in portraits of performing artists.[22] Marion was happy to have helped Trude, but she often felt that she should be doing more to oppose the malignant force she had encountered in Europe.

Marion's other serious interest was, of course, photography. Helen

was now in New York City, making a living as a photographer. She had a "railroad flat" with a large bathroom, which had been fixed up to serve also as a darkroom. On weekends, Marion would drive down to the city in her recently purchased Model T Ford to take pictures and work in her sister's improvised lab. Helen taught Marion about darkroom technique, and both women would develop and print, looking at each other's work with a friendly, critical eye. Marion was now taking pictures at the Hessian Hills School and beginning to get other assignments as well.

Marion also had friends in the theater. The Group Theater, active in New York in the mid-1930s, was beginning to attract top young talent. Marion began to photograph at the Group Theater. In Europe she had learned some techniques which were considered advanced in this country, particularly the use of available light, and so her performance and dressing-room pictures looked different and fresh to many people. The lens on her camera was slow by modern standards, but she was able to hand-hold fairly long exposures without flash, often with striking results. When she did not give them away, Marion sold pictures for five dollars each to actors, directors, and authors. Among her friends and customers, she remembers Clifford Odets, Elia Kazan, Lee Strasberg and Morris Carnovsky.[23] Some of her work appeared in *Stage Magazine.* With these relatively small successes, Marion began to think that a career in photography might just be possible.

As the year at Hessian Hills School progressed, Marion became more and more convinced that she did not want to make a lifetime career of teaching. Although she loved the school and enjoyed working with young people, she was not satisfied. Photography now seemed so much more involved in the processes that affected life. At age twenty-five she wanted to be one of those who influenced events, not merely one who reacted passively to history's shifts. At the end of the year she resigned from Hessian Hills and moved to New York to live with her sister and try her hand as a freelance photographer.

Freelancing in New York proved to be a difficult way to earn a living. Marion continued to work with theater people, but she quickly realized that her five-dollar portraits would not keep her solvent. She did one assignment for *Fortune* magazine and some work for *Survey Graphic,* a widely read journal of social concern. She did occasional jobs for *PM Magazine* and had a few pictures published by the *New York Times Magazine.*[24] A friend, Ed Stanley, working for the Associated Press at that time would sometimes send her an assignment, but mostly it was a very hard existence. Marion

Morris Carnovsky, 1935.

was a survivor, however, and she rose to the occasion with typical flair.

> I can remember always being glad when a date was able to take me to a nice restaurant for a good meal because I didn't get many good meals during that year. I was more than usually appreciative of dates that had enough money to take me out and feed me well. [Marion laughs] . . . Ed Stanley used to buy me lunch because he knew I wasn't eating too regularly and this other fellow loved to dance and he had money. So we'd go out for dinner and he'd take me to all the best places. Well, he was a fairly interesting guy but I doubt if I would have dated him much if I hadn't needed a good meal.[25]

Sometime during her freelance year, Marion attended her first meeting of the New York Photo League. This organization was at the

Elia Kazan, 1935.

height of its creative powers in the mid-1930s, influencing many of the country's best young photographers. Far more than a "photography club," the league sponsored lectures and exhibitions of photography, encouraged major documentary studies of the New York environment, and provided a place to meet and talk about serious photography and its ability to change the social and cultural assumptions of the nation. At her first meeting, Marion heard a talk by Ralph Steiner, one of the most stimulating and articulate photographers of his time. Steiner posed several questions in the course of his lecture. Most people sat passively, but Marion became interested in his approach and responded with questions and answers of her own. After the lecture, Steiner sought her out and asked what she was doing. When Marion admitted that she was *trying* to be a photographer, Steiner was encouraging and suggested that she bring some prints for him to look at.

A few days later Marion appeared at Steiner's studio with the images she considered to be her best efforts. Steiner saw quality in the portfolio. "You can see," he said. "You have heart and I like that. But it's a little arty, Marion. You say that you have never had any formal training and it does look to me like you need to go back to basics."[26] Steiner mentioned a small group of serious young photographers who met at his studio informally from time to time to discuss photography and look at each other's work and the work of top-level photographers. Would Marion care to join them? Marion found these meetings among the most valuable learning experiences of her photographic life. Ralph Steiner had the wonderful ability to see the strength in a person's work even if the technical quality was not there yet. Marion was now maturing visually, developing her own way of seeing and approaching the world with her camera. Ralph Steiner showed photographs by Paul Strand in that first Photo League lecture that Marion had attended, and she was impressed by the purity and simplicity of Strand's work. Before long, she had a chance to meet Strand through the Group Theater, where he also had friends. Strand and Steiner took time with Marion, sharpening her eye and critiquing her printing technique. Within a few months her work began to show a marked improvement. In fact, they were impressed enough with it to invite her to be the still photographer on a film project that their jointly owned company, Frontier Films, was undertaking with Elia Kazan as assistant director. *People of the Cumberlands* was a film about labor organizing in the South. Ralph Tefferteller of the Highlander School was helping to organize workers in the lime-quarrying and lime-burning industry (burned lime is a key ingredient in portland cement), and it was thought that this would make a good subject for a film.[27] The film was clearly prolabor, and it was being made in a section of the country where labor unions were not welcome. It might not even be safe. Yet this was what she had given up the steady income and genuine pleasures of teaching for. This was a chance to use photography in an influential way.

Marion stayed up on the Cumberland plateau of Tennessee for several weeks and then spent a few days at the Highlander School. It was a great learning experience for her. Not only did she work with people of the caliber of Strand, Steiner, and Kazan, but she also came in contact with the southern region of the United States for the first time and, just as important, met the small, rather embattled band of southern liberals who were trying to effect social change. She did not earn much money, however, and by the time she returned to New York, she really needed a full-time, steady job.

One day over lunch Marion told Ed Stanley that if she did not

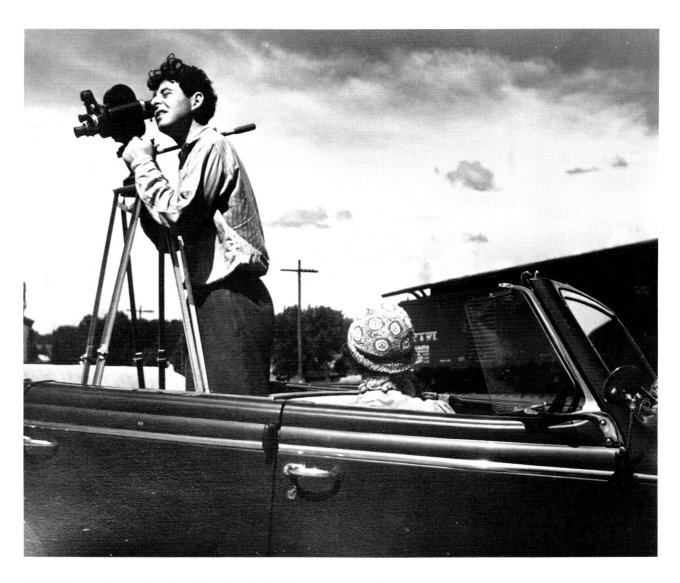

*Ralph Steiner filming "People of the Cumberlands" for Frontier Films. Near
Highlander School, Tennessee, 1937.*

find a job soon, she would have to go back to teaching. Ed was sympathetic and also confident in her abilities. Before long he called to tell her about a job at the *Philadelphia Evening Bulletin.* Marion went to Philadelphia, showed a portfolio of her work, and got the job. She held it for the next year and a half, becoming a member of the Newspaper Guild. Although it was not a great job, it did provide a steady income, which Marion needed even more since her sister was now married. It would no longer be practical or even possible to live with Helen in New York for extended periods of freelancing. Helen was not even in town much anymore. Her husband, an Austrian named Rudolph Modley, was a management consultant and economist who had occasion to travel in the American West. Helen went along and over the next several years found her métier in photographing American Indians. During the late 1930s and 1940s, she took hundreds of photographs of Native Americans.[28] From Marion's standpoint, her sister's happiness and success sharpened her dissatisfaction with her own work. Helen was doing wonderful things. Her brooding and sensitive pictures of major western tribes were being bought by the Bureau of Indian Affairs and used in books such as *As Long as the Grass Shall Grow* by Oliver La Farge and *Brave Against the Enemy* by Ann Clarke. Marion had a deadline for the ladies' page.

The job at the *Bulletin* was not easy, nor did it carry the sort of social impact that Marion was seeking for her work. Furthermore, Marion was not exactly welcomed into the masculine precincts of the *Bulletin's* photolab. The "boys" with the Speed Graphic cameras were accustomed to doing and saying whatever came to mind while working in the darkroom. They hardly knew what to do with a pretty young woman in their midst.

> They thought their whole lifestyle was going to be curbed because this "young lady" was coming in and invading their territory. So they were polite and outwardly friendly but didn't really accept me in the beginning. We had a little tiny cubbyhole for a darkroom —of course I had to learn an entirely different kind of processing system. . . . They were doing annoying little things, like throwing spitballs at me. They'd slip into my darkroom when I wasn't there . . . and they'd put out their cigarettes in the developer. So I'd have to change my developer and couldn't get to work right away. And each one would take me aside and say, "Look, all these other photographers are wolves; they're all out to make you. Just beware."[29]

After a few weeks of this treatment, Marion made it clear that she was at the *Bulletin* to make a living, and she didn't give a damn

what the men did or said. She was used to coarse language and perfectly capable of using it herself. She would be glad to help them with rush jobs when she wasn't busy and would appreciate some help from them in the use of the Speed Graphic camera, which was still largely a mystery to her. A truce was struck, and Marion was able to do her job without interference. It was her first encounter with the rough side of male camaraderie. It would not be the last.

Aside from her difficulties with the photographic staff at the *Evening Bulletin,* Marion was disappointed in her assignments. Her editor quickly typed her as the photographer for the ladies' page, covering fashion news, tea parties, and "artistic" events. Given her upbringing and her contacts with the well-born, Marion could easily blend into the fashion scene and bring back good, predictable pictures, but the work did not seem worthwhile to her. As time passed, she became more and more disillusioned. On a trip to New York, she told Ralph Steiner her problem. "Ralph," she said, "I'm sick of this job. I don't want to stay in photography if this is all I can do."[30] Steiner recognized Marion's dismay and suggested that she might find a position with Roy Stryker in Washington at the Farm Security Administration. Had she heard about this project? She had heard rumors but nothing definitive. Steiner told her about the FSA project and what Stryker and his team were trying to do. It sounded intriguing to Marion, so Steiner suggested that they assemble a portfolio of her best work. Since Steiner was planning a trip to Washington, he would take it along and show the pictures to Stryker. The director of the FSA Historical Section, as the photography project was officially called, was impressed with the portfolio and sounded encouraging. A few days later, Marion set off for Washington with more pictures and a letter of introduction from Paul Strand.

June 20, 1938

Dear Roy,

It gives me great pleasure to give this note of introduction to Marion Post because I know her well. She is a young photographer of considerable experience who has made a number of very good pictures on social themes in the South and elsewhere. Incidentally, the stills for our recent film, *People of the Cumberland* were made by her. I feel that if you have any place for a conscientious and talented photographer, you will do well to give her an opportunity.

Paul Strand[31]

Luck was with Marion. Roy Stryker had just received authorization to enlarge his staff and was looking for someone to send into the South. This young woman appeared capable and seemed to have an interesting background. The two met in early July 1938; Stryker offered her a job beginning in September. For the next three-and-a-half years Marion Post was a photographer for the Farm Security Administration. It would not be an easy job. It would require all her skill as a photographer and all the stamina and tact and social commitment that she had garnered in her twenty-eight years. But this job would give her the opportunity to become a social documentary photographer, and to seek and find her own version of the influential image.

CHAPTER TWO

A Time of Testing

In recent years it has become fashionable for art historians and social historians to find fault with the photographic section of the Farm Security Administration, the federal agency that Marion Post joined in 1938. In his influential book *American Photography: A Critical History, 1945 to the Present,* Jonathan Green states quite flatly that "Roy Stryker, who headed the F.S.A. photography program told his staff exactly what to find," and then sent them out into the field to take pictures that would favorably propagandize the agency's programs and goals.[1] In the context of the late 1980s, this cynical view of government might well be justified, but it betrays a lack of understanding of the 1930s, of the agency, and of the people who worked for it. Part of the problem lies in the word *propaganda* itself. Today, that word is understood to connote lies that are used to make a government program or leader look better than they really are. Prior to World War II, however, no such connotation existed. Propaganda was considered the legitimate process of a government or institution's selling itself and its programs to its own and other people. A great artist like Ben Shahn could say, "I have never shrunk from the word *propaganda*" and simply mean that he felt comfortable using his talent to support government programs in which he believed strongly. There has also been a shift in our perception of government. While most educated people today probably view the actions of the American government with considerable distrust, in the 1930s, the government of Franklin D. Roosevelt enjoyed high credibility among a large majority of the American people of all but

the wealthiest social classes. To return to the specific agency that was Marion's employer, it is true that some of the work done was propagandistic in the sense that it was designed to sell the programs of the agency, but much was not. In many cases the photographers were accorded a great deal of personal and esthetic freedom. What should be understood is that the photographers who were hired and retained by the agency shared its goals and aspirations and felt comfortable taking pictures that illustrated problems to be overcome as well as the general social context of American rural poverty. They thought of themselves as telling the truth, and if they were asked to take pictures that they felt were untrue they did not hesitate to balk.[2]

The agency had been mandated under a presidential order in the spring of 1935 in an effort to overcome a major problem in American agriculture. The depression had left American farmers, already reeling from seven or eight bad years during the 1920s, in terrible shape. By 1929 there were about 1.7 million farms in this country with a gross yearly income of less than $600. This represented nearly one-third of all the farms in the country. At this time an urban family of four needed $1200 per year to be considered above the poverty line. Among those 1.7 million farms, 900,000 grossed less than $400 for the year and 400,000 farms less than $250 for a year's hard labor. By the early thirties starvation was a reality on many American farms.[3]

When Franklin Roosevelt came to power in 1933, he attempted to develop a program to meet the needs of poor farmers. His advisers and the political leaders in the Senate and House formed the Agricultural Adjustment Administration, which proposed to raise agricultural prices to a level capable of supporting a family while taking a considerable amount of land out of production. The experts in Washington had correctly perceived that a major problem for American farmers was overproduction. Decreased production, they reasoned, might lead to higher prices. Paying farmers to take land out of production did work—in a limited way and for a limited number of farmers. The program enabled the large-scale farmer to predict with reasonable accuracy his earnings at year's end.

For the small farmer, who had little land to put into the federal program, and even more for the tenant farmer, the renter, or the sharecropper, the AAA was an unmitigated curse.[4] Farmers who were being paid to take land out of production were not likely to want renters and sharecroppers putting land back into production. In the Midwest where renting was common, and in the South where sharecropping was even more common, the human displacement

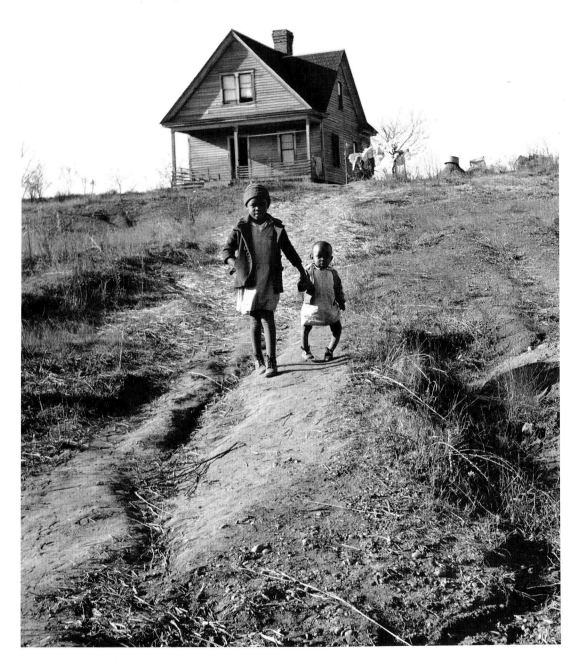

Tenant farmer's children, the younger one with rickets. Near Wadesboro,
North Carolina, 1938.
LC-USF 34-50720-E

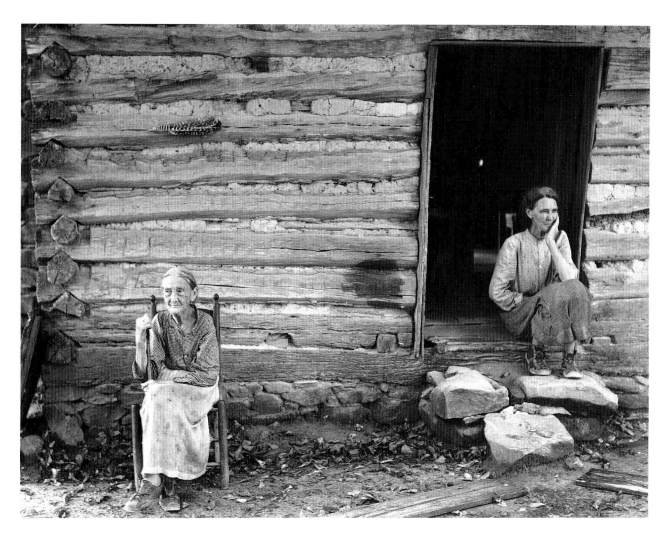

Mrs. Lloyd, ninety-one years old, and daughter with pellagra, in doorway of old log house. Near Carboro, North Carolina, 1939.
LC-USF 34-52046-D

was staggering. Tens of thousands of Arkies and Okies hit the roads in their broken-down cars, looking for work picking peas in California, or cotton in Texas, or citrus fruits in Florida. They lived in makeshift tents by the side of the roads, their children dirty and uncared for, their resources shrinking by the day. Other small farmers stayed on their land, clinging to worn-out soil, trying to make one more crop and somehow stay alive. In still other rural areas, where mining or small industries had provided livelihood and were now closed, stranded men and their families tried to eke out a living from thin, often hilly soil that had at best been only marginally capable of supporting agriculture and was now ruined beyond repair for at least a generation.

In an effort to deal with several problems of the poorest third of American farmers, Roosevelt created the Resettlement Administration in 1935 (the name was changed to the Farm Security Administration in 1937, the year before Marion joined the agency). Programs to find new land for small farmers on worn-out soil and resettle them on better acreage were combined with collective farms for displaced renters and sharecroppers, and another program provided decent camps for migrant workers. A number of experimental communities combined small, settler-owned landholdings of ten to fifteen acres with seasonal factory employment. The idea was to encourage families to raise a good garden along with a few hogs and a calf or two while a light industry such as food processing or textile manufacturing would be encouraged to move into the community to provide some cash flow. Even the most hopeful government planners knew that many of these programs were little more than stop-gaps, ways to keep poor rural people from flooding into cities that were unprepared to receive them. Yet these programs did help people improve their lives.[5]

Obviously many of these programs were controversial. Wealthy cotton planters, for example, did not like to see a federal agency offering their laborers a better way of life. If a man has alternatives, he may be unwilling to work for ten cents an hour. Some of the programs contained elements of socialism and thus were offensive to conservatives. The collective farm idea, for example, was borrowed directly from the Soviet Union. If the agency was to survive, it needed to sell itself and its programs to the general public and to those in decision-making roles in the federal government.

In 1935, just as the agency was being organized, the project's director, Rexford Tugwell, brought in Roy Stryker, an economics instructor from Columbia, to direct the Historical Section. Stryker had developed a reputation in New York as a man who knew how

27

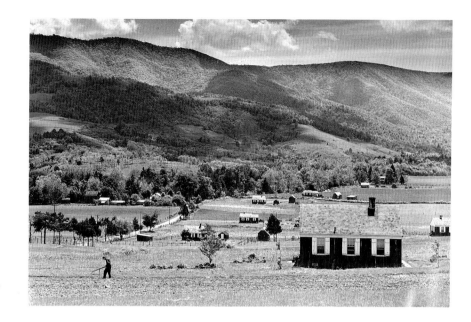

Ida Valley Farms, Shenandoah Homesteads. Luray, Virginia, 1941. LC-USF 34-52546-D

to use visual images to illustrate economics textbooks and lectures. Bright and ambitious, Stryker from the beginning identified two roles for his section. He understood that the photographs should, if possible, support and defend the general work of the agency. But Stryker also wanted to create an intellectually respectable document of American life in the 1930s. In October 1935, just months after the agency's start-up, Stryker wrote to Dr. Harry Carmen, his friend and mentor in the history department of Columbia University, that the time seemed right to "start making an historical picture of America in photographs."[6] Throughout the seven-year life of the agency, Stryker and the photographers would balance these two goals.

Stryker and his team did not operate in a cultural vacuum when they conceived the idea of a broad document of American life. As early as the 1920s, the proper role of art was under active discussion among people who cared deeply about visual images. Should it appeal to a small elite or should the artist try to reach a much larger number of people, and perhaps help the mass of Americans to understand who they were? Could art help to define the American character? In 1925, influential New York art critic Thomas Craven had laid down some dicta for American art. He felt that American artists should reject as elitist and sterile the European ideas about modernism. Craven was certain that European art was based more on technique than communication and that Americans, a practical people, wanted an art that communicated directly with them.[7]

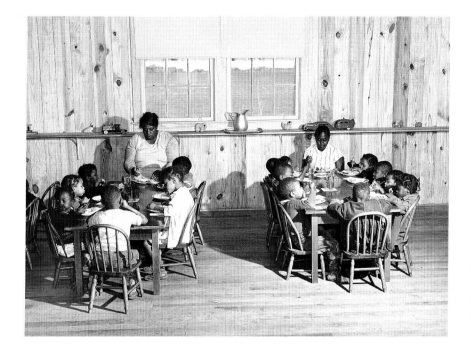

*Hot lunches for children of
agricultural workers in day nursery
of Okeechobee Migratory Labor
Camp. Belle Glade, Florida, 1941.
LC-USF 34-57238-D*

While Craven's populistic ideas were narrow and isolationist in some respects, they were widely read and influential. By the late 1920s many of the country's best artists—Edward Hopper, Thomas Hart Benton, Grant Wood, John Steuart Curry, and others—were attempting to define visually the "American character," and it was an intellectually respectable thing to do. Much of their work might today be looked upon as nostalgic, but they saw it as a process of exploring their roots. They shared the populist assumption that the "common man" was definable and was a more interesting and significant subject for art than the activities of the upper classes or the interior writhings of the artistic soul.

The depression had injected a note of urgency into the art world. There was a sense that now, more than ever, Americans needed to understand who they were and where they had come from. Many painters continued to explore the past for reassurance, but others sought to use realistic painting to bring about reform. In New York, painters like the brothers Isaac and Moses Soyer, Ben Shahn, and Reginald Marsh portrayed the troubles they saw all around them in a harshly realistic style. In the Midwest, Joe Jones glorified the worker in the fields and condemned the stupidity and greed that had brought waste of natural resources and soil erosion to destroy the American dream of owning one's own farm.

Many of the recognized artists of the 1930s worked in one or more groups. In many cases, they worked on government-sponsored

29

projects, either painting murals at a local post office or meeting with people of similar interests to do easel paintings of "The American Scene." Even if not employed by the government, however, artists of the thirties tended to work together in groups. This is a difficult concept for most of us today to understand, since it contradicts our idea of the artist as a lonely creator, working in isolation, but during the 1930s the group idea was strong. In 1931, the *American Magazine of Art,* the organ of the influential American Federation of Art, proclaimed an "American Renaissance" designed to reach the masses, and the journal made it clear that this would be a group effort. There would be no modern Michelangelo to lead this movement, and in fact there would be no unfettered individualism within the movement, for that was the European way. Americans would work together, cooperatively, to understand and portray their culture.[8]

The photography project of the Farm Security Administration was born into this intellectual climate, and it reflected both its goals and its approach. It was oriented toward realism; it was essentially populistic, taking as its venue the "common man" and rural and small-town America. It was a group effort. The photographers were asked to place their talents at the service of the twin goals of supporting the agency and building up a great file of images of American life. Photographers who could not accept these goals usually did not last very long with the agency. The agency was charged with the job of helping poor farmers, and its photographic section was expected to take pictures that supported that end. Marion Post fit into the group perfectly. After all, she had been swimming in the same sociocultural mainstream, and she strongly supported the basic ideas of the group.

Marion's earliest assignments were in the South. It may be that one reason she was hired (aside from the strong recommendations from Strand and Steiner) was the fact that she had at least a smattering of knowledge of the region, which she combined with a clearly liberal world view. It was not easy in 1938 to find a competent photographer who was able to function in and relate to the problems of the South. The programs of the FSA, arguably one of the most liberal of the New Deal agencies, were often at odds with the deeply conservative mores of the South. Stryker needed someone liberal enough to see the problems and tough enough to photograph them. But the person also had to get along with local administrators or even police chiefs who might not share the central office's views on race relations, or collective farming, or planned villages for stranded workers. This attractive "girl" (for that is how he thought of her) might just be able to pull it off.

On July 14, 1938, Stryker wrote to Marion at the *Philadelphia Bulletin* offering her a job with a three-month trial period. The starting salary was $2,300 per year with a $5.00 per diem when she was in the field plus 4$^{1}/_{2}$ cents per mile when traveling in her own car. Marion was to use her own camera equipment for much of the work, with the agency providing a 3$^{1}/_{4}$ by 4$^{1}/_{4}$ Speed Graphic and all of her film, flashbulbs, and other supplies. All negatives were to be the property of the agency.[9] The offer was standard. The same salary and conditions had been offered to Arthur Rothstein and Dorothea Lange when they joined the agency in 1935 and to Russell Lee when he joined in 1937. Walker Evans had received more for the two years that he had been with the agency, but he had been designated senior photographer. It was not a princely wage, but it was adequate, and the allowance for expenses on the road was almost generous. Ben Shahn remembered that he could usually save money while he was on the road.[10]

In the same letter in which he offered Marion a job, Stryker began to show some signs of nervousness concerning his plan to send this "girl" into the South. Marion had announced her intention of traveling alone (indeed she had no choice since no one was available to travel with her), and Roy was not at all sure that was a good idea. The only other woman photographer he had sent into the South, Dorothea Lange, usually traveled with her husband, economist Paul S. Taylor. The problem that Stryker raised was a real one with possibly tragic consequences, but the tone in which he expressed himself revealed both male embarrassment and condescension.

> There is still another thing I raised with you the other day, that is the idea of your traveling in certain areas alone. I know that you have had a great deal of experience in the field, and that you are quite competent to take care of yourself, but I do have grave doubts of the advisability of sending you, for example, into certain sections of the South. It would not involve you personally in the least, but, for example, negro people are put in a very difficult spot when white women attempt to interview or photograph them.[11]

Stryker was clearly uncomfortable with the situation. Since his concern was real, Marion restrained herself from the retorts that must have occurred to her and reassured her employer that she was careful and sensitive. It would be some time before they were able to communicate as equals.

Marion's first trip was a short one into West Virginia. In late

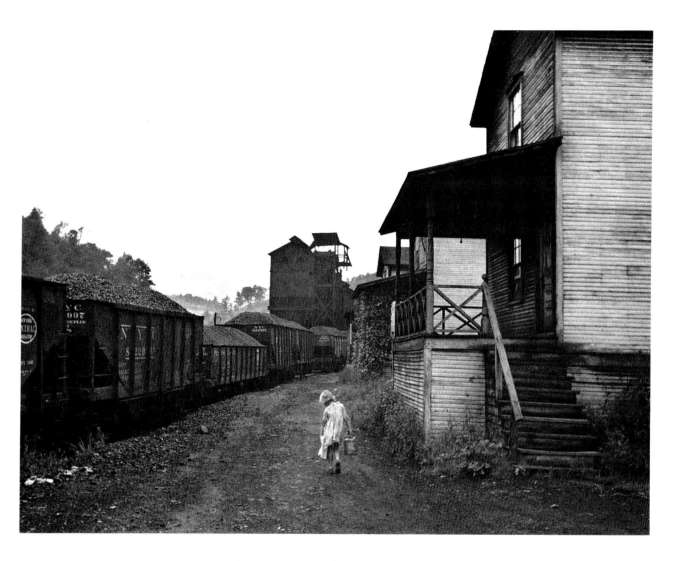

Coal miner's daughter carrying home can of kerosene to be used in oil lamps. Pursglove, Scott's Run, West Virginia, 1938.
LC-USF 33-30180-M2

*Miner's wife on porch of their
home, an abandoned company store.
Pursglove, West Virginia, 1938.
LC-USF 34-50243-E*

September she received a note from Stryker addressed to her at
Morgantown. None of her letters from the first trip has survived to
indicate her feelings, but she clearly felt herself to be on trial. At
least one great photograph did emerge from the trip. At the tiny
mining community of Pursglove, West Virginia, she watched a small
girl struggling to carry a can of kerosene home, her body bent in
the effort to compensate for the heavy fluid. The grey day, the coal
cars, the dirty house nearby, the road bending to the right, and the
child's body bending to the left combined into a powerfully evocative
image. It was the kind of picture that could be used to convince
people of the need for programs to help children like this. Marion
had secured her job at this point, whether she knew it or not.

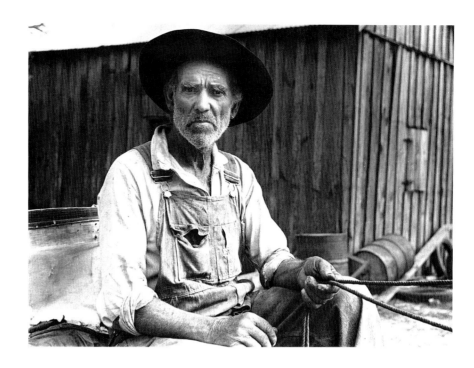

*Project borrower. Greene County,
Georgia, 1939.*
LC-USF 33-30341-M3

In November 1938 she left Washington, D.C., for a major trip
through the South. After making routine photographs of various
FSA camps and rehabilitation clients, she arrived in Columbia,
South Carolina, a few days before Christmas. By now the culture
of the deep South was beginning to wear on her and she vented
some steam good-naturedly to Clara Dean Wakeham (better known
as "Toots"), Stryker's secretary who had quickly become Marion's
best friend in Washington. The culture shock of a northerner coming
into contact with the "real" South was apparent.

> You should see these Southern towns, decked out fit to kill with
> more lights and decorations and junk than you could find in the 5th
> Avenue big 5 & 10 cent store. The houses too. But damn all the
> firecrackers everywhere, all the time, day and night. . . . I wish
> they'd celebrate and serve a decent meal in one of the restaurants,
> just for a change—for the holidays! Vegetables for one meal are
> usually fried potatoes, mashed potatoes, sweet potatoes, rice, grits or
> turnips![12]

Marion went on to report that her work in the area had consisted
mostly of "dashing around from one tenant purchase farm to another
with one idiot or another." As an example she reported that she
had expected to photograph some interesting places and people that
day but had had to spend most of the time waiting for one Mr.
Devieux "who was finally ready to leave here at *noon* and then we

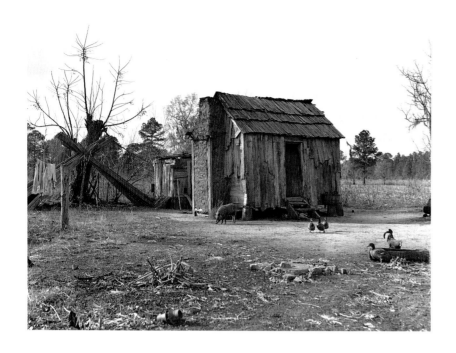

*A Negro shack with a mud chimney.
Beaufort, South Carolina, 1938.
LC-USF 34-50520-D*

had to pick up his wife and drag her along, and spent the remaining couple of hours admiring holly trees, etc." What, in fact, occurred that day in South Carolina was a classic case of two cultures failing to understand each other. Marion was unaware what a socially dangerous position she was putting Mr. Devieux in when she asked him to accompany her on a series of short junkets around the county in her car. She needed directions to homes of specific clients of the Farm Security Administration. Mr. Devieux knew, however, that if he were seen in a strange car with an attractive young woman, traveling the backroads of the county, he would be the subject of endless gossip, to say nothing of having to explain the situation to a very unhappy wife. In order to protect himself he invited his wife to go along. It was an essentially silly situation, but it reflected the realities of the South at the time. (And the small-town South would not be very different today.) It would take time and experience for Marion to learn to deal with such situations, and they would always try her patience to the limit.

The pace of life in the South during the late depression was a source of frustration during Marion's first major trip. During a stop in Raleigh, North Carolina, she wrote to Stryker that she found the slow pace of life there "amazing": "It takes so *much* longer to get anything done, buy anything, have extra keys made. . . . Their whole attitude is different. You'd think the Xmas Rush would stimulate them a little, but not a chance."[13] The overall tone of the

letter was one of good humor, yet the sense of frustration was real.

A few days later, Marion wrote Stryker to tell of some rather more serious problems that she had encountered. She had been driving her car through some of the harshest and poorest backcountry in the Carolinas. The trip from Raleigh, North Carolina, to Charleston, South Carolina, had been difficult because she had found the people uncooperative.

> I found most of the [poor] people very suspicious, quite unfriendly. It was practically impossible to do anything about it because of the cold weather. To *them* very cold and unusually windy. They just get in their little huts or shacks and build a little fire and close the wooden window and door and hug their arms close to them, waiting till it gets warm again. And they won't let a stranger inside. Often they wouldn't let me photograph the outside of the house. I tried every different line I could think of, and carried small bribes and food along with me. Along the bigger roads they were *very* commercialized—*immediately* asked for money, and no nickels or dimes either—*real* money. And even then they'd just stand up in front like stiffs and not move until you "snapped it and left."
>
> Some said they didn't understand why I was riding around in that kind of country and roads all alone. A couple thought I was a gypsy—(maybe others did too) because my hair was so "long and heavy" and I had a bandana-scarf on my head and a bright colored dress and coat. All of which I remedied immediately but it didn't seem to help.[14]

Marion needed help and advice as to how to approach people who were so different from her that they almost did not speak the same language. She had just traveled through one of the poorest and most difficult sections of the entire South and she wanted reassurance that other photographers had had similar problems in the same area (which was true), but Stryker reacted instead with a lecture. "I'm glad that you have now learned," Stryker wrote, "that you can't depend on the wiles of feminity when you are in the wilds of the South." Warming to his subject, he went on:

> Colorful bandanas and brightly colored dresses aren't part of our photographers' equipment. The closer you keep to what the backcountry recognizes as the normal dress for women, the better you are going to succeed as a photographer. Russell and Arthur learned this too: when Russell bloomed forth with his skyblue jacket covered with all manner of pockets, I raised my eyes unto the heavens, but said little. The backcountry people solved the problem. Russell doesn't wear it any more.

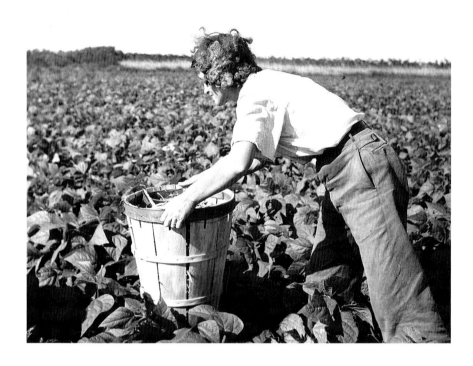

*A woman from New Jersey picking
beans. Hampers are heavy and must
be moved along as one picks.
Homestead, Florida, 1939.
LC-USF 34-51050-E*

I know this will probably make you mad, but I can tell you
another thing—that slacks aren't part of your attire when you are in
the back country. You are a woman and "a woman can't never be a
man." If you could see me stroking my whiskers while I am giving
you all that fatherly advice, you would take it in much better form.[15]

Had not Marion been committed to the goals of the agency and to
the work itself, she might have left at this point. While Stryker
tried to soften the edges of his condescension by referring to supposed
sartorial indiscretions of two of the male photographers, Arthur
Rothstein and Russell Lee, he also ruined the effect by admitting
that he had "said little" to them while he obviously had quite a lot
to say to a young woman who stepped, however unwittingly, across
the line. Marion's response, written from Belle Glade, Florida, where
she was photographing harsh conditions in some of the private camps
for migrant workers, shows that she had been stung by Stryker's
words. Yet through the skillful use of humor, she was able to make
her own points without creating a serious rift in the relationship.

Stryker must have been impressed; this young woman could write as vigorously as she could photograph.

> Now Grandfather—you listen to me for a minute too—all you say is perfectly true, *but* I just wish you had been with me for just *part* of a day looking for something, particularly with POCKETS. Let us assume that we agree on the premise that photographers need pockets—badly—and that female photographers look slightly conspicuous and strange with too many film pack magazines and rolls and synchronizers stuffed in their shirt fronts, that too many filters and whatnots held between the teeth prevent one from asking many necessary questions. Now—this article of clothing with *large* pockets must be cool, washable if possible, not too light or bright a color. Try and find it! . . .
>
> You can see you touched on a sore subject. About slacks you can't make me mad. I learned that you can't wear them in the stix when I was in Tennessee, etc. a couple of years ago. But Florida in *most* sections, is an exception. Everyone wears them—idle rich, winter and year round residents, migrant whites and negroes. Especially picking. If you'd seen the results of the pleasant feast the insects and briars and sticker grasses had on my legs the first day I took photographs of the tomato and bean pickers you'd know why. I wore a skirt and heavy stockings and socks and was still a mess. But not again.
>
> And I DIDN'T use feminine wiles. I usually wore an old jacket and sweater but it was too cold that day [up in North Carolina]. But I'll be a good girl and buy an old brown swagger coat next winter.
>
> My slacks are dark blue, old, dirty and not too tight OK? To be worn with great discrimination, sir. [16]

Both Stryker and Post used humor in this exchange to mute possible controversy. Stryker wanted Marion to stay with the photographic unit and Marion clearly wanted to stay. In fact, by the time this letter was written, in January of 1939, she was finding a great deal to photograph in Florida. Conditions in the vegetable growing area of the state were very bad in the winter of 1938–39. A cold drouth gripped the state, wiping out the early crops, leaving the poor migrant workers in a very bad way. Marion wanted to photograph the effects of poverty on people's homes, but she found it hard, at times, to approach these people and win their confidence. Perhaps it was because she was young and well educated and urban. Certainly time was a factor, for there were always pictures that someone wanted, and when these demands were satisfied, there was little time left for her to get to know people. In January 1939, she wrote to Stryker from Belle Glade that "there's good material for me here. Conditions

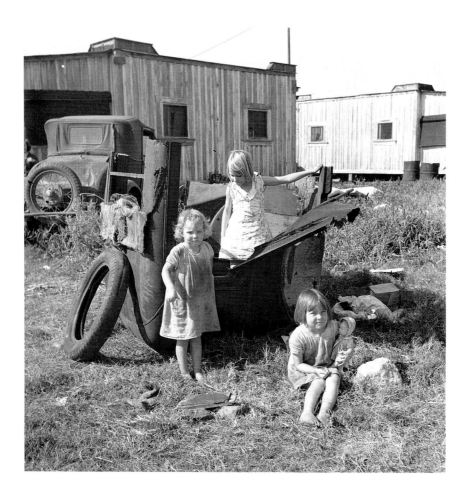

*Migrant laborer's children living in
overcrowded camps with very bad
sanitary conditions. Belle Glade,
Florida, 1939.*
LC-USF 34-51200-E

are awful at all times, just more of it and easier to find at the busy
season."

> It takes time, Roy . . . talking and listening to people, going back
> again to pursuade them, or returning when the one (sometimes *either*
> the mother or father, not both) who objects to pictures will surely
> not be at home, or returning when the light is right.[17]

Marion was particularly struck by the problems of the women. A
few days after this letter, she wrote Stryker about women workers
in the fruit- and vegetable-packing plants.

> A woman the other day told me how she'd been waiting around
> the packing house all day long. They were told there'd be *some* work.

Finally something came in and she got *nine minutes* work. They never know so they not only don't get paid but they can't stay home to take care of the "house" and kids either.[18]

Marion's observation was one that many men would have missed, and it was important. Stryker had to be impressed by this; it was exactly this capacity for social observation that he wanted his people to have. Stryker also had to be impressed with Marion's willingness to keep going through difficult conditions. One of her letters describes, with typical humor and flair, the dangers that she faced in the fields of Florida.

> More wildlife trouble. Other day in the middle of a field where I was photographing the pickers, there was a terrific commotion and sudden screaming and yelling and before I knew what was happening one of them pushed me, knocking my camera out of my hands and literally dragged me to the road. Two of the foremen fired some shots . . and the *biggest* rattlesnake you've ever seen—about ten feet long and as big around as a stovepipe—went tearing along. They didn't kill him. (They said they usually do and hack him 'sure dead' with hoes.) I've never seen such a big snake . . but there are a lot of them around the glades. . . .
> I'm not afraid of snakes unless they're poisonous. Now *spiders* are something else again. Bite or no bite, harmless or poisonous, I don't *like* them. I get cold and pale feeling inside. And here they are like elephants. At least you can sometimes see *them* first. Especially if they are in the bathrooms and toilets and cabins. Me for the bushes with the chiggers and ticks.[19]

Marion was smart enough to know that any reference to the bathroom would embarrass and at the same time titillate Stryker. She enjoyed the effect her humor had on him and used it well. Stryker never knew quite how to take this disconcertingly frank young woman, but he knew he liked her and the pictures she was producing. By now Marion's trial period was over, and Stryker was happy to accept her on the staff. Even so, his handling of Marion was not always smooth. As the earlier letters indicate, there was a period of learning to work together, and that period was not over.

In the early days Stryker seems to have thought of Marion as a sort of "ladies' auxiliary" to the photographic project, someone to handle "women's" issues that no one else wanted to bother with. In late January 1939, with Marion still in Belle Glade, Florida, Stryker wrote to recommend that she make contact with Miss Edith Lowry, who worked with an agency called the Federal Council of Churches

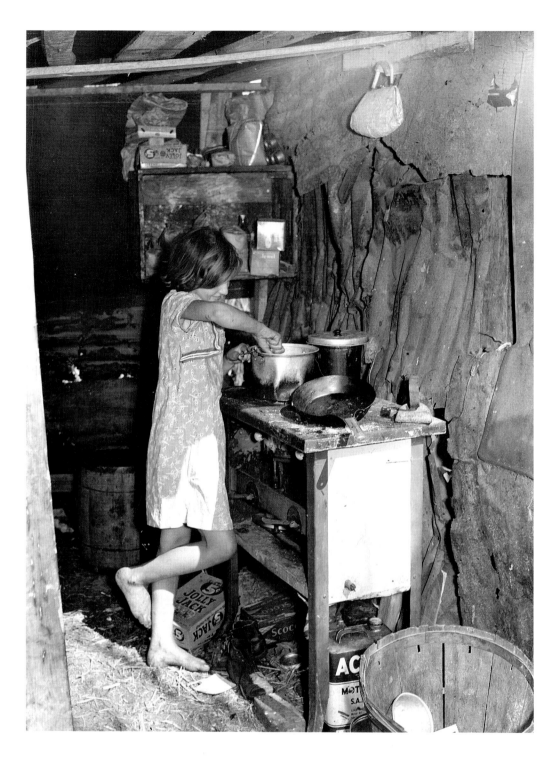

Oldest child of migrant packing-house workers preparing supper. Her parents
work during the day and sometimes until 2 A.M. *The children are left alone.*
Near Homestead, Florida, 1939.
LC-USF 34-50907-D

Home Missions Board. According to Stryker, "she and her crowd are trying to stir up the church groups on the whole migrant, displaced agricultural labor problem." Stryker suggested that Marion work with Miss Lowry if it was convenient to do so without upsetting her own shooting schedule. He thought that Lowry might benefit from some conversation or even travel with Marion.[20]

Stryker failed to realize, however, that Marion's attitudes toward the church had been influenced by a mother who had little use for organized religion. More important, Marion's schedule taxed her time and energy to their limits. She did not appreciate having an uninvited traveling companion pressed on her from above. Marion tried to work with Miss Lowry for a few days and then blew up.

> Went to Palm Beach to see Miss Lowry Thursday, found she'd
> gone to some meeting and tea. (I'd wired her several days before that
> I'd be there.) Couldn't see her until after dinner. Spent the evening
> with her discussing possibilities and whether or not our plans could
> coincide. Gave her names and general information, etc. Arranged to
> take her around on Saturday. She arrived in B[elle] G[lade] Saturday
> morning with two other women (she has no car) and couldn't come
> back with me Friday. Well, I made the best of it and took her to visit
> several families and looked for other people for her to talk with—
> doctors, nurses, mayors, etc.
>
> Maybe I'm intolerant in my own way and I suppose these women
> are at least aware of a few more things and interested and active, but
> god damn it I can't stand their sentimental way of handling it [sic].
> After a whole day of that crap and listening to them play Jesus I
> could just plain puke! "Just a little daily bible reading for the kiddies
> and a service on Sunday for all the folks."[21]

Stryker's response was immediate. He clearly understood that he had misjudged both Marion and the situation. Stryker, himself no great friend of organized religion, professed himself delighted with Marion's reaction to "God's Chosen" and then went on to an apology and a pledge. "I am awfully sorry that you had all this mess," he wrote. "You have done your part and never again do you need to go out of your way to help her out. I think this will cure me of imposing any more people on you photographers."[22] Stryker kept his pledge as far as it related to outsiders. The letters do not reveal any further such impositions. Within the organization, however, Stryker continued to regard Marion as his best "troubleshooter," the person who could be counted on to go into a situation and smooth ruffled feathers and get along with difficult local administrators.

Several recent short studies have indicated that Stryker assigned

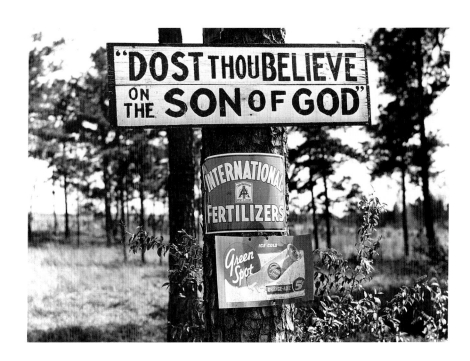

Roadside signs. "Bible Belt," Greene
County, Georgia, 1939.
LC-USF 34-51274-D

Marion these details because she was a woman.[23] Undoubtedly this
was true, but the fact is that Stryker's strategy was not entirely
wrong. Attractive and enthusiastic, Marion Post *could* make contact
with local administrators, take a few pictures for them, and drive
away leaving a warm, cheery glow behind. It was not that Stryker
did not trust her to take on the sort of large-scale independent
assignment that all the photographers loved and that Marion longed
to do more of. In fact, by 1939, those assignments were rare and,
during her years with the agency, Marion probably got her share.
More important, to Stryker, Marion was a superb natural public
relations resource for the main office in Washington. Conceding
that it was unfair to use her that way, Stryker did so, particularly
during her first major trip. Her chores did limit her ability to seek
out and follow up on her own visual ideas, but they probably also
kept her in the field and active for longer periods of time than might
otherwise have been the case.

It is regrettable that Stryker did not at first feel able to give her
more creative leeway because Marion had a very sharp eye for social
observation. In January 1939, she asked for some time to pursue an
idea of her own. She wanted to do a study in contrasts between the
very poor people and their living conditions, which she was pho-
tographing more or less daily, and the very rich in the nearby Florida

towns. She wrote to Stryker that she wanted to return to the area in the early spring when everything would be in "fool bloom" because "there are also those wonderful gardens and estates there—a wonderful contrast. I want to get some nice juicy shots of them and a few of the big homes. . . ."[24]

It has been implied that Stryker called her off this idea fearing that her work might offend powerful people, but there is no evidence in the letters or papers to support this.[25] In fact, the entire FSA and its photo file were offensive to many powerful people, and the agency was eventually destroyed by powerful people. Stryker and the others who directed the agency in Washington cannot have been too worried about giving offense. Furthermore, Stryker's own populist upbringing instilled in him a great delight in contrasting the rich and the poor. Eventually, Marion did complete the project she had in mind, but during the spring of 1939 Stryker had other work for her. He could not spare her to go off and "do" Miami just then. The directors of various FSA projects were pressuring him for photographs of their local accomplishments. He needed his ace public relations "girl" to move up into the heartland of the South and do some "project" photography.

By March Marion was in Montgomery, Alabama, taking pictures of local FSA clients and programs. Stryker's instructions to her give a sense of the sort of routine work that she and all the other FSA photographers spent a large percentage of their time doing. "Watch particularly," Stryker wrote, "for more pictures which cover the food diet problems of FSA."

> We want any type of photography which emphasizes the good results (if there are any) of the FSA Rehabilitation Supervision Program. We need more canned goods pictures out of the South. Get a little more variation in these. These are terribly important to our "higher ups."[26]

This short quote encapsulates the photographic section's approach to "propaganda." Stryker certainly wanted photographs that showed good results, but he qualified his request with the parenthetical "if there are any." The agency was trying to help farmers who were very poor and often quite ignorant, through a program of careful supervision, showing them new crops that offered a greater promise of income than cotton, and showing their wives how to vary the family diet, especially through canning garden vegetables. The FSA had even established canning kitchens in many rural locations, and the women were being encouraged to use them. Marion's assignment

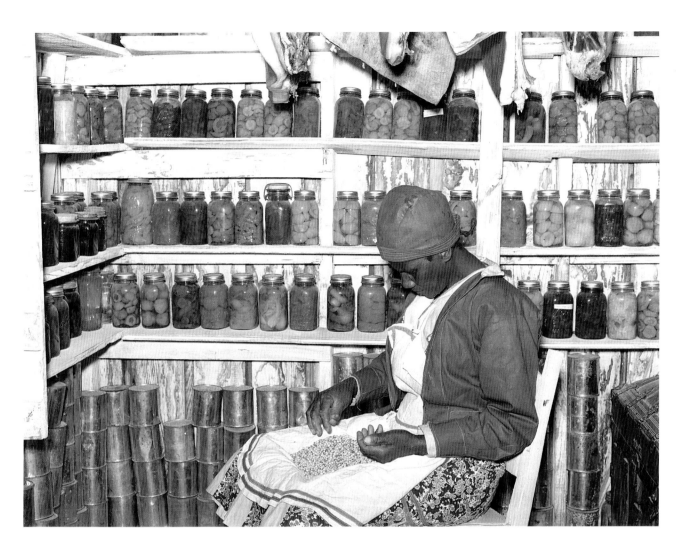

Jorena Pettway sorting peas inside her smokehouse. She still has many fruits and vegetables, which she canned last year, on the shelves around her. Gee's Bend, Alabama, 1939.
LC-USF 34-51542-D

in this case was to produce photographs for which the agency had an immediate need. She could have treated the work routinely and taken routine photographs, but Marion never regarded any job as routine. Many of her canning photographs are effective and moving documents of strong women at work.

As it became clear that Marion had a talent for this sort of "project work," Stryker began to see all sorts of new possibilities. Constance Daniels, a respected social scientist of her day, had requested a photographer to accompany her for several days to study a resettlement project for blacks at Gee's Bend, Alabama, a job for which Marion would be perfect.[27] There was also an FSA repair station in Atlanta, where agency trucks and tractors were sent; she could cover that on her way to Gee's Bend. In Atlanta she could contact Arthur Raper, the brilliant sociologist whose books on the South were changing everyone's perceptions of the area.[28] Harold Dent, who ran the regional office for Alabama, was also requesting photographs. Maybe Marion could spend a week or ten days working on some of the projects he wanted photographed.[29]

Stryker proposed a tremendous work load, but Marion shouldered her equipment and did her best, although the new demands came at a bad time for her. Her mother had just lost her position with the Margaret Sanger organization owing to a reorganization at the top. Not yet ready to retire, she was looking for something to do. Marion was worried about her and wrote to Stryker about the problem. Stryker did try to help the senior Marion Post find a job, for which Marion was grateful, and she eventually found work designing and selling maternity garments.[30]

Stryker clearly wanted Marion to function not only as a photographer but also as a public relations person for the central office in Washington, evidenced by his instructions to her regarding her contacts with Harold Dent.

> Work about ten days with our friend Dent, doing pretty much the things he wants, in his own way; do also at this time those things I mentioned in my previous letter—canning, eating, etc. . . .
> Take it easy with Dent—he is a nice guy and very much our friend. If there are things he needs, maybe you could get them developed and give him the negatives right there.[31]

Stryker was breaking precedent in the last sentence of that quote. In his letters to Russell Lee, Arthur Rothstein, Dorothea Lange, and all the other photographers, such suggestions that the photographer give negatives to the local administrator are very rare. In

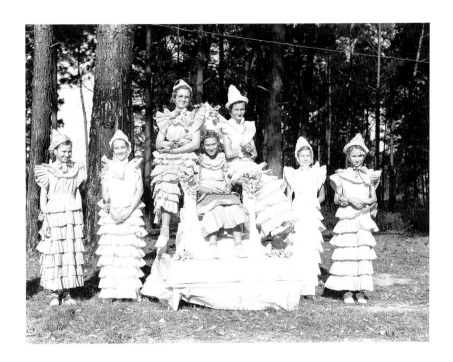

*The May Day–Health Day queen
and her attendants. Near Irwinville,
Georgia, 1939.*
LC-USF 34-51609-D

effect he was signaling Marion to do a certain amount of "throw away" work, such as photographs of Dent and his staff standing in front of a new housing development—photographs that could be used regionally to send out to area newspapers but which would have no value for the central office. Although the letter was friendly in tone, Marion must have felt a bit like a junior partner in the organization. It may be that she signaled this in some way, for Stryker soon followed with a letter that was designed, at least in part, to massage her ego. Yet even this letter contained a small barb at the end.

> A word of caution: still remember that you are the photographer, and that you are the boss, even with Constance [Daniels]. . . . Just be sure you are right and I will back you anytime. . . . There is one thing they all have to recognize—that photographers are not to be bothered. They can be advised and talked to, but not bulldozed. We do that up here from this office.[32]

Stryker undoubtedly considered his final statement a joke, but it is the sort of joke that is only funny between equals. Stryker and Post were not equals.

Throughout the month of April and early May 1939, Marion dutifully covered the Farm Security Administration's programs in

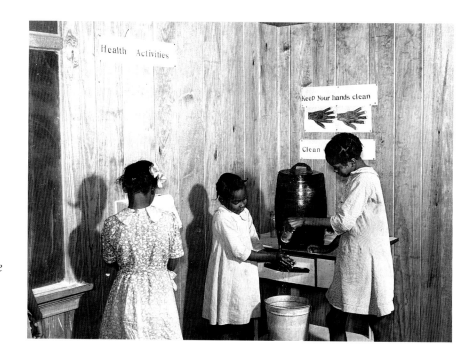

Gladys Crimer drying her hands on a paper towel and Bernice Mathis and Edna Law washing theirs in the cleanup corner in the second- and third-grade schoolroom. Near Montezuma, Georgia, 1939.
LC-USF 34-51636-D

Alabama. Short telegrams, which all the photographers used to keep Stryker informed of their whereabouts, recorded the constant movement. "Leaving Montgomery for Camden several days work in Gees Bend." Or, a few weeks later, "Leaving Montgomery for Atlanta and Greensboro." Sometimes the work was very satisfying; Marion enjoyed working with Constance Daniels and Arthur Raper, both of whom she found to be intelligent and socially aware. She read Raper's book, *Preface to Peasantry,* and found it excellent. She was also pleasantly surprised to find him helpful in his comments on her photographs.[33] On the other hand, Harold Dent was a disappointment. His ideas for pictures were wooden, and the FSA resettlement villages that he took her to seemed to hold little visual interest. In early May, Marion wrote to Stryker that both the Irwinville and Flint River Farms had fallen far short of expectations. A May Day celebration at Irwinville had turned out to be a disaster. She had hoped for a nice, rural, outdoor celebration; it had turned out to be an interminable indoor meeting with politicians speaking too long, children screaming, and nothing happening that was very photographable. Dent's logistical information was "all screwy," and she was ready to move on. And speaking of moving on, did Stryker understand exactly what he had scheduled for her to do in the next month? There were to be six days in Greene County, one day in Atlanta shooting the heavy equipment depot, two days in Birmingham, one or two more days in Gee's Bend, two days photo-

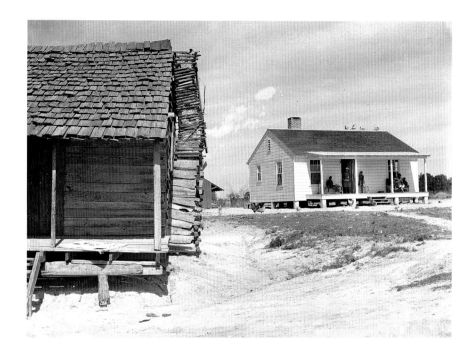

*Part of the old house and the new
home of Little Pettway's family.
Gee's Bend, Alabama, 1939.
LC-USF 34-51508-D*

graphing a rehabilitation client's family, three days in New Orleans, two days at Orangeburg Farms, one or two days working for Public Health at Savannah, a Public Health project in Columbia, South Carolina, a trip to St. Helena Island for some work on rural rehabilitation with Mrs. Daniels, and then a visit to Lincolnton, Georgia, where, on advice from Arthur Raper, she hoped to spend three days. It was all too much.

> This does *not* include any time for migrants in either Florida or any other state in this region. . . . Nor any time for "gold avenue" [Marion's proposed study of the wealthy]. . . . Nor any time for traveling from one place to another. Nor any rainy weather or days out for captioning, etc. and I do need one day a week to sort of get myself together, take a breath, or maybe just snoop around or do some laundry.[34]

Marion noted that the only way that she could complete these assignments was to work in the daytime and drive at night.

> Driving at night is definitely *not* a good idea for a gal alone in the South. And you know I'm no sissy. I've done it some, but no more than absolutely necessary. Everything closes up, including gas stations, and everyone goes to bed. The only ones who stay out are bums who are pretty drunk or tough or both—Negroes and whites. If anything goes wrong you are just out of luck and no one understands

if a girl is out alone after dark—believe it or not! Besides evenings are very often spent checking equipment, changing and packing film, and all the million and one things that are to be done.[35]

The letter succeeded in bringing Stryker up short. By return mail, he canceled a number of her jobs, including, unfortunately, several that she wanted to do. The Public Health jobs in Savannah and Columbia had to be retained because Public Health was a separate agency that *paid* the FSA to take pictures, and the photographic section needed the money. All the FSA photographers in the late thirties and early forties did Public Health work, and all disliked it. The job in New Orleans was also a Public Health contract and would have to be retained. Besides, while she was there she could get in touch with the local FSA people and start to learn that region. Stryker even suggested that Marion take a little time off while in New Orleans, just to see the town and sample the food. On the other hand, she was to do no more work for Dent for the present, nor was she to worry about getting back to Florida on this trip. It was obviously more than she or anyone else could do. "By no means drive around the South at night," Stryker wrote. "I would feel very much upset if anything should happen to you while doing our work. To hell with the work. When night comes find yourself a nice safe place and settle down."[36]

In late May, Marion was working at the large Marine Hospital in New Orleans. By June she was headed back to work in Savannah and Columbia. By early July she was making preparations to return to Washington, D.C., for a time. She had been on the road continuously since the previous November. Precise dating is impossible, but her first trip for the FSA had lasted at least six months, and perhaps seven. Among the FSA photographers, only Russell Lee's tremendous nine-month first trip was longer. On July 5, Marion wrote to Stryker that she was on her way back to Washington and glad of it.

I'll also be glad of a rest from the daily and eternal questions whether I'm Emily Post or Margaret Bourke-White, followed by disappointed looks—or what that "thing" around my neck is, and how I ever learned to be a photographer, if I'm alone, not frightened and if my mother doesn't worry about me and how I find my way.

In general I'm tired of the strain of continually adjusting to new people, making conversation, getting acquainted, being polite and diplomatic when necessary.

In particular I'm sick of people telling me that the cabin or room

costs as much for one as it does for *two*, of listening to people, or the "call" girl make love in the adjoining room, or of hearing everyone's bathroom habits, hangovers and fights through the ventilator. And even the sight of bedroom furniture, the feel of clean sheets, the nuisance of digging into the bottom of a suitcase, of choosing a restaurant and food to eat.[37]

Weary and ready for a break, Marion returned to Washington. Her trip had been an unqualified success for the agency although she probably would have considered it a somewhat more qualified success from her own perspective. What she needed now was time—time to write captions, to look at the growing file of photographs at the main office, to look at her own work, and to enjoy a bit of social life, for she was still just twenty-nine and single.

The long trip had changed her. Marion had taken the job as a promising young woman who had an interesting background and a clearly defined talent with a camera, but little more. Now she was a seasoned professional who knew how to work with a wide variety of people, to take the pictures that other people wanted taken and, in many cases, make them her own. What was left was to convince Stryker to accept her as something more than a public relations resource. If she could make him look at her photographs as the quality images that they were, she would know that she had, indeed, arrived.

Professional
Government Photographer

After her first big trip for the Farm Security Administration, life settled into a professional routine for Marion. Although she continued to travel, she also had time in Washington too, which was important to her from both an educational and a psychological standpoint. From mid-July through late September of 1939 was her first extended stay in the capital city. On earlier short visits she had stayed at the old Blackstone Hotel, a popular stopover for the photographers because it gave special rates to government employees. Now, however, she needed a more permanent stopping place. Without the $5.00 per diem she received when on the road, finances would be very tight. Luckily, one of the other photographers, Arthur Rothstein, was in a similar situation and so, for about a year, beginning in the summer of 1939, the two "shared an apartment." It was all quite respectable; their schedules were juggled to make certain that Marion and Arthur were not in town at the same time. Roy Stryker approved of the arrangement, and it worked out quite well most of the time. Marion does recall one incident, however, that, despite its humorous overtones, illustrates the constraints under which she worked.

The apartment was so arranged that there was a tiny entrance hall from the outside and then a door to the right. You had to have two keys to get in—one to the outer door and one to the inner one. If you couldn't get in the first door, you couldn't get into your apartment. So, one evening when I was in my nightgown I went

outside to get something—I don't remember what—maybe the paper—and the door closed and I couldn't get in. So I thought I might get in through the front windows. So there I was, clawing at the windows in my nightgown, and a policeman came along. He watched awhile, I suppose. (My back was to him so I'm not really sure.) And he finally came up and said, "Look, Lady," and startled me, of course. Well, he thought there had been a fight and my husband had locked me out, but he was a little bit fresh too, and I suppose my nighty was not thick old muslin and he was having his fun, not that he actually bothered me. But when I tried to explain, he wouldn't believe me. He said, "Oh, he'll get over it. Let me go in and talk to him." And I said, "No, really, I'm locked out. There's nobody in there." So finally he did help me get back in.

But I was so afraid that it would become an incident and get back to Stryker that I wouldn't tell the guy who I worked for or who the other name on the mailbox was [Arthur Rothstein]. Naturally, he thought, because there were two different names, that we were living together and that wasn't acceptable then. I was so scared that the guy would check my papers and it would get back to Roy and then we'd be done out of our apartment. . . . Roy was always conscious of the fact that an incident might be more likely to happen with me than with anybody else and I was always conscious of that too. I was afraid that Roy might say "Well, we'd better not take a chance."[1]

Somehow Marion's sense of humor helped her extricate herself from what could have been a seriously embarrassing situation. This sense of humor shows through in her retelling, but the fear and worry are also still there after forty-five years. Always there was the sense that she was exposed, vulnerable, and that everything that she had worked for could be taken from her very quickly and easily.

Marion spent most of her time in Washington working in the photographic files. After months on the road, it was time to get familiar with the work of the other photographers and to write the detailed captions that were such a chore and yet so important to the file's development as a serious historical tool. Looking through the file was work that Marion enjoyed and would have liked to spend more time on. Captioning was hard work, but Marion understood why it had to be done.

The file was already something of a legend. Through Stryker's persistent efforts, newspapers and magazines had learned that the FSA photographic file was a rich source for photographs of small-town and rural life in America. The photographs were available free to users provided that the agency was credited. Stryker also fought to get credit lines for the photographers too but would compromise

on that point when he felt it to be necessary. Thus Stryker achieved the widest possible distribution of the images that he wanted so badly to show the American people. In 1939 the file contained at least 60,000 images from all sections of the country, taken by half a dozen photographers, and it would continue to grow. By 1943, when it ceased to function, the file contained over 130,000 images.[2]

The file was Stryker's pride and joy. He saw it as the promise of permanent academic legitimacy for his project, proof that a balanced view had been sought and maintained.[3] It was also the repository of a very large number of truly excellent photographs. Any photographer could benefit from looking through the file, noting how other photographers had solved a particular problem. In addition to the photographs by Russell Lee, Dorothea Lange, and Walker Evans, there was work by Ben Shahn, a major artist in his own right; and by Arthur Rothstein, younger than Marion but a veteran, by 1939, of four years with the agency. Carl Mydans's early 35-mm images showed the versatility of the small camera. It was all carefully stored, with prints mounted on grey cards and full captions attached for the users' convenience. Marion was encouraged (read expected) to spend a certain amount of time with the file, and she willingly did so. It gave her a sense of what had already been done and where gaps might exist that could be filled on later trips.

Contact with other photographers was also important. Arthur Rothstein was always delightful and helpful company. He was a sensitive and experienced photographer, genuinely interested in the technical aspects of photography and always willing to give aid and advice. Russell Lee did not come to Washington until 1940, but his photographs were there to see and study. All the younger photographers looked up to him as a role model. Due to turnover in the agency, Marion never met Walker Evans and only met Dorothea Lange briefly, but Ben Shahn, who was still in Washington working for another division of the Farm Security Administration, often came by to chat with Stryker and his assistant, Edwin Rosskam, and Marion found such conversations fascinating. As time went on, newer photographers were added to the staff, each of whom had something to contribute to the group in general and to Marion's own development.[4] Certainly John Vachon and Jack Delano both learned from and contributed to Marion's photographic vision. The sort of cross-fertilization that took place in the agency's offices in Washington, D.C., was a far cry from the frustration that Marion had known at the *Philadelphia Evening Bulletin* and was a welcome change.

One of the people who most influenced Marion's photographic

standards was Edwin Rosskam, who served for several years as Stryker's assistant and designer for all FSA traveling exhibits. Rosskam and his wife, Louise, were experienced magazine and newspaper photographers and had strong instincts about how photographs should be used and what constituted a good photograph. Marion recalls that "Ed would try to educate Stryker about what were good pictures and why. Ed had a much better sense of this than Stryker did."[5] Rosskam was particularly encouraging to Marion. He saw real quality in her work, while Stryker was still thinking of her as his "one-girl public relations staff." As a result, Ed Rosskam and Marion Post became good friends, and Rosskam took more time critiquing and analyzing her work than he might otherwise have done.

Finally, there was Toots. Clara Dean Wakeham, Stryker's executive secretary, was a friend to all the photographers, but she particularly befriended Marion. "I had a very close relationship with Toots," Marion recalls.

> She and I were close and we liked each other very much. During the times when I didn't have an apartment (which was most of the time) she would store things for me. She'd let me put boxes of clothing I didn't need for a particular trip in her small apartment. She would crowd her closets with my things, and she would also write to me on the road and talk to me when Stryker would call, or even call separately. I suspect she even tried to protect me once in a while.[6]

Even though she had friends like Ed Rosskam and Toots Wakeham in Washington, Marion never really viewed it as "home." Home was Philadelphia or New York, where her oldest friends and her family were. When she was staying in Washington, she would leave whenever possible for the weekend to attend exhibitions and concerts in New York or Philadelphia. It was also nice to get away from the watchful eye of Roy Stryker for a date now and then.

At twenty-nine, Marion was by no means ready to give up her social life, though she thought of herself as antimarriage. Both in Washington and on the road she found Stryker's Victorian standards (which were, in fact, a double standard) more than a little confining. Stryker had made it clear that while she was working for the Farm Security Administration there was to be no hint of "scandal," and scandal to Stryker meant even a date with one of the local administrators. So she went away for her weekends, thus separating work and relaxation. This worked well enough when she was in Wash-

ington. In the field, however, even the weekends disappeared into work, and the social side of her life simply ceased to exist.

As mentioned earlier, much of the time Marion spent in Washington was devoted to writing captions. Each photograph placed in the permanent file had to have as complete a caption as possible, for Stryker insisted that pictures were not enough; there had to be specific, precise words to go along with the images. Writing captions was a chore that no one enjoyed. At the end of a field trip there might be several thousand pictures plus notebooks full of field notes that had, somehow, to be correlated and accurately captioned. Of course, if one had a companion on the trips, field notes could be delegated to that person. In fact, on longer trips, it was not unusual for packets of prints to be sent out to the photographer for captioning while material was fresh in mind; in this situation a traveling companion could be of tremendous help. Most photographers did travel with someone. Lame in one of her legs, Dorothea Lange nearly always traveled with her husband, economist Paul S. Taylor. After his first trip alone, Russell Lee made a connection with Jean Smith, a Dallas newspaper woman, who traveled with him as his "secretary" for a number of months until his first marriage could be brought to an end and he and Jean were able to marry. (His wife, Doris Lee, was at this time living with the artist Arnold Blanche.) Edwin and Louise Rosskam traveled together on those rare occasions when they were able to do field assignments for the agency; Ben Shahn took his wife, Bernarda, along on his trips. Among all the early photographers, only Arthur Rothstein and Walker Evans traveled alone. Of course, Evans teamed up with James Agee on what was probably his greatest assignment, the work done for *Fortune* magazine that later became the book *Let Us Now Praise Famous Men.* Looking back on the difficulties of traveling alone, keeping all one's own notes, and writing all one's own captions, Marion found herself complaining, not only about the burden of work that this imposed but, more important, about the restrictions imposed on her and not on the others.

> I always felt envious of the photographers who had wives (or in the case of Lange, husbands) to do their captions, or who traveled with their so-called secretaries as Russell did. I nearly died when I found out about that years later. And I had to be so *careful* not to meet anybody or see anybody. It was so unfair. If I had ever tried anything like that Roy would have *killed* me! I'd never have gotten away with it because everyone was so curious about a woman

traveling alone in those days and any gossip they could figure out they used.[7]

In 1939, however, there was no point in such reflection. Society agreed with Roy Stryker and that was that. By late September 1939, Marion was back on the road for another swing through the South, and this time there was at least one plum assignment in her itinerary. Stryker was indicating a high level of confidence in her abilities when he gave Marion this particular project, for it was something that he wanted well done. Utilizing her on this high professional level, Stryker was acknowledging that this project needed just the combination of visual talent, intellectual background, and tact that Marion possessed.

The University of North Carolina's nationally respected sociologist, Howard Odum, had for some fifteen years been studying his region's history and social fabric. His Institute for Research in Social Sciences had become a major center for studies of the role of cotton or tobacco culture in the lives of the people in the area, for example, or the impact of a system like sharecropping on the people involved. He and his staff had done hundreds of interviews with piedmont and mountain southerners, learning more than anyone had ever known about the South's "plain people"—their value systems, their hopes and dreams, their attitudes toward each other, and their work habits. A major book of this material had just been published, and it was hoped that more were on the way.[8]

In 1939, after a series of conferences with Stryker and other interested parties, Howard Odum had set up a cooperative project called the Subregional Laboratory for Research in the Social Sciences. The "laboratory" was actually a thirteen-county piedmont area with ten counties in North Carolina and three in Virginia. What made this particular area so attractive was the variety of human experience that it contained. There were small hill farms and large commercial farms; textile mills and other relatively simple manufacturing concerns; farming villages and fairly large cities. As noted in the descriptive prospectus that was used to raise money for the project, this was an area "containing in emphasized and compact form the problems and potentialities of a new rural-urban, agricultural-industrial, folk-technic balance." Odum and his staff believed that the area immediately around Chapel Hill, North Carolina, could be used as a predictive microcosm to understand the general direction in which the South as a whole might be headed over the next few decades. If the "subregion," as they called it, developed a more diversified and urbanized economy, then the rest of the South

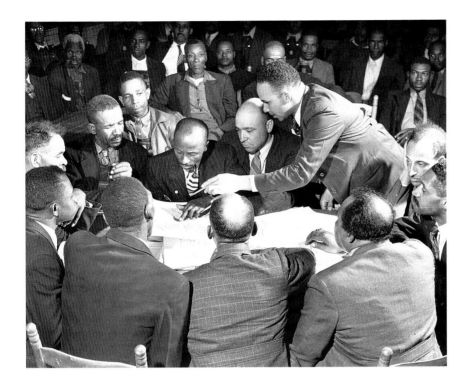

Members of the Negro county land-use planning committee working on the county map, at a meeting which is being held in the schoolhouse. Yanceyville, North Carolina, 1940. LC-USF 34-56364-D

could be expected to follow. Thus by studying this area some of the possible problems might be understood and headed off before they affected the entire area. While it is true that the subregion contained somewhat more of an economic mix than did the South as a whole, the area remained predominantly rural and devoted to tobacco farming, with small farms the norm.[9]

Several projects were subsumed under the Subregional Laboratory for Research in the Social Sciences, but the one that interests us concerned photography. Odum and his staff wanted to see if the high-quality documentary photography that they had been seeing for several years from the Farm Security Administration could be integrated into their own studies in such a way that the camera would actually become a research tool. These were very advanced ideas. Indeed, some of the best scholars in sociology, history, and social anthropology today are still wrestling with the same basic notion.[10] This was the project that Marion was to work with for the next several weeks.

Marion's contacts at Chapel Hill were Margaret Jarman Hagood and Harriet L. Herring. Hagood, a member of Odum's top staff, was an expert in the problems of women in the South, and Herring was an industrial sociologist brought in to work with the photographs on the subregional study. Both were extremely able, but neither they nor anyone else knew exactly what they wanted or just how

A Negro tenant family on the porch of their home. They are Farm Security Administration borrowers. Caswell County, North Carolina, 1940.
LC-USF 34-56172-D

photographs might be used in a major sociological study. Herring had drawn up some guidelines calling for a comprehensive pictorial cataloging of all aspects of life in the area. It was too much. At least two full-time photographers would have been needed, an impossible commitment for the FSA at that time. Even so, Stryker and, more important, Stryker's boss, Dr. Will Alexander, chief administrator of the Farm Security Administration, wanted to cooperate with Odum's team, so photographers were sent to Chapel Hill from time to time to help out in any way they could. Dorothea Lange spent a week in the area in August, and Marion Post arrived in late September. After a run into the deeper South in mid-October, Marion returned for an extended stay in late October and November.

In fact, Marion worked so comfortably with Hagood and Herring that she became the principal FSA photographic liaison with the University of North Carolina study.[11]

On her first visit to Chapel Hill, Marion could see that this was a genuinely interesting project. She found both Hagood and Herring challenging and stimulating, unlike the sweet little church ladies with whom she had tried to work in Florida. These women were professionals who knew their territory. During one of her earliest drives with Hagood, she later reported to Stryker, the two women had come across "a very interesting settlement of Negro [land] *owners* with well equipped large farms, some of the grown children going to college. We want to do much more photography there and Dr. Odum was particularly pleased."

> I think it [the University of North Carolina and the subregion] is a good place for us to work on the use of photography in social research. Good territory because it has several aspects—from the very rural farmland and crops all the way thru the processing and industries. A variety of land and terrain, crops and industries. We will be able to get some things that we ordinarily might not be able to get into. . . . All the families I spoke to seemed very friendly, quite reasonable about being photographed and working with us.[12]

Marion was really enthusiastic about using photographs in social research. Here was the camera taken seriously, the photograph to be used for something beyond illustration. Pleading for a quick return of prints from the negatives she was taking, she showed that she was impressed with the way these people were wrestling with the problem of using photography.

> In the beginning they particularly want to see prints within a "reasonable" time since they are all so inexperienced in photography and have no idea whether or not a camera can record what they are trying to present and how it can supplement their work. They have never been conscious of any visual approach and don't know the possibilities and limitations photography has to offer them.[13]

Marion's language in this quote is worth careful analysis. Notice that she was talking about the ability of photographs to "supplement" the work of the social scientists. She was not insisting on photographs as ends in themselves. Along with the staff of the project, she was trying to learn the "possibilities" as well as the "limitations." Her own attitude was that of a social scientist. With her educational background including courses in anthropology and psychology, she

Members of the Wilkins clan at dinner on corn-shucking day at the home of Fred Wilkins. Stem, North Carolina, 1939.
LC-USF 34-52663-D

could easily make this transition. A more art-oriented photographer like, for example, Walker Evans, might have demanded the right to make Art, and the results might have been a small group of beautiful pictures that did not serve the sociological purposes of the institute. Marion had to find a balance between her own strong esthetic sense and the needs of the regional study. The results—and the fact that she was invited back again and again—indicate that she was successful.

Stryker was pleased with the results of Marion's early visits to Chapel Hill and with her observations and her contacts with the people there. Shortly after she wrote the letter quoted above, Stryker responded. "I appreciated your comments on the subregion very much," he wrote. "From the little I have seen of it and from what I can gather from these people, I would say that you have made some very accurate observations. . . . We are very much delighted with your discovery of the prosperous Negro community," he continued, suggesting that Marion keep her eyes out for more of this sort of thing. "Odum, by the way, is very much excited over the whole project of this photographic survey."[14] Stryker was now treating Post as a full professional. Being able to take the pictures that Howard Odum needed and wanted was evidence enough for Stryker.

In April 1940, before Marion's second series of visits to Chapel Hill, Ed Rosskam mounted an exhibition of FSA photographs made in this region, mostly consisting of photographs by Dorothea Lange

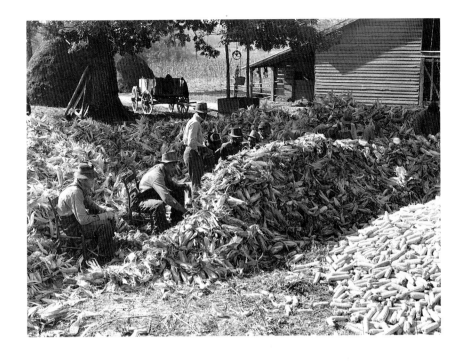

*Corn-shucking at the Fred Wilkins
farm. Stem, North Carolina, 1939.
LC-USF 34-52669-D*

and Marion Post, to be on view at Chapel Hill during a regional
conference on "Population Research, Regional Research, the Mea-
surement of Regional Development." Everyone was very excited
about the chance to show social scientists what the camera could
do. When the preplanned panels of photographs arrived, Margaret
Hagood wrote to Stryker, "My state of pleasure approaches ecstasy,"
and she also reported that Howard Odum was "simply delighted."[15]
A recent dissertation has faulted the exhibition, and, by extension,
the entire project at Chapel Hill, as unfocused and lacking in a
unifying philosophy, but this criticism misses the point.[16] The pic-
tures shown at the Chapel Hill conference were selected because
they could appeal to a large number of visually unsophisticated
viewers. They were not selected as the best images from the stand-
point of social science. Those could be utilized later in more aca-
demic publications. Furthermore, as is clear from Marion's letters,
everyone involved was trying to define a new role for the camera.
For a project to yield a unified body of work with a clearly defined
philosophical base at such an early stage is simply asking too much.
In fact, the work at Chapel Hill yielded a large number of valuable
images that help us to form a clear impression of daily life in the
thirteen-county subregion. Most of these pictures are quietly un-
derstated, the sort of images that George Abbot White has called
"vernacular" in his useful study of health care photographs, *Plain
Pictures of Plain Doctoring.*[17] Marion worked with the Chapel Hill

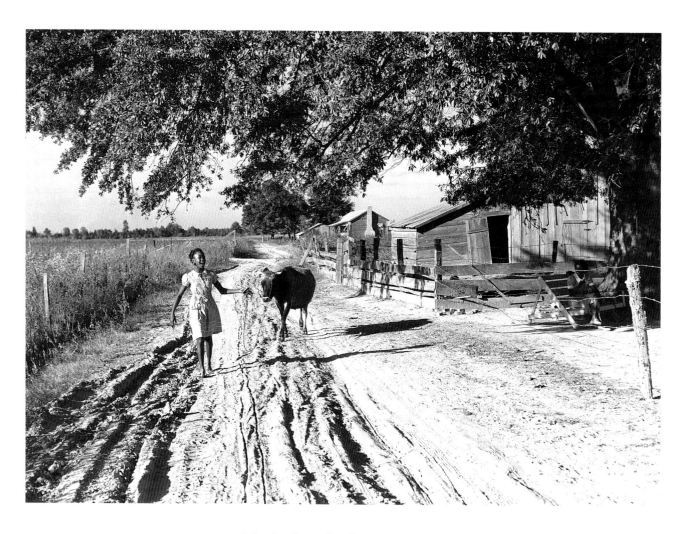

The daughter of Cube Walker, a Negro tenant purchase client, bringing home their cow from the fields in the evening. Belzoni, Mississippi, 1939.
LC-USF 34-52272-D

project a total of nearly two months over a two-year period. It was one of her best and most productive assignments.

The work at Chapel Hill was interrupted in October by a quick trip into the deeper South. Marion's instructions were to go to Memphis, Tennessee, and farther south into Mississippi to cover the cotton harvest. Although Lange and Shahn had both visited the South and both had taken strong photographs of the cotton harvest, Stryker clearly felt that Marion had something to offer in that area too.

The deep South in 1939 was the South of John Dollard's famous study, *Caste and Class in a Southern Town*, a Faulknerian combination of beautiful, lazy days and terrifyingly hard work, of warm human

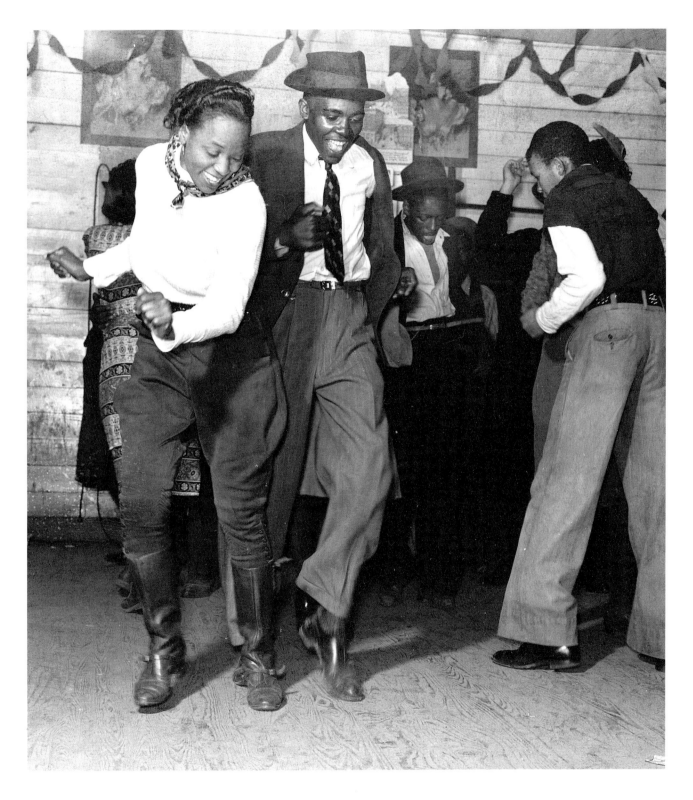

Negroes jitterbugging in a juke joint. Clarksdale, Mississippi, 1939.
LC-USF 34-52594-D

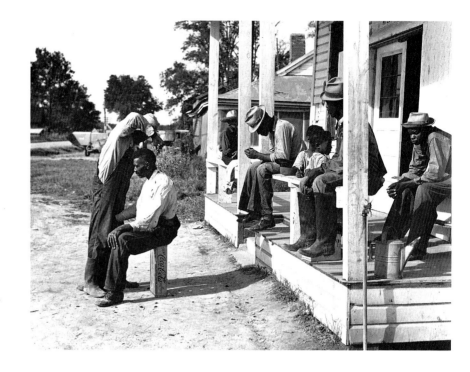

Haircutting in front of general store, Marcella Plantation. Mileston, Mississippi, 1939.
LC-USF 34-52447-D

relationships and pervasive racial exploitation. In many ways the area was feudal, with the black population roughly corresponding to the serfs of medieval Europe, held in their defined place by a network of law and entrenched custom. Marion did not like it. She saw the beauty of a bright summer morning and the happiness in the heart of a young black girl innocently leading her family's cow along a dirt lane, but she also saw the patterns of servant and served, of underling and overlord. Promising the son of a local planter a date if he would accompany her, she visited a "juke joint" on the outskirts of Clarksdale, Mississippi, where blacks enjoyed their own music and dancing far from the prying eyes of whites.[18] There she was able to get a series of intimate pictures of black social life that equals any observations of Dollard's. In other instances she caught the subtle dominance and submission in the body language of whites and blacks in a variety of social interactions. On a visit to the large and commercially successful Marcella Plantation at Mileston, Mississippi, she made an unforgettable photograph of a black woman receiving her pay for the day's cotton picking, forced by the white paymaster to reach through a tiny window at the plantation office to retrieve her small sum. The body language is clear. The white man cannot be bothered to shove the packet the extra eight inches to make it easy for the woman to grasp it. She must grope for it as best she can.

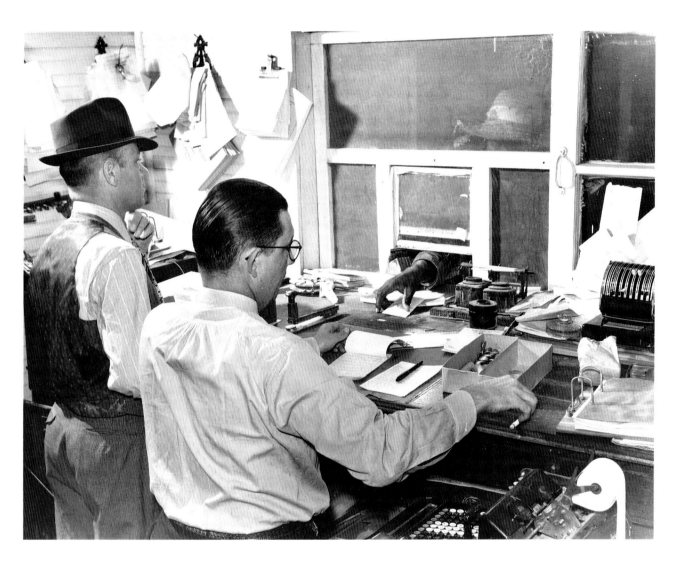

Cashiers paying off cotton pickers in plantation store, Marcella Plantation.
Mileston, Mississippi, 1939.
LC-USF 34-52908-D

This was social documentary photography at its best, and Stryker was well pleased with it. However, few of these pictures were used during the years that Marion was with the agency. They remained buried in the file to be rediscovered by recent researchers. Why this neglect? In a 1983 essay, art historian Sally Stein identified one of the factors. She pointed out that the New Deal was based on a powerful coalition of northern labor and southern white farmers and that Roosevelt was unlikely to endanger his relations with the southern wing of the party by offending the whites of that section. Thus the publication of such images was likely to be "discouraged" by New Deal leaders.[19] Stein is correct, as far as her analysis goes, but it is also worth noting that Dorothea Lange's picture of a white landowner near Clarksdale, Mississippi, in 1936, with his foot on the bumper of his car and a group of cowed-looking black men in the background, was published several times during the late thirties. Furthermore, one must understand that although Stryker was not able to publish such images very often, he did encourage photographers to make them for the file and future researchers. In short, when we go back to the file and find these materials, we are doing exactly what Stryker hoped we would do.

Another reason why pictures like this were not more widely used may have been that they were too subtle for the photographic layout requirements of the day. Magazines, from the popular *Life* to the more intellectual *Survey Graphic,* used photographs in ways that look cluttered today. Many books did the same thing.[20] Seldom was an image set on a page by itself surrounded by white, giving it the luxury of making its own statement, as is the style in many photographic books and even magazines today. Usually, six to eight images were grouped together. As a result, the simpler, more direct and emotional visual statements of a photographer like Dorothea Lange were more likely to be chosen. Finally, photo editors, like all of us, tend to be lazy or in a hurry and tend to select pictures they have seen before. It has been estimated that during the 1930s about 300 of the FSA pictures received most of the use. These were the "cookie cutter" pictures that Dorothea Lange referred to more than once.[21] All the photographers would have liked to see more of the file in use, but they were never able to get the editors and other users of photographs to look at the newer, more subtle images.

In late November 1939, Marion drove back to Washington, D.C., with a nice letter from Stryker congratulating her on a job well done. She had spent over two months working in North Carolina and covering the cotton harvest in Mississippi and west Tennessee. It was time to rest and enjoy her friends and, again, to write those

Barnyard blizzard. Near Woodstock, Vermont, 1940.
LC-USF 34-53276-D

captions. This time, however, her stay at Washington was a short one. By mid-January she was headed for Florida to pursue the "gold avenue" pictures of wealthy locals and tourists that she had started a year earlier. After her time in rural Mississippi, the contrast between rich and poor in Florida must have been particularly noticeable. Some of her sharpest images of the wealthy come from this period. In late January, after seeing first prints of her work, Stryker observed dryly, "Apparently you found Sarasota very interesting."[22]

In February 1940 Marion's assignment was the polar opposite of the luxury of Sarasota, and she loved it. For the first time she was to work outside the South, and no one was ever readier for the change. Stryker had learned that she had some experience with skiing in the Austrian Alps and had concluded that she was just the person to cover rural New England in winter. Several photographers

Workers in paper mill returning home. Berlin, New Hampshire, 1940.
LC-USF 34-53571-D

had visited the area during more hospitable seasons, but all were reluctant to tackle the full force of a Vermont or New Hampshire snowstorm. It turned out to be a particularly enjoyable and productive trip for Marion as she found that she loved both the area and the people. One of her telegrams, taken out of context, has been used to indicate that she was miserable. "You are a cruel and heartless master," she wrote to Stryker. "I feel like a Finnish boy-scout . . am fingerless, toeless, noseless, earless. Wish you were here with the wind whistling through your britches too."[23] Those who know Marion, however, will immediately recognize this as her own special brand of humor. In more complete letters, the sense of fun

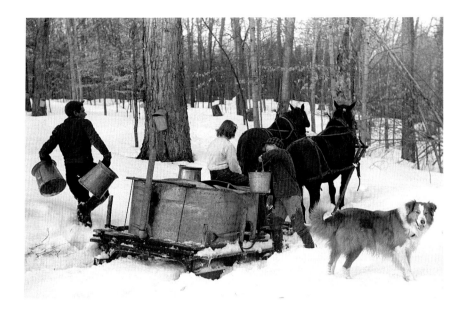

Maple sugaring—gathering sap from trees. North Bridgewater, Vermont, 1940.
LC-USF-33-30892-M1

comes through clearly. "Obliging, Juicy blizzard" was her assessment of one winter storm. Later she wrote, "I feel well, no colds or sinus and most of the time I enjoy this wintry life." She did, of course, have to make adjustments, but even here Marion's sense of humor helped to see her over the rough spots.

> It's all been slow going and I've had a lot to learn these first few days about caring for the car in this bitter cold and learning more about driving and managing on these icy snowy rutty roads. It's been below zero every morning—from 10 to 20. . . .
> What really ruins my disposition are the icy cold toilet seats.[24]

Like the earlier reference to the "cruel and heartless master," that last sentence was designed to get a hearty if somewhat embarrassed laugh out of Stryker. But Stryker was pleased with the photographs that were coming from Brattleboro and Woodstock, Vermont, and from North Conway and Littleton, New Hampshire. When Marion asked for more time, Stryker was quick to grant it.

> By all means take the necessary time that you are going to need to do a good job. It is, after all, terribly important. It is our first chance to do real good winter scenes, and New England has pretty much been neglected, as far as our files are concerned.[25]

By early March, Marion was very involved in the assignment. She

reported that she had been photographing "various barnyard activities" such as milking, wood sawing, and splitting. She also had pictures of logging and kids riding on sleds and engaging in a snowball fight. She hoped to go to a town meeting in Woodstock the next Tuesday and was enjoying the little villages. On the other hand, the cold was still making things difficult.

> This last week was so cold I practically took to sleeping in my clothes—had on so many layers I couldn't be bothered to try to get down to skin again. And no Miss fancypants underwear either—long, wooly and ugly. Shall I even try to tell you the difficulties I ran into with equipment when the temperature was so low? Everything stuck and just refused to operate at *least* half the time. Shutters, diaphragms, rangefinders, tracks, films and magazine slides became so brittle they would just snap in two. I tried everything from wrapping them in sweaters and jackets with a hot water bottle on their dear tummies (literally) to keeping them in little nests near the car heater (which also refused to function). . . . Tripods were out of the question because of the time element and also the snow drifts. I finally rigged up something which should help—have put a skipole basket on each tripod leg so that they act like snow shoes and it doesn't sink in so easily.[26]

This is not the letter of a woman being beaten down by a heartless master. This is a woman coping with a difficult situation and enjoying herself. Stryker was particularly pleased with the prospect of her photographing a New England town meeting. In a letter responding to her plan he wrote, "We wish you luck. What an addition that will be to our files and to the small town book."[27]

The small town book to which Stryker refers was a major project that the photographic section had recently undertaken. The writer Sherwood Anderson was working on a book series called "The Face of America," in which he proposed to define the essence of what was uniquely American. Similar efforts had been common during the depression, and, in the increasingly heated prewar atmosphere of 1940, it seemed even more important to define the qualities that were uniquely American. Anderson had been approached by Ed Rosskam about devoting a book in the series to the small town, to be heavily illustrated by FSA photographs. Anderson loved the idea, and Stryker gave the project his blessing and assigned Ed Rosskam the job of selecting the photographs to accompany Anderson's text. The book appeared in late 1940, containing a large number of Marion's New England shots.[28] Stryker was so pleased with the finished product that he committed the photographic section to

*Town Hall. Center Sandwich, New
Hampshire, 1940.*
LC-USF 34-53448-D

helping with publicity, including free enlargements of many of the
photographs to place in store windows. In addition, he set up a fund
to buy copies of *Home Town* for distribution to "key people" and
asked all the photographers, including Marion, to contribute.[29]

Back in New England in the winter of 1940, Marion knew little
about the small town book or other developments in Washington.
In late March she reported particularly liking the town of Berlin,
New Hampshire. She had gotten pictures of logging with a horse
instead of a tractor, and had gotten some nice long views by climbing
up into the hills with a "hopeful young collitch boy" helping to carry
some of the equipment.[30] As the snow was beginning to melt at the
lower elevations, she planned to take a few days off for rest and
skiing and then return to Washington. It had been an interesting
assignment. The next job that Stryker had in mind for her would
not be so pleasant.

This time there was no rest period in Washington. A few days
after her return, she was in her car again, headed back to the South,
to a massive backlog of "project work," increasing heat, and racial
tensions. By the middle of May she found herself in Memphis,
Tennessee, trying to photograph an experimental food stamp pro-
gram that the Department of Agriculture was getting started. The

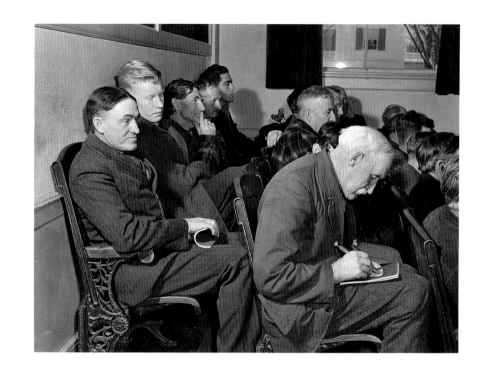

Townspeople at town meeting.
Woodstock, Vermont, 1940.
LC-USF 34-53261-D

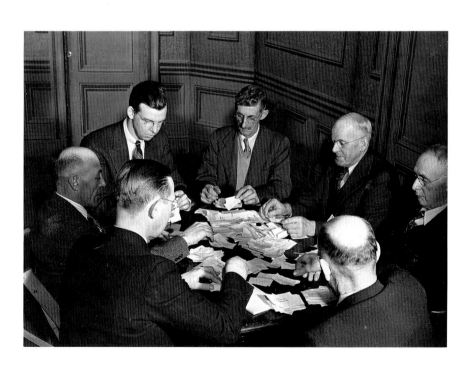

Counting ballots to see whether the
town will go wet or dry. Woodstock,
Vermont, 1940.
LC-USF 34-53255-D

Main street during blizzard. Brattleboro, Vermont, 1940.
LC-USF 34-53014-D

program was a mess. Under the administration of local racist whites, with little idea what they were doing, the black people who were supposed to benefit were mired in hopeless misery. Marion knew that she was expected to get photographs that showed the program in a favorable light, and she did her best. But afterward, in a letter to Stryker, she protested the assignment and the degree of "faking" that she had been asked to do. This was not documentary; this was public relations.

The stamp office people and the welfare staff were just about crazy trying to get the whole thing going [the new stamp program] and at the same time take care of the Memphis news photogs, a LIFE

photog who had been very demanding for two days *and* newsreel movie guys too. I was the last straw! . . .

I had to get the families, scrub the children, dress them and drag them downtown—then cook their dinner. It was practically impossible to get a man for the pix as they were either working on WPA, or sick, or drunk, or in the hospital, or refused to do it. The white one we finally used was a half cripple and had to go to the hospital before we were finished. The Negro family "husband" was taken to the hospital the morning we got there, so we went ahead without him. . . . So many of the Negro relief and welfare "families" have only a "chronic transient man" in the house—illegitimate children by the dozen. The one we used was pregnant again and when the "investigator lady" remonstrated with her for bad behavior and breaking her promise to be a good Christian, she said, "Well Ma'am, I'se sorry but I had to make the rent somehow."

Jesus Christ these social workers are fierce, inhuman stupid prigs. I can't call them enough names. I was literally sick to my stomach after a day of visiting their "cases" with these two. They love to humiliate people.[31]

What Marion described in that letter was certainly a contrived series of photographs. The problem was that the work had been contracted out for the USDA and was not under the control of Stryker and his office. This sort of contract work was done in increasing amounts during the latter years of the FSA. Nobody liked it, although all the photographers had to do a great deal of it. It brought in money and extended the increasingly skimpy budgets. No one, then or now, would argue that this was a proper or even an honest approach to documentary photography. It just happened to be necessary at the time.

While doing a job that she did not enjoy for the USDA, however, Marion was also able to do some of the sort of social commentary photography that she did enjoy, particularly in the South. May was the time for the Memphis Cotton Carnival, a celebration by the city's wealthiest and most socially prominent families of their dominance over the rest of the town. It was loosely based on the New Orleans Mardi Gras, but Marion saw it as a pale imitation. "Am also getting a few Cotton Carnival pictures," she wrote to Stryker, noting that they fit in with the general cotton story. "This kind of American show and celebration and crap is terrible and such a waste of time and money—but they love it."[32] Even today Marion's pictures of Cotton Carnival retain their critical bitter edge.

Even as Marion was finding much to detest in the South, she was also finding much to love. The drive through Tennessee to Memphis

Dancing during the Cotton Carnival. Memphis, Tennessee, May 1940.
LC-USF 34-53648-D

Working in the field, Ida Valley farms, Shenandoah Homesteads. Near Luray, Virginia, 1940.
LC-USF 34-57547-D

at the west end of the state had left her breathless with the beauty of the land in springtime. In fact, she was sorry to have hurried since no preparations had been made for her when she arrived. "It wouldn't have mattered," she wrote Stryker, "if I had taken my time and gotten some photos of the spring and planting, etc. on my way." On reflection, however, she wistfully concluded:

> Perhaps it was better so—the lab might have gotten too many apple blossoms and budding trees and spring clouds to print. More F.S.A. cheesecake. Or if I *had* stopped, I might have begun to dig in the red brown earth in some farmer's garden and just stayed there.[33]

Marion's reference to FSA cheesecake is a good example of her special brand of self-deprecatory humor. She did have a reputation for being able to make beautiful photographs of the good earth, and she had taken a certain amount of ribbing about her "pretty" pictures. Although she tried to dismiss her images of fertile, productive land as "cheesecake," she harbored very strong feelings about the earth, as her last sentence indicates. With two years of hard work behind her and with a world war closing in on the country, it would not have taken much to convince Marion to settle down in some lovely valley somewhere and find a simpler and perhaps more basic mode of life. For Marion, however, it was not yet time for that. Instead, it was time to go to Louisville and then down to Florida, then back to Lousiville and into eastern Kentucky. There were thousands of miles to log before she could even think of getting back to Washington. There were many more miles to travel before she could think of settling down.

A sign advertising tourist cottages. Pensacola, Florida, 1941.
LC-USF 34-57045-D

CHAPTER FOUR

Maturing and Changing

Marion Post Wolcott's personal files at her home in Santa Barbara contain a fragment of her writing which was clearly done while she was working for the FSA. It may have been a speech that she was to deliver, or notes for a possible magazine article on her work. Whatever occasioned it, it is revealing for in it she talks about the difficulties of being a young woman on the road for long periods of time. "People often mistrust any young girl who drives alone around the country," she wrote.

> They become particularly suspicious if she goes out alone in the evening, since it is not customary in their town. They do not realize that I take photographs at night or that I wish to get a cross section of life in their town. Sometimes when one does go out alone, one is bothered by males who think one is a "pick-up."

Another problem that she had faced many times was the matter of finding lodging. While lodging could usually be found, safe, quiet lodging was another matter.

> In hotels a single girl, traveling alone, is often annoyed. Men may bribe the bell boys or clerk to find out her name or room number, or they may watch which room she goes to. There are the insistent drunks who keep phoning to get you to come to a party, or come to your door to apologize for the noise. There are the convention brawls, the traveling salesman's parties and loud, raucous, lengthy descriptions of their binges. It is a liberal education, from anyone's point of view.

Once safely ensconced in a room, Marion faced evenings filled with hard work. She had little time for entertainment, and the administration in Washington did not approve of its women employees enjoying much in the way of a social life on the road anyway. Marion wrote,

> I am often asked, "How do you spend your evenings? You must have a lot of time to read and see many movies." I answer that there are reports, travel forms, notes for future captions and further work, and letters to answer. There are film magazines to be changed and dusted, boxes of film to be labeled and packed carefully and mailed, equipment to be cleaned and put in order and minor adjustments to be made, car to be serviced, cleaned and put in order, repaired if necessary. Clothes to be packed; underwear, stockings and hair to be washed. Rips and tears beyond the safety pin to be mended. Work must be planned, routes and trips mapped out. Reading material on a particular job, region, or problem to be absorbed. Local newspapers to be looked through, telegrams sent. Contacts made and various arrangements for following day's work. Sometimes meetings or recreational evenings to be photographed. Even miscellaneous shopping to be done.[1]

It was a rigorous life, but it was the life that she had asked for. As long as she felt that her pictures might influence the social policies of the federal government, or that they might help convince the general public of the need for federal programs to aid the rural poor, she could bear up under the pressure and even, at times, laugh about what she was seeing or what she had to endure.

When Marion left west Tennessee, after photographing the experimental food stamp program and the Cotton Carnival there, she headed north, with a certain sense of relief, into Kentucky, to do a routine job for the Public Health Service in Louisville. She quickly found that she liked the town, finding it progressive and intellectually interesting compared to the rough-hewn commercialism of Memphis. She contacted members of the staff of the *Courier Journal* and found them to be cooperative and well informed. A letter to Stryker reflected her own upbeat mood. Referring to the wealthy and handsome owner of the *Courier Journal*, Barry Bingham, and to what was obviously an office joke back in Washington, she facetiously offered to pursue some extra support for the agency in a new and unorthodox way.

> Those tales and reports about his way with the ladies . . may not have been exaggerated. . . . If you were definitely interested and our

situation became desperate enough and you gave me enough time here, I *might* be persuaded to work on him—only in the line of duty and out of devotion to you and our dear files and those loved grey mounts. Just a little blackmail might do it—nothing too serious, no scandal of course—and think what a contribution we'd continue to make through our sociological studies via the camera.[2]

But Louisville and speculations about wealthy young newspapermen had to be put aside. There was project work to do. In June 1940 Marion drove down to New Orleans to do another job for the Public Health Service, then back to Belle Glade, Florida, via train, to photograph the slowly improving migrant camps there. After returning to New Orleans to pick up her car, she drove to Texas to photograph more migrant camps. "Roy," she wrote, "would somebody please find out *where* the camps are in the state of Texas?"[3] In Louisiana she worked on a number of important FSA cooperative farms including the Terrebonne project and Transylvania Farm. She photographed the black cooperative, LaDelta, as well as two cooperatives in Arkansas, Plum Bayou and Centerville.[4] In each case she tried to cover as broad a spectrum of activity as she could. For example, she reported that in Arkansas she had photographed "buildings, mattress making, tractors working and being repaired, machine and woodworking shop, forge, welding, horse shoeing, etc."[5] It was rather routine material, and the work was not entirely pleasant. For one thing, the weather in Louisiana in July without air conditioning is a prospect to wither the stoutest heart. Then there was the rain. "Jesus Christ and my God and all the Saints! MORE RAIN," Marion reported.

> The other day I got caught in such a storm (small hurricane) when the rain and wind blew so hard that the telephone poles went down one after another just like the Roxyettes, only a little too close to my new automobile, with its convertible top, for comfort. And now there are rumors of floods—well I needed my feet washed anyway.[6]

Marion could be a good sport where her own comfort was concerned. However, where the welfare of the clients of the Farm Security Administration was concerned, her patience was not endless. In fact, by the summer of 1940 she was beginning to get disillusioned with some of the FSA efforts. So many of the camps she visited seemed poorly planned. She could take pictures that made everything look nice, but she knew that the reality was often quite different. Marion offered some serious criticism of one of the camps that she had visited in Florida:

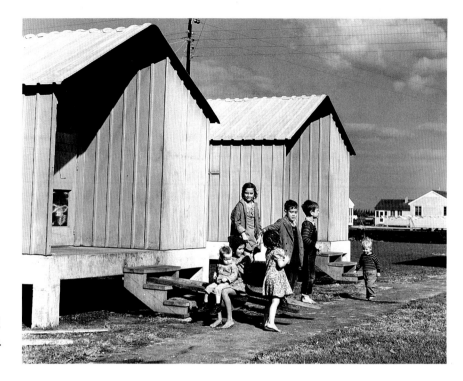

New housing for migrant agricultural workers. Belle Glade, Florida, 1940.
LC-USF 34-57118-D

It seems the camp is not a great success from the construction standpoint (as usual). They got rushed and had to spend the money immediately and instead of building shelters to meet Florida's peculiarities they simply transplanted the California ideas. Consequently the people are prostrate from the heat, poor ventilation in those tiny metal shelters (cold in winter) and holes and cracks for mosquitoes and flies by the millions and screening too large so that the special little biting gnats that chew around one's eyes, nose and mouth can come right thru. It's really disgusting. Every place I visit its the same story—something wrong with the original planning, construction or setup, causing the whole project to suffer. It's a mess. Isn't it time they got over some of the experimental stages?[7]

Later in the same letter, Marion apologized for having "squawked" but noted that she had had an unusual amount of project work on this trip, which, along with the bad weather, were getting on her nerves. The problem that she raised was, of course, a serious one. In fact, it was a major cause of the later demise of the agency. It was not, however, a problem that either she or Stryker could solve. Their job was to support the agency in any way they could and hope that the problems would be resolved.

Stryker had no criticism for Marion's having complained. He

recognized that Marion had been in the deep South too long. It was time to get her out and give her a really nice assignment for a while. He sent her back to Kentucky. By the end of July Marion was working out of Louisville, driving into the area immediately around the city, taking beautiful photographs of the blue grass country and *trying* to get some pictures of the middle-class farming people in the district. It proved to be more difficult than anyone had expected. In a long letter, written on July 28 and 29 from Louisville, Marion described her problems with her usual flair.

> Chief Stryker! Calling all cars. Caution all photogs! Never take pictures of pregnant woman sitting on rocking chair on sloping lawn while visiting family on Sunday afternoon! Consequences are—Lady doesn't want photograph taken in present state, starts hurriedly to get up and run in house but chair tips backwards dumping her (and embarrassing, not seriously damaging) her. Photog. is surprised, sorry, tries to apologize, enquire after victim's health, etc. etc. and succeeds only in almost being mobbed and beaten and driven off by irate and resentful and peaceloving members of family—*dozens* of them. (P.S.—Camera was saved.)[8]

It was a good story but, as usual, a more serious point lurked just beneath the surface. Marion's next sentence in the letter pinpointed the issue.

> In fact, I've decided that it's a helluva lot easier to stick to photographing migrants, sharecroppers, tenants . . . clients—and the rest of those extremely poverty stricken people, who are depressed, despondent, beaten, given up. Most of them don't object too strenuously or too long to a photographer or picture. They believe it may help them. . . . But these prosperous farmers and "middle clawses"—they will have none of it. They are all "agin" the government and the agricultural program and much of the FSA.[9]

Marion identified a problem here. The FSA file is slanted toward the people that the agency was supposed to be helping, the poorest one-third of American farmers. Even photographs taken on broader assignments or by photographers on their own initiative tend to concentrate on the poorer people. As Marion indicated, poor people are much easier to approach and photograph than are the middle classes or the wealthy. There are exceptions to this in the file. In fact, Marion's work with upper- and middle-class people in Florida and Virginia is a major exception. But in general she was correct, and those who accept the FSA file as a true and complete picture

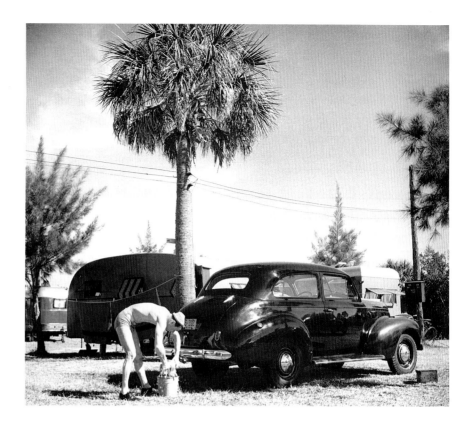

A guest at a trailer camp washing his car. Sarasota, Florida, 1941. LC-USF 34-56932-E

of American life in the late 1930s and early 1940s betray a lack of understanding, both of the file itself and the populist nature of documentary photography as it was practiced in the 1930s and early 1940s.

Beyond the general problem of approaching middle-class people for photographs, Marion was running into another problem by the summer of 1940. Although the United States had not yet been drawn into World War II, the war in Europe was already a year old, and it was becoming clear that the United States could not stay out forever. As war fever rose, people's suspicions of outsiders increased, making it much harder to complete her assignments. Looking back on her last few months' experience, Post was aware of the change. "It's hard to get away with just taking pictures anymore," she wrote Stryker. "Everyone is so hysterically war and fifth column minded. You'd be amazed. So suspicious!" Marion also noted that the threat of war was engendering a new level of interference from local and regional law enforcement people. Reporting that the FSA photographers really needed some sort of new and very official identification in order to avoid trouble, she described the sort of harrassment that she had recently received.

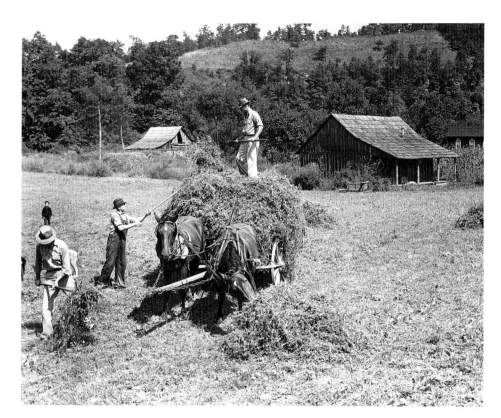

*Loading hay on Edgar Back's
farm. Noctor, Kentucky, 1940.
LC-USF 34-55836-D*

Seriously, several times when I've had the car parked alongside the
road and taken pix nearby, a cop or state trooper has come up and
watched me, examined the cameras and searched thru the car and
questioned and looked at all my identification, etc. The bastards can
take their own sweet time about it and ask many irrelevant and
sometimes personal questions—slightly impertinent questions too.
I've had to visit more than one sheriff's office and write my signature
and go thru the same routine, but the worst of it is the time they
consume—just chewing the fat with you, making you drink a coca
cola, showing you everything in the place. They haven't anything
else to do and they don't feel like working anyway—it's too hot and
they think you're crazy anyhow.[10]

Within two weeks Marion had her new identification card with the
official seal of the government on it. There was not much else that
Stryker could do. The story does indicate the increased nervousness
of certain policemen, which would become a problem for the agency
in the near future.

In general, however, Marion was upbeat about her visit to Ken-
tucky. It was cooler than the deep South and she liked the people.
By mid-August she was in the eastern part of the state, working out

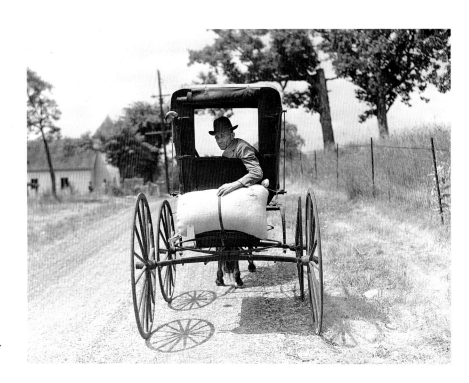

Farmer in buggy taking home sack of feed. Lexington, Kentucky, 1940. LC-USF 34-55449-D

of Morehead, photographing the activities of late summer such as potato harvesting and hay making. This was the time for church picnics, county fairs, and horse shows. Best of all she liked the mountains. In a letter to Toots Wakeham she expressed her feelings about eastern Kentucky as well as a certain sense of frustration.

> You will have to make allowances for me—there's a full moon, a clear, beautiful night in the mountains [and] I'd at least like to go for a little ride in the country with the top down on the car, but no— good girls . . . in this country don't *ever* ride around after dark. And since I'm trying to make a "good" first impression I must do as the natives do. Ain't it awful.

In the same letter Marion reported that she had been fairly ill and had gone to the doctor, thinking that she might have contracted malaria. The doctor had assured her that her condition was only acute gastric upset and that proper diet could clear it up. Marion responded with a diet of her own.

> Post has been drinking only orange juice, milk and beer and has not been bothered again. However the "chiggers" nearly ate out her

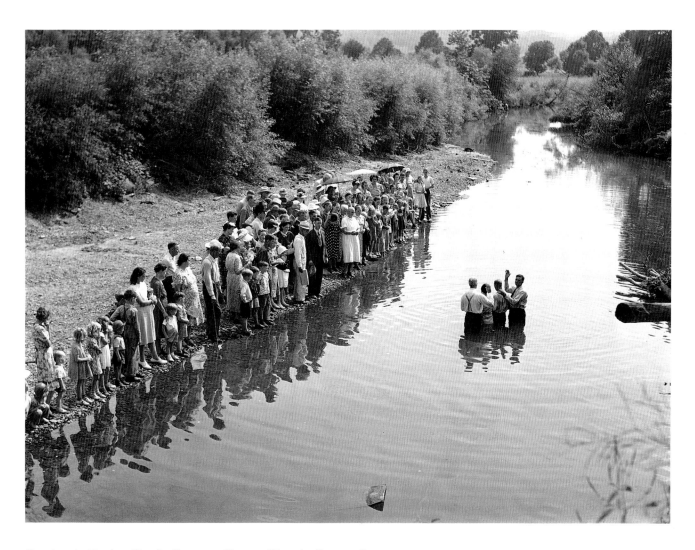

Baptism in Triplett Creek, Primitive Baptist Church, Rowan County.
Morehead, Kentucky, 1940.
LC-USF 34-55314-D

bellybutton and other delicate spots on her anatomy, after sitting on
old wooden benches and climbing around all day at the church
picnic supper. It's the church that will do you dirt every time![11]

By early September Marion had penetrated a good bit deeper into
the mountain culture of eastern Kentucky. She worked around Haz-
ard for about a week and then went to Jackson, a small town well
up in the hills. There she found rich material that she could interpret
in her own way. If Stryker was interested in images of farming and
small-town life as it had been in many parts of the country a gen-
eration earlier, this was a perfect place to see the older patterns still

Marion Post Wolcott helping change tire, with fence post as jack, in borrowed car, up creekbed road. Breathitt County, Kentucky, 1940.
LC-USF 33-31079-M1

accepted as normal. In North Carolina, she had functioned as a social scientist with her camera, recording a type of agriculture that was, for its time, current. Here she could be a historian, recording a culture that was quickly passing from the scene. She found it interesting and fun. In a letter to Stryker, Marion pleaded for as much time as possible.

> *Please please please* let me stay for this week at least. Right now is the most interesting season. Every thing is happening. They're just beginning to make sorghum molasses and have "stir offs" when all the neighbors and friends come to dip into the syrup with their cane sticks and hang around and talk and help each other, etc. Then there are community apple peelings and bean stringings (like corn huskings)—all the women neighbors get together. . . . A large dinner

*The hazards of travel by car.
Jackson, Kentucky, 1940.
LC-USF 33-31133-M4*

is cooked too and *sometimes* a dance afterwards. . . . Court day in
Jackson is this coming Monday when they say *everyone* comes to
town and it's wonderful. . . . Then the tobacco is beginning to be
cut around here now and is the only cash crop practically any FSA
borrowers have. I'm supposed to go out tomorrow with the county
supervisor here to get some pictures.[12]

Marion reported that she had recently gone into the backcountry
with the local superintendent of schools, a middle-aged woman
named Mrs. Marie R. Turner, a loved and respected figure in the
community. Mrs. Turner's presence meant that Marion had an open
welcome wherever she went. The trip itself, however, had not been
easy.

We borrowed an old car the first day—had to be pulled out of a
creek by a mule, then later hauled out of the sand, and finally had a
flat miles from everything and no jack! Tore down a fence post and
while our driver (a young kid who is the son of the school janitor)
tried to prop the car up, I was down on my belly on the creek bed
piling rocks under it. But we finally got it fixed. We had to do some
walking too, so that when we got back late I was one tired girl.[13]

CHAPTER FOUR

A trip taken a few days later was even harder. This time Marion decided to take her own car, and she reported that it had done "amazingly well over the worst and most dangerous roads and creek beds I've ever seen. Got a long way with it and only bent the running board a little and ruined one tire." At this point Marion and the school superintendent had switched to a mule, which, she stated, "was not *too* bad." Finally someone met them with a horse, and they rode to the next tiny settlement as dusk settled over the area, "two of us on one little mountain pony, picking his way over and around the rocks and up the steepest places." At one point the pony had drawn the anger of a mule hitched to a fence by the narrow path. The mule kicked and badly bruised Mrs. Turner, but the two women had continued their journey. Marion was extremely pleased with the experience and the results. "It is wonderful country," she wrote to Stryker.

> The people are so simple and direct and kind if they know you or you're with a friend of theirs. I got some excellent school pictures I think, and some other things as we went along. . . . They are having all these religious meetings and "memorials" too, some of them coming for miles on foot and horseback. I'm getting children walking to school up creekbeds and teachers riding for miles—the mail carried by horseback, etc., people carrying heavy sacks of supplies and so much else.[14]

Marion would have liked to stay in eastern Kentucky much longer, but Stryker could allow only the extra week that she had requested. She was needed elsewhere. Even so, her pictures of eastern Kentucky have to be considered as one of the great series of FSA photographs, on a par with Russell Lee's Pie Town series or Dorothea Lange's pictures of the California migrants. No other photographer was able to form the kind of friendships and contacts with local leaders in that area that she achieved. No other photographer was able to win the local trust that she won there. Her visual dissection of the mountain society was a genuine high point in her own career and a standard-setting series for later photographers. As usual, Stryker was impressed. "Your exploits, trials and tribulations in the mountains of Kentucky will make a whole chapter in the book we are all going to write someday," he wrote. "My God, what a time you had!"[15]

From Kentucky, Marion returned to North Carolina to work again in Chapel Hill. Now, however, the Bureau of Agricultural Economics, an agency concerned primarily with the collection of statistics, was interested in obtaining photographs to illustrate their otherwise

92

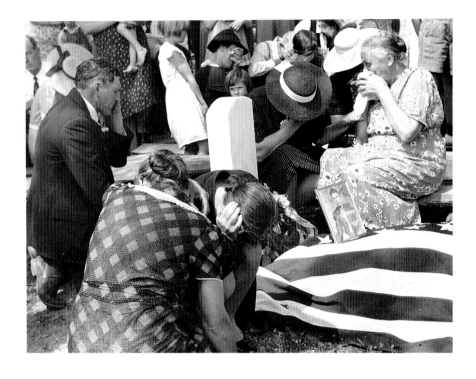

*Minister, relatives, and friends of
the deceased at a memorial meeting.
Breathitt County, Kentucky, 1940.
LC-USF 33-31074-M2*

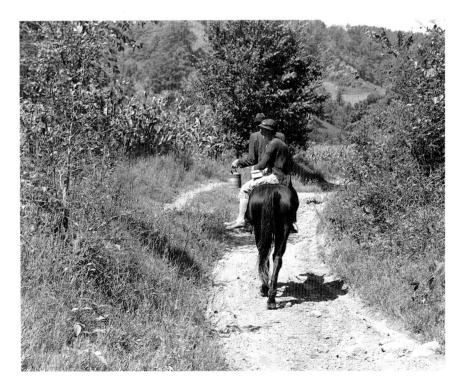

*Couple carrying home groceries,
kerosene on horseback. Kentucky
Mountains, 1940.
LC-USF 34-55584-D*

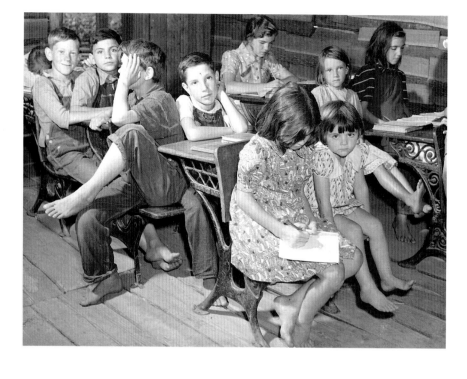

Children at desks, one-room schoolhouse. Breathitt County, Kentucky, 1940.
LC-USF 34-55901-D

dull reports. They requested the "loan" of Marion for a few days while she was in North Carolina. After nearly a week of wading through the turgid prose of BAE reports and dealing with professional administrators she was ready to get back to work with Margaret Hagood, and she let Stryker know it in typical fashion.

> And now, Pappy Stryker, the truth, the whole truth, and nothing but the truth—
> 1. Do you have divergent neighborhood bonds, chronic farm tax delinquencies, existing dependable opportunities, AND soil depleting allotments??
> 2. Should your permanent vegetative cover be restored?
> 3. How's your lespedeza, forest seedlings, perennial grasses and permanent pastures?
> 4. Do you have difficulty of tillage, internal drainage or "wetness," frequent or occasional gullies—stoniness, high acidity or salt content, sheet erosion?
> 5. Have you a purebred boar and have you propagated your nursery stock!!
> At this point I'm *slightly* goofy but what I would *really* like to know is—since this is an outside job for the BAE, is there a *definite* limit on the *amount* of time I should spend on it? Is it rush? Shall I take

outdoor pictures even on very dreary grey days . . . ? . . . Do you want me to try to pose or "fake" some of the things on M. Taylor's list which are "out of season" or not actually happening while I am here?[16]

As was so often the case, Marion raised some very serious issues within the context of her humor. Was this the best way to utilize a skilled photographer? What about the issue of setting up photographs? She would do it if required, but she did not like the practice. Was she expected to take pictures when lighting conditions were bad? She needed some answers. Stryker's reply, which arrived almost by return mail, picked up the humor and indicated that he was, at least, sensitive to some of the problems she had raised. "Dear Marion," he wrote:

> The way I feel this morning, I am certain that I have all the things you asked about. I can assure you that there's nothing I would like better at this particular moment than to have my vegetative cover restored, and if the days keep on like they are now, I have a sneaking suspicion that it *will* be restored! . . .
>
> First, let's not worry too much about this being a job for the BAE. I suspect I am going to want all the good pictures anyway, for our set on the subregion, and won't feel inclined to charge them for it after all. . . .
>
> A lot of things which Russell Smith and Mary Taylor mentioned in their letter and outline are not going to make very interesting photographs . . . so let's use a little discretion and take only those things which after all have some photographic interest when they are put on 8 × 10 paper. . . .
>
> Do not worry about taking any of the things which are out of season. I think that they are so busy over there with Defense and other things that they are going to forget about this request anyway.[17]

Stryker shared Marion's dislike of "set up" photographs and only used them when there was no alternative.

Once her work with the Bureau of Agricultural Economics was finished, Marion became involved with tobacco harvesting and auctioning in the North Carolina area. Howard Odum and Margaret Hagood were interested in this material, as was Stryker; thus she was able to devote several uninterrupted days to it. A nonsmoker herself, Marion had, of course, no knowledge of the dangers of tobacco smoking. What she saw was an agricultural product that was important to a large region, a product that affected the lives of those who grew it in dozens of ways. The small farmers of the hill

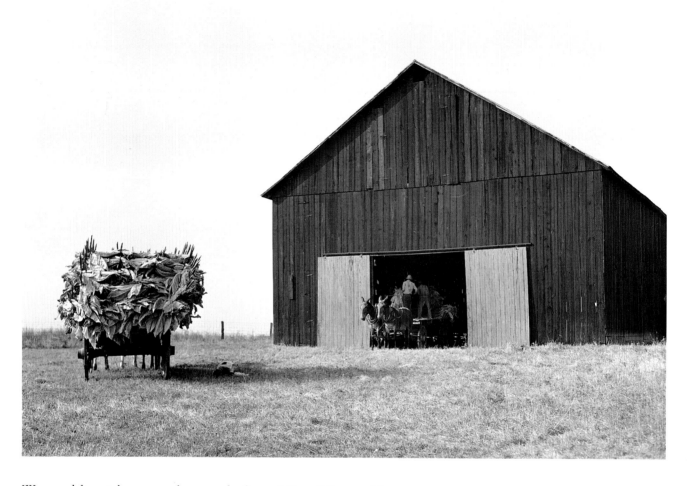

Wagons deliver tobacco to a barn on the farm of Russell Spears. Near
Lexington, Kentucky, 1940.
LC-USF 34-55398-D

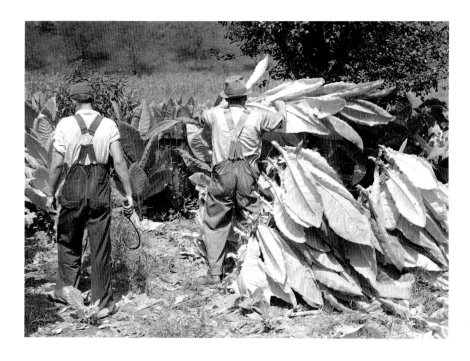

*Mountaineers cutting tobacco.
Jackson, Kentucky, 1940.
LC-USF 34-55723-D*

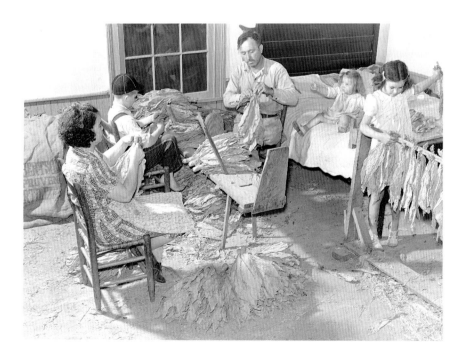

*The Titus Oakley family stripping,
tying, and grading tobacco in their
bedroom. Granville County, North
Carolina, 1939.
LC-USF 34-52629-D*

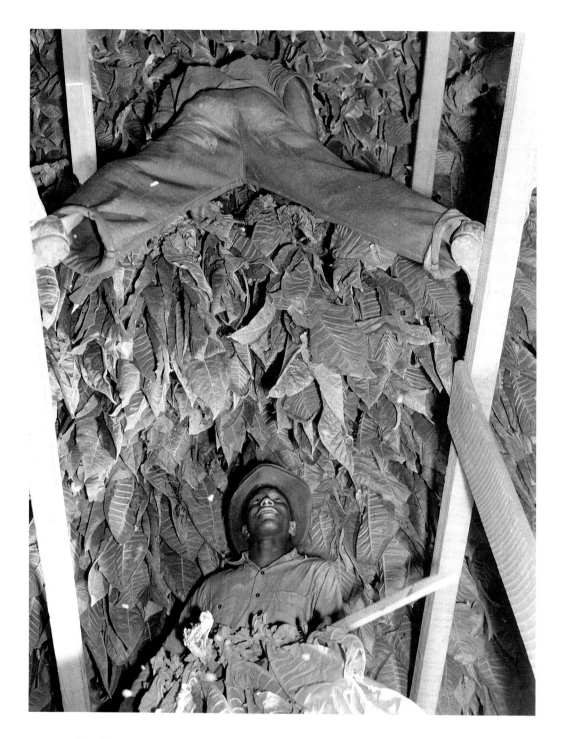

Hanging hands of tobacco in barn to dry, Russell Spear's farm. Near Lexington, Kentucky, 1940.
LC-USF 34-55412-D

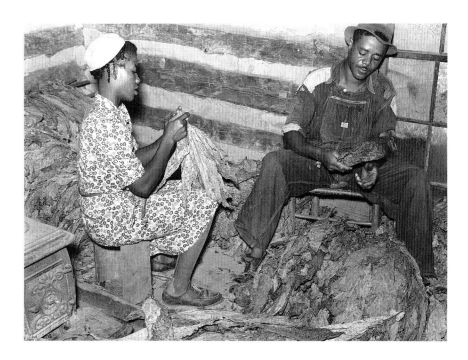

Mr. and Mrs. Compton, Negro sharecroppers, stripping and grading tobacco. Carr, North Carolina, 1939.
LC-USF 34-52055-D

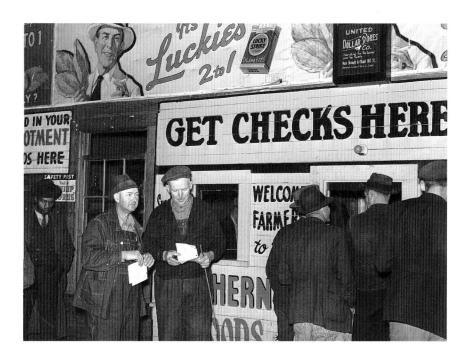

Farmers getting their checks at the warehouse office after their tobacco has been sold. Durham, North Carolina, 1939.
LC-USF 34-52780-D

South often used tobacco as their main source of cash. Their lives were regulated by the planting, harvesting, curing, and auctioning of the crop. Visually, it was a beautiful crop, and its cultivation required a great deal of hand work, an advantage to a people-oriented photographer like Marion. She enjoyed her work in the tobacco country and managed to document most of the major phases of the crop cycle. She particularly enjoyed the tobacco auctions that she attended, where the crowds in the large auction barns, the piles of carefully twisted tobacco, and the faces of buyers and sellers all combined into a constantly changing collage of patterns, each different and each waiting to be captured on film.

Her work in North Carolina finished for the time being, Marion returned to Washington for a short stay (probably with Toots Wakeham this time) and then headed into the deep South once more. She took the usual pictures in Florida and then moved west into Louisiana to cover a story that George Wolfe, the south-central Regional FSA Director, had turned up. Deep in the swamps of Louisiana was a small culture of Spanish people who made their livings as muskrat trappers. They were interesting folk, living thoroughly happy-go-lucky lives despite the grim reality of their poverty. They loved their music and their wine, and they loved a party most of all. Wolfe was sure that they were worth a major story, at least for the file in Washington, if not for publication, and so the idea for what became known as "the muskrat story" was born. Marion was intrigued by the muskrat folks and was always willing to work with George Wolfe, whom she found to be a thoroughgoing professional with an encyclopedic knowledge of his region. She went into the swamps of Louisiana and had a fine time photographing the people, attending a party, and even, at one point, falling asleep on a stack of dried muskrat skins.[18] At the outset, however, she made it clear to Stryker that she was ready for some assignments elsewhere. As she planned her trip into Louisiana in October, she wrote to Stryker,

> I think we would have to get it [the muskrat story] in November to have it usable this year in any news publications. I'll check this with Wolfe. It probably varies a little each season, according to the weather and how the little beasties feel about this whole FSA and the New Deal.

As it turned out, the muskrats were ready to be photographed in October, so Marion left right away. But the same letter called for a change in the venue of her work.

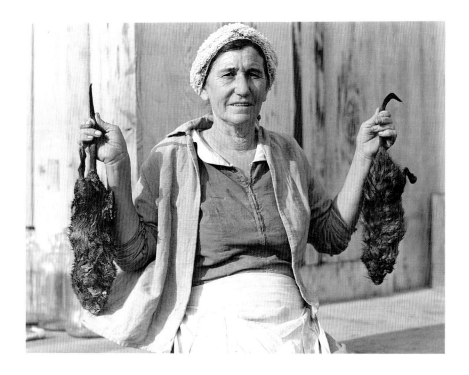

*Wife of Spanish-American muskrat
trapper. In the bayou area of
Louisiana (Delacroix Island), 1941.
LC-USF 34-56778-D*

After that last trip to Florida in that lovely broiling June weather,
I think I could stand another migrant camp session during December
or January, or any "normal" season. . . I think after Louisiana I will
have had a temporary "bellyful" of the dear old South. *Sometimes*, I
even have the faintest suspicion that I already have. At other times I
know damn well I have. . . . You know I have never been west at
all—hardly even middle west. Don't you feel sorry for me? Just a
little bit?[19]

Marion was tired of the deep South, and she really did want to see
the West. She returned to southern Louisiana for a few more days
with the muskrat folk and one memorable dinner of muskrat cooked
in garlic and red wine, then she went back to more routine pursuits.
In Natchitoches, Louisiana, parish supervisor R.D. Prothro was
planning an achievement-day program and wanted six or eight of
Marion's pictures for publicity. Trapnell, at the Louisville *Courier*,
wanted prints of pictures she had taken in his area during her last
visit, and Stryker needed captions for the specific prints as soon as
possible. She was also under pressure to get the last batch of North
Carolina pictures captioned.[20] For a tired person, there was a great
deal to do.

Although no letter specifically discussing it survives, Marion must have telegraphed her exhaustion to Roy because he soon began to show some concern. In one letter he suggested that she take some leave time as soon as possible. It was an idea that appealed to her so strongly that she mused about it through several pages of her next letter. "About leave," she wrote:

> the prospect of a real honest to God vacation seems so sacred and important to me now that I'm wanting to make it a good one and take it at the right time. You may not realize it, but I haven't had a vacation or leave (that wasn't honest sick leave, or three or four days after a trip or "long weekend") for *three* years!

Marion went on to explain that she had taken no vacation during the year that she spent at the *Philadelphia Bulletin* and had found no opportunity for any time off during her two years with the FSA. For Marion, the timing of a "real vacation" was important, and now was not the time.

> You see I like to go where it's either very warm (for swimming and sunning) or very cold and much snow (for skiing, etc)—for at least two weeks of it anyway, especially if I *do* want to rest. At this time of the year you can't do either one.

Warming to her subject, Marion mused about what she would really like to do with a vacation.

> Now tomorrow, I'd like to wake up in the morning and say I can go where I damn well please. I don't *have* to let F.S.A. and Stryker know where I am; I don't *have* to go to Western Union or the Post Office or the railway express, or feel guilty because I haven't done my travel reports and can't find the notebook that has the mileages of the first half of the month in it. I can sleep all morning no matter how bright the sun is shining and stay up all night and not give a damn how I feel the next day. So then, after all this, I'd probably jump out of bed, grab my camera and run off and take some more pictures. What a dope.[21]

What Marion had in mind was a three week leave after Christmas. Until then she would just stay in the field and tough it out. Stryker, however, was not satisfied with this idea. He had no objection to the long leave after Christmas, but he thought it was time to get Marion in from the field for a while. After all, she had taken a tremendous number of pictures which now needed captioning, and she could do that sort of work as well in Washington as anywhere.

As he was leaving on a short vacation himself, he instructed Toots Wakeham to write Marion, inviting her to come in from the field. Toots carried out the assignment in her usual chatty style, clearly delighted with the idea of Marion's return Washington.

> He [Stryker] said I should write you a little note, saying you should come on in if you'd like to. I personally feel that you have been in the field long enough for any human photographer! So if you have nothing else to do right now—except captioning—and you'd like to, why don't you come on in and let the staff spoil you for a while and get our telephones ringing with "Miss Post, please" in masculine voices.[22]

Marion did get back for a short visit. It may have been during this stay in Washington that she was finally able to meet Russell Lee, whose work she so admired. Even so, her time was mostly spent captioning. All too soon she was needed back in Chapel Hill. The tobacco harvest was still going on, and there was much to be documented. By early November she was traveling the subregion with Leonard Rappoport, a scholar of considerable distinction, and had been introduced to the document librarian at Duke University. The lady had written an "encyclopedic study of tobacco" and loved to talk about her region.

> Anyhow, she's very nice, made Caswell County more interesting and alive for me and she knows a great deal about why things were planned or built or laid out as they are, and the significance of certain types of architecture, etc.[22]

This was, of course, just the sort of information that Marion needed to make her photographs as socially informed as possible. She always enjoyed working with the highly competent women she encountered at the University of North Carolina and Duke. These women knew their job and did it well and did not constantly relate to her as a "pretty girl." It was a great relief to be treated as a person instead of an object of either condescension or desire. By contrast, the local doctor who normally treated FSA clients in Caswell County, nearly drove her to distraction. "He simply won't, or can't keep his appointments and has kept me waiting so much and so often that now I'm going to make one last attempt to connect up with the guy—if that's not successful, I give up."[23] The final contact was successful, and Marion got a strong set of photographs of the doctor visiting with and treating local farmers and their families.

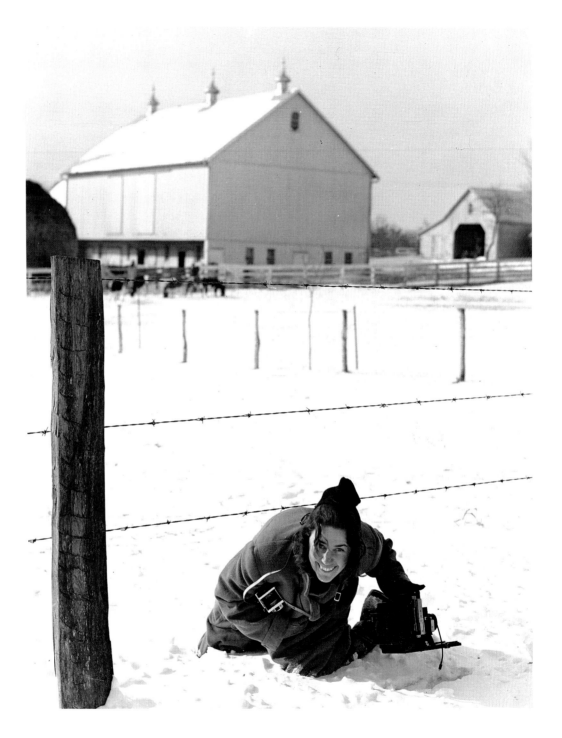

Marion Post Wolcott with Rolleiflex and Speed Graphic in hand, on assignment. Vermont, 1939–40.
LC-USF 34-29245-D

Marion spent most of November 1940 in the Chapel Hill–Durham area; then she drove down to Jacksonville, Florida, to do some more work on the migrant camps (which were, by now, improving considerably). After that she returned to Louisiana to complete the muskrat story. By early January 1941 she was in New Orleans, engaged in contract work for Public Health and trying, again, to cope with the demands of various FSA parish supervisors. February found her back in Florida. Finally, in March 1941, Stryker cleared her for her long-awaited vacation. Marion took herself off to Manchester, Vermont, to spend three weeks skiing and, of course, taking pictures. At least, however, what she did and what she photographed were her own decision, though Stryker was happy to add the pictures to the permanent file.

For a few weeks she was able to put the agency out of her mind. Her one short note to Toots during this period exults "not even thinking of you people" and then goes on to describe the ways that the agency can get in touch if necessary.[24] Near the end of her vacation, Marion became ill with a bad cold and had to stay an extra week in Stowe, Vermont, but by mid-April she was back in Washington, captioning recent work and making plans for a long-awaited trip to the West. While in town she heard of a major horse-racing event to be held in nearby Warrenton, Virginia, and she made a quick trip to see if she could expand her coverage of the rich enjoying their leisure time. Her instincts were correct. The Warrenton races drew the elite of the "horse set," and here they were relaxed, their guards down. The pictures she got that day are among her most published and in one case, most misunderstood. In January 1986, *American Photographer* magazine printed Marion's devastating image of a fat, aggressive field judge in full English country riding garb and English equipment, atop a horse that looks equally well fed and haughty. The magazine coupled this apotheosis of the eastern gentry with a bit of doggerel titled "The Last Buckaroo" mourning the end of the open prairie and the passing of the cowboy. (The gentleman photographed is as far from a buckaroo as it is humanly possible to get.)

Marion was working well at Warrenton. Though tired and nervous about the future, she was sharp in her instincts and polished in her technical grasp. She was planning a major trip into the high plains and mountain West. Her relations with Stryker and the staff in Washington were friendly and professional, yet she was not entirely happy or even satisfied. Something, she felt, was missing. It was at this point that her life took a major turn.

Sometime in late April or early May Marion received an invitation

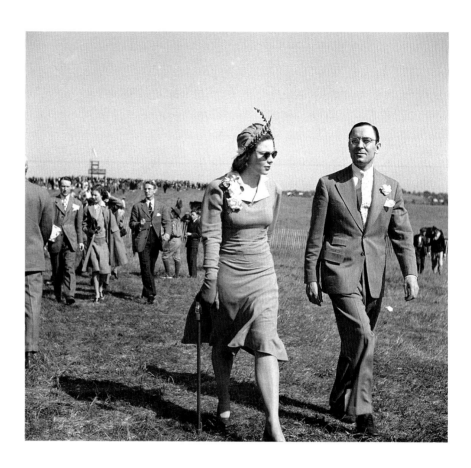

Affluent couple leaving the horse races. Warrenton, Virginia, 1941. LC-USF 34-57497-E

to dinner from a former boyfriend who was now married and father of several children. He worked in Washington but lived on a small hobby farm in the suburbs. Marion had remained friends with him so she accepted the chance for a nice outing, and a bit of home cooking. The dinner went well and Marion enjoyed herself, mainly because of the presence of another guest. Lee Wolcott lived on a ten-acre plot next door and had been invited as Marion's "date" for the evening. A handsome, hard-driving widower with two children, Lee Wolcott interested Marion immediately. During the evening she learned that he was a former newspaper man who had also done two years of graduate work at the University of Wisconsin and was now an official at the U.S. Department of Agriculture. After supper, he offered to show her his house, and the two walked over together. "I'm not sure exactly what it was about that evening," Marion recalls with a twinkle, "whether it was the seven foot long goose down couch or the pine trees or the beautiful moon—or maybe I had just

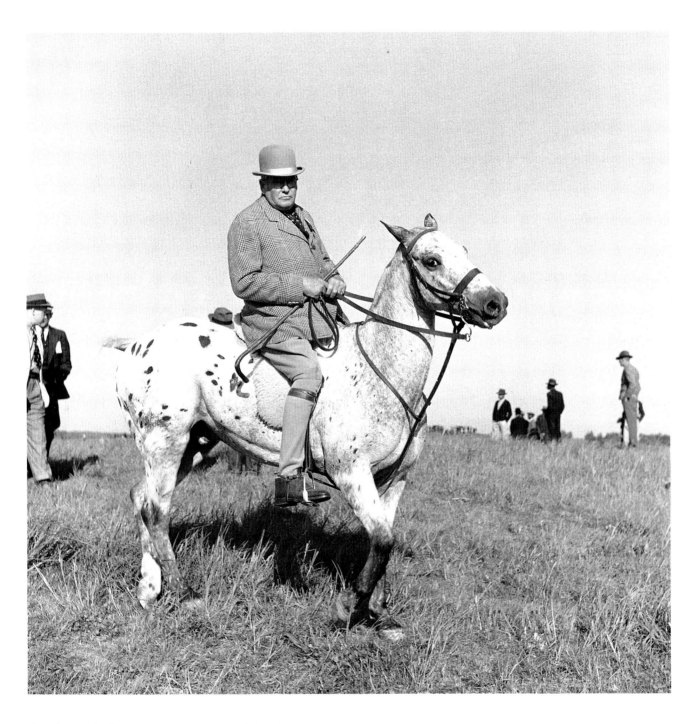

A judge at the horse races. Warrenton, Virginia, 1941.
LC-USF 34-57465-D

been on the road too long. What I do recall is that I never got back to my friend's house that night."[25]

Marion and Lee Wolcott fell totally in love. Six weeks later, on June 6, 1941, they were married in a simple ceremony with only Roy Stryker and the presiding minister's wife, along with her yapping little dog, as witnesses. Having observed the failed marriages of her parents and other couples she had loved, Marion had always said that marriage was not for her. Besides she had thoroughly enjoyed both the freedom and the variety that being single allowed her. Now, however, that sort of thinking seemed suddenly irrelevant.

Marion and Lee dated constantly and seriously throughout May. From the beginning it was clear that marriage was a strong possibility. They spent long hours discussing each other's values and needs. Would Marion keep working? For a while, at least, she would have to. There was work she was committed to do. But it was clear that Lee was not taken with the idea of her continuing to work on an extended basis.[26] Marion accepted this tremendous change in her life with equanimity and even enthusiasm, throwing herself into marriage with the same force and passion that had characterized her professional career. It seems worth our while to try to understand why. Remember that Marion knew a great deal about children and their needs and she was rapidly finding that she loved Lee's children, four-year-old Gail and two-year-old John, and she wanted to participate in their rearing to a much greater extent than she could if she were on the road for the FSA for four to six months at a time. They also wanted children of their own. Marion, now thirty-one, suddenly found the idea of having her own children immensely attractive. If she and Lee had children soon, the younger group would be closer in age to the older children, and it would not be quite so much like two discrete families.[27] Furthermore, war had broken out in Europe and would soon engulf the United States. In such circumstances, many couples have sought the stability of marriage and the reassurance of children. For Marion and Lee, however, marriage was never a retreat; indeed it was more of an adventure, a risk. Both were and are risk takers and that quality was a major part of their attraction.

Just as important was the question of her own job satisfaction with the FSA. The past three years, although satisfying, had also been hard, and Marion was tired. She was also uncertain about the quality and status of her own work. Recently Marion was asked if Stryker ever told her that her work was taken seriously by the front office. She recalled encouragement from Edmund Rosskam, but Stryker's own comments were usually fairly measured. She thought she

could remember one letter from Stryker in which he complimented her highly on her work, beyond the usual "swell stuff" sort of comment.[28] By contrast, when she was working in Washington, she constantly heard remarks concerning the importance and significance of the work of Walker Evans and Dorothea Lange. Within the office, it was clear the Stryker personally favored the work of Russell Lee over all others. A mystique clung to the "original team," which included Arthur Rothstein and Carl Mydans; this mystique never quite transfered to the later staff members such as John Vachon, John Collier, Jr., and Marion Post. She enjoyed her work, of course, and took it seriously. But no one ever said to her, "Marion, you are a wonderful photographer. You take pictures that no one else can take and we need you here." For that reason she felt no great sense of responsibility to her photography, no need to give up her personal life to pursue it. The photographs speak for themselves. Marion was a great photographer with a strong sense of light and composition and an ability to capture fleeting moments of social significance. One certainly cannot fault her, however, for her decision to leave her career for wifehood and motherhood. Photography had been for her a creative act, but not the only creative act. Raising and teaching children, working on a farm, and a dozen other activities would be just as creative and fulfilling for her. She would approach all these activities with the same grace and flair that she exhibited with the camera in the later days of the depression.

Marriage did not bring Marion's career at the Farm Security Administration to a sudden end. In fact, just a few days after the wedding she left on a trip to New England to do some work for the Tolan Committee, an investigative committee set up by Democratic Representative John Tolan, to look into the problems of migratory labor on a nationwide basis. As Stryker was anxious to help this committee, he wanted his best photographers producing fresh visual materials to bolster and illustrate its work. Marion worked in the potato and tobacco fields of New England. Her cameras were stolen at one point, a short-term setback, but she enjoyed the New England summer in spite of troubles and separation from Lee. She returned to Washington briefly, but in August there was no break, for it was now time for her to take her western trip.

A few months earlier, while she contemplated another broiling summer in the deep South, a trip to the West had seemed like a beautiful dream. Now, however, since her marriage, Marion had a whole new set of priorities, and the trip seemed burdensome. Even so, she undertook to do her job to the best of her abilities. The letters and telegrams that she sent back to Washington allow us to

trace her movements—to Madison, Wisconsin; St. Paul, Minnesota; and then Fargo, North Dakota. She spent several days in the area of Williston, North Dakota, and then she worked her way through eastern Montana.[29] As always, she took with her maps, names of people to contact, books about the region, and a series of shooting scripts.

During the later years of the FSA, Roy Stryker became quite enamored of the idea of providing photographers with rough outlines of things to look for and concepts to emphasize. These outlines, or shooting scripts, were worked out in Washington in consultation with the USDA people and Stryker's own staff. The earlier photographers seldom had shooting scripts. There is no evidence that Walker Evans ever saw one. The later photographers, on the other hand, were expected to use their shooting scripts fairly extensively so that gaps in the file could be filled and similar shots could be avoided. The scripts were usually quite general, calling for the photographer to "look for long shots that give a feeling of the high plains," or "look for people relaxing on their front porches."[30]

Marion had different scripts for different regions and during her western trip tried to follow them fairly closely. When she saw something that was particularly beautiful or interesting, however, she felt free to take both film and time to follow up on it. On this trip, she could not resist giving full expression to her strong feelings for the rugged land. Marion was staying at a ranch near Birney, Montana, when she wrote to Stryker about her recent work and her feelings. The high plains had not attracted her at first, but the western mountains were a different story.

> Having gotten an eyefull, camerafull and carfull of wheat, flatlands and sun, I spent a brief weekend in Glacier Park "recuperating." The weather and the cloud effects were so dramatic and such a startling change and the mountains so terrific that I just kept taking pictures of the different "expressions" and changes in the landscape as I would with people.
>
> I worked very early in the morning and very late a couple of evenings too, trying to get the weird strange quality and feeling that a human sometimes has in seeing mountains and being "on top of the world" and not exactly part of it anymore. I was so dizzy and lightheaded and headachey most of the time that I am not to be held completely responsible for the results. I'd get excited and go tearing along and get so out of breath—even when I knew better. I just forgot. I didn't think that you'd object to a little of that kind of America-the-Beautiful for your files.[31]

Cutting crested wheat grass, old binder-four horse team. Judith Basin,
Montana, 1941.
LC-USF 34-58307-D

Freight train, grain elevators, wheat, Great Plains. Carter, Montana, 1941.
LC-USF 34-57959-D

It was a long letter, typical of the sort Marion had written to Stryker on earlier trips. Now, however, such letters were rare because most of her letter writing time was devoted to communicating with Lee. Marian talked about work she had just finished out on the plains and how she had "tried to get the feeling of space and distance" in some of the pictures by using devices like the road itself, telephone poles, and long trains on the horizon. She had also discovered that the grain elevators on the high plains "sticking up out of much space" provided a powerful sense of distance and loneliness.[32] She wondered, however, whether any of the pictures she had taken, either on the plains or in the mountains, expressed the feelings that she wanted to express. This area was new to her, and she needed to know if she was handling it well.

Marion's request to Stryker for comments points out a very real problem with the way in which FSA photographers had to work. Often she went for months without seeing the results of her efforts. Stryker tried to overcome this difficulty by taking bundles of pictures home in the evenings and writing long letters on legal pads with comments about the photographs. (All the photographers seem to have received these letters, but since they did not go through the agency's mail system, very few have survived.) These letters, however, were no substitute for actually seeing the photographs. In the fragment of writing mentioned at the beginning of this chapter, Marion also refers to this problem.

> Not seeing one's own negatives or prints until one has left the region, sometimes until much later, is very bad. It gives me a feeling of uncertainty, of insecurity. It has given me a tendency to overshoot and sometimes to work too long after I am tired and no longer have any vital reaction to the material or subject.[33]

It was one of those problems for which there was really no right answer. The only alternative would have been to take some sort of portable darkroom into the field, a course that Stryker would not have accepted and Marion was unprepared to follow. It would have, among other things, increased her already heavy work load. She had to rely on Stryker's reactions to her work and hope for the best. Stryker wrote back that her pictures were looking fine, particularly the Glacier Park series. He understood the problems that she was having getting excited about the high plains and advised her not to be in too much of a hurry. "You have to get acquainted with the plains," he wrote. "It takes time. They have to be courted."[34]

The Rocky Mountains, west of the Continental Divide, as seen from the top
of Logan Pass on Going-to-the-Sun Highway.
LC-USF 34-58021-D

While in the field, Marion's mind was strictly on business. In the evenings, however, she very much missed Lee. She was in western Montana when she learned to her delight that Lee was coming out to spend a few days with her. Lee was deputy director of the Office of Agricultural War Relations within the USDA and deeply involved with the build-up necessary to get the nation ready to enter World War II. He had been asked to meet in San Francisco with executives of the Weyerhouser Company to see if they would be willing to produce waterproof boxes for the government.[35] Naturally, he was glad to make the trip since it would give him a chance to spend a few days with his wife on the way back to Washington. Marion happily asked Stryker for a few days off. "Now—a big surprise!" she wrote.

> My dearly beloved husband has gotten so many grey hairs and is so lonely that he is coming out here! . . . I *suspect* that he might like to take a few days leave while he is here—perhaps go to Yellowstone or Jackson Hole Country. I don't know. Anyway, wherever we are, I'd sort of like to see him without three cameras hanging around my neck and one in each hand and film coming out of my ears—for a couple of days at least.

Later in the same letter she ruminated about her new relationship, her job, and the changing, dangerous world around her.

> It's sort of awful to be separated from someone you love very much, for a long period of time and at a great distance, and keep reading in the paper that we may be getting closer, very rapidly, to the kind of world system that may drastically, and perhaps tragically and seriously, change our whole lives. There seems so little time left to even try to live relatively normally. I get very frightened at times.[36]

Marion's declaration of her love for Lee and her fear of the future were clues to Stryker that she should not be expected to remain on staff much longer. In fact, the western trip would be her last for the agency.

Lee Wolcott did join Marion for a few days in early September. Marion had expected to take some time off, but Lee quickly vetoed that. He wanted her work completed as quickly as possible so that she could return home.[37] Instead of taking vacation time, Marion and Lee simply traveled together for about a week. It was not what she had originally had in mind, but Marion enjoyed herself. It was great to have someone along to read the maps, to remind her of

this or that item on the shooting scripts, or to ask people questions and keep them distracted with conversation while she took pictures. After he was gone, Marion missed him even more intensely. She wrote to Stryker, "Just in those few days I realized more than ever how much more interesting and alive this kind of job can be when there are two people (if compatible, etc.) doing it. What a difference it makes!"[38]

After Lee left, Marion traveled through Nebraska, which she found more interesting and varied than she had expected. She photographed several FSA cooperative projects, including one at Scotts Bluff (which she thought poorly run) and the Two Rivers Farmstead (which she liked very much). At Two Rivers she was supposed to photograph some baby pigs but reported to Roy that "the damn little suckling pigs didn't want to suck this afternoon. Any *other* day they wouldn't stop sucking if you wanted them to."[39] Even more frustrating were the cows. One of her shooting scripts called for her to get some "portraits" of western cattle, that is, head and shoulder close-ups. The problem, of course, was that western cattle are quite wild and not easily approachable. "Now—about your cattle in the great BIG West," she wrote Stryker in late September.

> It's harder to get "portraits" of bulls or cattle on the range, or, calves sucking, than it is to get into United Aircraft for pix! [This last was a reference to wartime restrictions.] I *might* get a picture of some around a reservoir or waterhole, if I rode in on horseback and camped with brush camoflage and my camera in my fly [tent] with a telephoto lens for about a *week*.[40]

Stryker wrote back to tell her not to worry about getting every item on the shooting script, that it was simply a guideline and not to be taken too literally. Having said that, however, he took several more pages to outline all the things he wanted Marion to do on the way back to Washington. He wanted her to head south, through Wichita, Kansas, where he hoped that she could get some pictures inside one of the aircraft assembly plants that was gearing up for war. Without special clearance, however, he recognized that she might have difficulty getting in (and, in fact, she did not get in). He was particularly anxious that she cover the oil industry in Kansas—"derricks, tanks, drilling equipment, *oil men* (portraits)." From Kansas, he routed her through Missouri and Iowa, where his concerns were mostly agricultural. He wanted shots of a new mechanized corn harvester, plus the usual long shots of farmsteads and outbuildings, roadside fruit and vegetable stands, and the little railroad towns

*Post office in
blizzard. Aspen,
Colorado, 1941.
LC-USF 34-59417-D*

that had grown up around the water tanks that were necessary to steam-driven locomotives. Stryker referred to these as "Tank towns," assuming that she knew the slang expression, but Marion's margin note betrays her impatience. "Exactly what is a 'tank town.' I can only imagine."

For another page, Stryker continued to happily spin out plans for Marion's next few weeks. Illinois, Indiana, Ohio, and West Virginia were all to be covered on her way home.[41] The letter was typical of Stryker, and at other times she would have been pleased to receive it. But now it did not fit her plans. What Marion wanted was to get back to Washington and to Lee and the children. Lee obviously wanted the same thing. When Marion sent Stryker's letter to Lee for comment, his reaction was angry and pungent. "Sweetheart, that no account S.O.B. didn't even ask about your health. How you feel or anything. He should be fired immediately."[42] Stryker had, perhaps, been insensitive to Marion's feelings. He so enjoyed having a good photographer in the field that he tended to get carried away with plans to fully utilize the person's time. In a sense, the work that he piled on Marion, both in the West and earlier in the South,

was a compliment—a signal that her photography was truly valued by the agency. Under the circumstances, however, Marion did not see it that way. She was tired of being constantly "on call" for the agency, tired of being on the road, and ready for a home.

Marion came home, finished her captioning, and never traveled for the agency again. She found that she enjoyed caring for Lee and the children. She was truly needed too, because Lee's housekeeper and babysitter had left to take a higher-paying job with the war-swollen government when she discovered that he had acquired a new wife. Lee Wolcott, a man of strong personality, was accustomed to making the decisions for the family, and Marion was ready to pass this responsibility to someone else. She was also ready to start a family and that, as much as anything else, symbolized the major change in direction that her life was taking.

Also symbolic of the change in Marion's attitude as well as her status was the controversy over her name. Lee decided that her professional name should be Marion Post Wolcott. This was fine with Stryker, as long as the new name was only used on pictures taken since her marriage. He was perfectly willing to caption these "Photo by Marion Post Wolcott," but he did not want his staff, busy as they were, go back through the file and change all of the thousands of photographs taken by Marion Post to Marion Post Wolcott. Stryker tried to hold out, but Lee was a deputy director, far up the administrative ladder, and he knew the regulations. Finally a memorandum came down from his office to the photographic section.

Memorandum to Division Chiefs and Regional Directors Regarding Female Employees

Please call to the attention of employees of your office, U.S.D.A. regulation paragraph 3221 which provides that when a female employee in government service marries, her legal surname *must* be used by her instead of her maiden name.[43]

Stryker, whose department was under great political pressure from other directions, did not think it was worth fighting over this point, and it must be supposed that Marion felt the same way. Staff time was allotted to go back and change all the pictures, and Marion Post now became Marion Post Wolcott, three years retroactively. Lee had asserted himself, and Marion, a strong-willed and independent woman, had accepted his assertion. Perhaps a less powerful man might never have attracted her.

Certainly she had had proposals before and had turned them

down. Perhaps it was also a matter of timing and being ready for the change. For whatever reasons, Marion now threw herself into her role as wife and mother with the same dedication that she had exhibited on the job. Such dedication to both the agency and her husband was not possible, and she had clearly chosen the latter. For the time being her professional career was over.

Michael and Lee Wolcott. Waterford, Virginia, 1949.

CHAPTER FIVE

Wife, Mother, and Sometimes Photographer

Shortly after her marriage to Lee Wolcott, Marion stopped thinking of herself as a professional photographer and began to redefine her life and goals. When she returned from the western trip it was clear that she was pregnant, a source of delight to both Marion and Lee. The pregnancy, however, meant that any further travels for the agency were out of the question for the time being. By the time she might have considered returning to work, the agency had changed, becoming the photographic branch of the Office of War Information. Stryker had left to pursue other interests, and most of the photographic staff had been replaced. All this helps to explain why there was no question of returning to the Farm Security Administration, but it does not shed much light on why there was no return to a professional career, using her technical skills and her unique sense of light and composition in some other venue. Today, a woman in similar circumstances might take a few years off for childbearing and perhaps, if financial circumstances permitted, a few more years for child rearing, but we would not expect a woman of Marion's talent to end her professional career permanently. Why, in Marion's case, did this happen?

Her continued commitment to photography was never the issue. If Marion had become tired of life on the road, that exhaustion and burnout did not extend to photography itself. She loved to take photographs and, indeed, never stopped. So again, the question confronts us. Why was there no later career? The answer lies, in part, in the social/cultural context of the mid-1940s. During the

Wolcott child. Oakton, Virginia, 1942.

war, when Marion was starting her family, many women did work outside of their homes in industrial and other situations, but they understood that they were not taking permanent possession of the jobs of "our boys overseas." The women were expected to return to their homes after the war and resume their domestic tasks. Government propaganda as well as a general national consensus supported this idea. Rosie the riveter was to return to Rosalyn the housewife as soon as the hostilities ended, and generally she did.[1] Thus, just at the time when Marion might well have considered a return to her profession, in 1948 or 1950, the national trend was in the opposite direction. Women were supposed to be happy in their split-level homes in the suburbs, devoted to children and husband. In order to resume her career at that time, Marion would have had to oppose a very strong national trend. She also would have had to oppose a very strong husband.

*John and Lee Wolcott. Waterford,
Virginia, 1944.*

Lee did not object to Marion taking pictures around the farm, or of neighborhood children, but he would not hear of her making a major commitment of time to photography. "Photography as a significant medium or art form didn't register with me at the time," Lee observes. "I was aware of the limited monetary value of photographs. I saw Marion hand out photographs as if they were just odd little mementos. She would give a friend a dozen photographs just as you might give a friend a highball or a cocktail."[2]

If Marion could simply give her work away, to Lee this meant that it was not to be taken seriously. Money was important to Lee. He had been raised in real poverty and had worked hard to attain a position of importance in the USDA almost wholly on his own effort. He would succeed equally well in several more careers. But the supposed poor return on time invested was only part of Lee's objection to Marion's return to serious photography. There is much

*John Wolcott with rubber doll and
Linda Wolcott. Lovettsville,
Virginia, c. 1946.*

evidence to suggest that he would have resisted such a move for
other, deeper reasons. One involved the then-current definition of
manliness. Marion believes that he would have been deeply hurt
by the implication that he could not support his family (which he
certainly could do) and that his wife "had to go to work." Another
reason had to do with the classic definition of family. In his own
way, Lee was very much a family man, loving his family and placing
it at the center of his life. In Lee's mind, Marion's return to work
could have posed a genuine threat to the family's integrity, a threat
that he would oppose with every ounce of his energy.[3]

There is no point in making Lee Wolcott the villain in the story.
Marion loved him totally, married him willingly, and stayed with
him through many difficulties. Marion and Lee had each come from
homes broken by divorce, and Marion's memories of her parents'

*Linda and John Wolcott in creek on
farm. Lovettsville, Virginia, c. 1944.*

break-up had been particularly searing. Both were committed to
making their marriage work, and neither would have considered
putting their children through the trauma of separation. For Lee,
this meant that there had to be strong leadership and he had to
provide it. For Marion, it sometimes meant that her own needs and
inclinations were deferred or even pushed into her deep subcon-
scious. Choices were made by both marriage partners and those
choices led Marion away from a professional career in photography.

For over a year after she left the Farm Security Administration
Marion and her husband continued to live on the small hobby farm
that he owned outside of Washington, D.C., but Lee was dissatisfied
with this. After years of serving in the agricultural bureaucracy, he
wanted the hands-on experience of actually farming himself. During
her years with the FSA, Marion had also experienced the urge to

go "back to the land." One has only to recall her letter to Stryker in May of 1940 where she wrote, ". . . if I *had* stopped, I might have begun to dig in the red brown earth in some farmer's garden and just stayed," to see that her exposure to rural America had made a profound impression on her. By the end of 1942, Lee and Marion had found a farm within long commuting distance of Washington. The family, now increased to five by the arrival of their daughter, Linda, in late August, moved out into the Catoctin Valley, to a farm they called "Grass Roots" near the village of Lovettsville, Virginia.[4]

Lee Wolcott was now deputy director of the Office of Agricultural War Relations, a position charged with the responsibility of presenting agriculture's case to the War Production Board and other agencies that controlled access to gasoline, rubber, lumber, and other priority items. Since he could not leave these duties in the middle of the war, he continued to work, commuting fifty miles each way in a car pool. Six days a week he got up very early, leaving the house before seven and returning late in the evening. Marion became the farmer. She learned to run the tractor, and she participated in the purchase of equipment and livestock. She became pregnant again and had a second child, a son named Michael, in 1945.[5] It was a very basic sort of a life, hard and often frustrating, but also rewarding. Marion experienced moments of intense enjoyment too— watching her children grow and develop self-confidence in the farm environment, watching the lovely patterns that the hayrake could make behind her tractor. She had a sense that she was building something personal, and that was at least part of what had been missing during her years on the road for the FSA.

The farmhouse at "Grass Roots" had been referred to in the neighborhood as "The Woman Killer." It was a large stone house with no internal conveniences to speak of. Gradually, despite wartime restrictions, Lee and Marion managed to upgrade the house, adding electricity, modern plumbing, and other amenities as they became available. Marion bought primitive antiques and furnished the house in a way that was both comfortable and attactive. "The Woman Killer" became a desirable showplace in the region.

At war's end, Lee resigned his job with the government and became a full-time farmer. Seeing new opportunities in agriculture, he acquired a second farm at Purcellville, Virginia, and set up a dairying operation there. Soon the dairy farm was consuming most of the time, so the family moved to Purcellville. Marion never liked the house at Purcellville as well as "The Woman Killer." It was smaller and a great deal easier to care for, but it lacked the character,

*Plowing. Near Waterford, Virginia,
c. 1951.*

and perhaps the challenge of the rambling old stone structure. It was also hard keeping two farms running, so eventually both were sold and the Wolcotts bought a third, larger farm near the community of Waterford, Virginia.

Waterford was a town that interested both Marion and Lee. It had attracted a group of bright young professionals who worked in the city and thus seemed less isolated than the earlier farms had been. At least there would be people to talk to who read books, and, they hoped, the schools might be better.[6] Lee set up a beef-raising operation, and Marion again furnished her house, sent Gail to boarding school, and prepared to build a permanent place for herself and her family.

Lee Wolcott proved to be a very good farmer. Linda Wolcott Moore pointed out that:

He went out and bought old farmhouses and saw the beauty that nobody else saw. He would rip off the newspapers [from the walls—a common wall covering in older Southern homes] and find the beautiful pine wood underneath. He and Mom took risks together and they worked very hard.

He has always been very forward looking and still is—quitting his job with the government and going into farming, building one of the best dairy farms in the county, growing oats [Lee says it was barley] where everyone said he couldn't grow such a thing. He even grew beautiful alfafa where everyone said that alfafa could not grow at all.[7]

Lee still had good friends in the U.S. Department of Agriculture. He knew the right questions to ask and where to go for the most current information. This combined with a tremendous capacity for hard work did make his farming ventures successful. His farms became beautiful and productive—and valuable.

Throughout all the years of work on the farms, Marion continued to take pictures. Her personal file contains pictures of Lee working on fences, of the children at work and at play, and of the houses that she lived in and worked so hard to improve. Her daughter, Linda Wolcott Moore, remembers, "I just expected her to be photographing. I can't remember a time when she didn't have a camera around her neck." When the children asked about photography, Marion was happy to show them what she was doing and talk about her methods. Linda Moore says that it was wonderful to watch her mother work. "We learned to see what Mom was seeing—not as well—but we could visualize what she was seeing because we watched her stop and take pictures so much."[8] For a while, Marion considered doing a children's book, using photographs of her children on the farm as illustrations, but the everyday pressures of farm life were too great, and the project never got beyond the dream stage.[9] On a very small scale, Marion did do some "commercial" work during the Virginia years. As the word got out that she liked to take pictures and was good at it, she was asked by various neighbors to photograph their children. The small fees that she charged helped to cover the costs of film and development for her own personal work. The photographs from this period that have survived provide us with a visual link to the Wolcott family and to Marion's feelings toward her life at that time, and if they do not have the "bite" of some of her earlier work, it is because she was photographing people and places that she loved. One could hardly expect critical analysis under such circumstances. The prints were commercially developed, giving her even less control over the finished product than she had enjoyed

*Gail with neighbor's goat. Oakton,
Virginia, 1942.*

during the FSA years. Indeed, once she left the *Philadelphia Bulletin*, it would be nearly forty years before she would have access to a dark-room again.

During the farming years, Marion's contact with her old friends and associates from Farm Security became occasional and tenuous. Christmas cards were exchanged and there were rare letters, but for all practical purposes Marion's life became centered around her husband, their four children, the farm, and the community. This was the way postwar society in the United States expected her to behave, it was the way her husband wanted to live, and, in general, it was satisfactory to her.

In 1952 the tranquility of life in the Catoctin Valley was suddenly and permanently ended. Lee was burning weeds along a fence row using a sort of miniature flame thrower, which operated from a tank

of gasoline. Something went wrong and the tank ruptured and caught fire. Lee, badly burned, was on the ground in great pain when the hired man got to him to help put the fire out. Marion was called to the scene, and somehow she and the helper got Lee into the family car and drove him to the local hospital, pausing just long enough to call a doctor friend to meet them there.

The burns on Lee's legs were dreadful. He almost lost a leg due to infection, and he spent five months in the hospital. Even after he was able to return home, he was far from mobile, and virtually all the day-to-day running of the farm fell to Marion. It was obvious that it would be a long time before Lee would be back to normal physically. Searching for a way to supplement the farm's income, Marion seriously considered returning to photography. She even wrote to Roy Stryker, now working as photography director for Jones and Laughlin Steel in Pittsburgh. Stryker was coming to Washington soon and agreed to meet Marion for lunch.

> Roy had always told me, "let me know if you ever want to work again," so I asked him if there was something I could do that wouldn't entail running all over the country. I explained that Lee was in bed and would be for some time and that I would enjoy getting back to work. But Roy said, "Marion, until Lee is back on his feet, I don't think you could handle it. I know that you would give it your best effort, but your mind would be back there with Lee and those kids. You've been through a hell of a lot and I don't want to put you through more."[10]

Marion left Washington to drive back to Waterford feeling both discouraged and rejected. It had been hard for her to get back into contact with Stryker in the first place. Now she felt even more isolated from her creative past.

It was time to make a decision. To stay on the farm would certainly be a burden for Marion, and times were definitely tight. In addition, both Marion and Lee could see problems inherent in staying that had nothing directly to do with farming. They were not particularly impressed with the schools in rural Virginia (even Waterford had proved disappointing in this regard). Marion's health was not good; she had chronic bronchitis and constantly recurring sinus infections, which farm life did nothing to improve. Beef prices were deeply depressed and other farm commodities were not selling particularly well; yet land prices were high. It might be a good time to get out of the farming business.

On a rainy day in the fall of 1952 the farm, the equipment, the

house, and most of its contents went on the auction block. For Marion it was a bad day. She cried as she watched a carefully crafted way of life disappear.[11] Lee, on the other hand, was optimistic. While at college he had read in *The Education of Henry Adams* that a man should not stay in one field more than six years lest he run the risk of stagnation. He was ready for a change. A friend had offered the use of a cottage outside of Denver, and Marion also took hope in the fact that they were moving to the Southwest where schools would presumably be better and where she might get some relief from her allergies and sinus problems.

The sale went well, and Marion and Lee found that they now possessed a considerable sum of money. As far as Lee was concerned, he was now "retired" at age forty-eight, or at least he had the luxury of time to decide what he wanted to do next. For a few months the Wolcotts lived in Colorado Springs, Colorado. Then they and the children traveled through Mexico. It was a good time. They all enjoyed travel. Mexico was cheap, and there was much to see and learn. The plan was to return to Colorado Springs in the fall, but they had hardly unpacked the car when a letter arrived from an old friend of Lee's, offering him a job. Lee and Howard McMurray had known each other in graduate school at the University of Wisconsin. Now Dr. Howard McMurray was head of the Department of Government at the University of New Mexico and he needed someone with experience in government operations to bring a needed dose of reality into his program. He knew about Lee's accident and wondered if he felt up to doing some teaching. Lee thought it over and decided that teaching was just the thing that he felt like doing, and so from 1954 to 1959 he was visiting professor of government at the University of New Mexico.[12]

Marion came to like Albuquerque a great deal. Her mother was now semiretired and working as a housemother at Whittier College in California, close enough to ensure regular visits back and forth. In fact, Marion tried to encourage her mother to come and live with them, but the senior Marion enjoyed her independence and refused.[13] By now the older children were teenagers and the younger children were more independent. Marion took some courses at the university and, at the urging of Howard McMurray's wife, Lucy, she got involved with a hospital school for American Indian children who were recovering from tuberculosis. The children, who required long periods of convalescence, also needed to keep up academically. Efforts by hospital personnel to interest them in books, however, had not been very successful. The U.S. Public Health Administration was in the process of setting up a small school in the hospital,

Indian children, recuperating from tuberculosis in Presbyterian Hospital. Albuquerque, New Mexico, c. 1957.

and Marion became interested. Working with the children, she found her old passion for progressive education rekindled. These children were bright, yet conventional textbooks clearly left them cold and unstimulated. Eventually Marion became the director of the school and spent many hours searching for materials which would be relevant to the children. She set up a "Trading Post" to teach math and language skills. Children were given credit at the "Trading Post" for successful completion of assignments and could trade their credits for desirable privileges. Marion enjoyed using long-dormant skills and found it rewarding to work with this particular group, but her term as director of the school was short-lived. By 1959 Lee was again restless, bored with teaching and ready for new challenges. Marion was ready for a change too. The grant under which she had operated her hospital school had run out. It was time to pack and move on.[14]

Lee Wolcott had always had a fine reputation as an administrator, and the years of farming and college teaching had not diminished

*Washing children and laundry,
cooking utensils, etc., in "jube."
Hamadan, Iran, 1961.*

it. In 1959 he was invited by the Agency for International Development (AID) to become the advisor to the prime minister of Iran. The goal was to help the shah improve both the efficiency and fairness of his government as well as to offer direct aid to that government. For two years the Wolcotts lived in Iran working in a close, if somewhat frustrating relationship with the prime minister. (The shah was more inclined to take advice on matters of efficiency than on fairness.) Marion taught fourth grade and remedial reading at the American School in Teheran and took a few pictures during this period. The two older children remained in the U.S.; Gail was already married, and John was attending Reed College. He later finished his degree at the American University at Beirut. Linda also took her sophomore year at the American University while the youngest boy, Michael, went to the American School where Marion taught in Teheran.[15] Thus Marion was able to keep in close contact with her immediate family throughout her travels in the Near East.

In 1961, Lee's status within AID changed. He left the direct

Tribal settlement enroute from Teheran to the Caspian Sea. Iran, 1960.

134

Clinic, Lahore, Pakistan, 1963.

control of the agency to work for the University of Southern California on a project that was funded by the agency. Thus he remained essentially within the AID program, but with a different boss. The new boss sent the Wolcotts to Pakistan for two years, again to try to improve that government's administrative methods.[16] By now, however, AID was also becoming interested in family planning, and Marion took some slides for that program, which were left in Pakistan. Marion also taught at the American School in Pakistan. Michael stayed with his parents while Linda returned to the states to finish her degree at Berkeley.[17]

By late 1963 the Wolcotts were back in Iran for nine months. During these years Marion's role, aside from occasional photography and teaching in American schools, was similar to that of an embassy wife. She was expected to provide support for her busy and fast-moving husband and she did. She also enjoyed the travel and getting to know people of totally different background and culture. It was a very interesting life, and, for her, there were few of the pressures that had made travel by herself in the American South so wearing twenty years earlier. Now and then, however, there were reminders of her earlier career and how completely she had left photography and her old associations behind.

Nurse discussing the "loop" with villager, family-planning clinic. India, 1968.

Sick people in front of clinic. Lahore, Pakistan, 1962.

In 1964 the Wolcotts returned to the States for an extended home leave. They took a house in Falls Church, Virginia, and Lee continued to work with the Washington office of AID, spending more and more time, now, on programs for the Near East. In June of that year Marion read in the *Washington Post* that Russell Lee was to have a one-man show at the Smithsonian Institution with an opening reception hosted by the great documentary filmmaker Pare Lorentz. Marion thought about going and then decided not to. After all it had been years since she had seen most of those people. They probably wouldn't remember her. Then, on the Sunday of the opening, she decided that she at least ought to put in an appearance. She drove into Washington and presented herself for admission at the door. "Invitation, Madam?" the doorman asked. She had no invitation. No one had known how to get in touch with her. She pleaded with the guard to let her in for a few minutes, but he was adamant. Finally, she asked if she could send Russell Lee a note, and the guard consented to try to get it to him. Marion does not remember exactly what she wrote, but the note wished him luck with his show and said that she was outside and would like to see him for at least a few minutes. Then she waited. After an hour it was obvious that either the guard had not gotten the note to Russ or that Russ had not been able or willing to get away.[18]

Inside a great party was going on. Russell and Jean Lee were there as were most of the other photographers who had served the FSA, many with their wives or husbands. Roy Stryker had driven down from Pittsburgh, and the guests included a number of people who had worked for the FSA photographic project in other capacities. Even several of the old darkroom staff had come to Washington especially for the reunion. Pare and Elizabeth Lorentz were keeping the food and beverages well supplied.[19] Outside on the steps Marion Post Wolcott sat and felt as lonely and rejected as she had ever felt in her life. Finally she left, driving home by a longer than usual route in order to regain her composure. Eventually the note did reach Russ Lee, and he immediately left the party and went to the entrance, but Marion was gone. Some time was spent locating her address in Falls Church, then Russ telephoned her home, but Marion was still driving, and no one at the house knew where she was. By the time she returned to Falls Church, the party at the Smithsonian was long over and the principals had dispersed. The opportunity to reestablish contact had been missed. It was a hurtful experience, but Marion put it behind her. She had too much to do and too many other responsibilities to afford the luxury of brooding.

Police waiting for the arrival of the shah, in front of the Majlis government building. Teheran, Iran, 1961.

In 1965 the Wolcotts returned to the Near East, this time to Cairo where Lee was supposed to help the Egyptian government with some administrative problems. Marion joined him after a month. Six months later, the Six Day War with Israel broke out, and Marion was involved in another wrenching experience. Trouble had been brewing almost from the time she arrived. Abdul Gamal Nassar, president of Egypt, had sought confrontation not only with the Israeli government, but also with the United States. When he chose to march a regiment past the American embassy in a show of contempt, the decision was made to evacuate all families of embassy personnel. This meant that Marion would have to leave immediately, but there were complications. Marion had with her a large number of slides, prints, and negatives, some of which had been taken recently in Egypt, but most of which represented the accumulation of her travels in the East. The word in the embassy was

Esso kerosene cart. Aswan, Egypt, 1967.

that all materials of that sort were very likely to be confiscated. Marion had to make a decision. She tells the story in this way:

> The night before I left we went through a whole pile of slides and negatives from all over and destroyed them. We burned them and cut them up. We knew we would not be able to keep them. Some of them were not flattering to the state and might get Lee in trouble, but I also felt resentment toward the Egyptian officials and did not want to leave anything behind that they might be able to use. . . . I guess I destroyed at least 200 images. It was partly just something to do. It was a very traumatic evening. It was separation. We didn't know if we would see each other again. I was emotional about it. I don't smoke and I didn't want to cry (though I was crying on the inside). It was a long night. I was giving away things to the cook, whom I was fond of. I just didn't want the Egyptian officials to have any part of me or anything I had done. So I chopped up slides.[20]

Marion got out of Egypt the next morning and was taken to Athens to await events. Lee stayed in Cairo and was eventually evacuated under cover of night to the ironically named Palestine Hotel in Alexandria, where he waited out the war and its immediate aftermath. For two weeks Marion had no word from him. It was a stressful time for both people, but eventually Lee arrived in Athens and they were reunited—minus all of Marion's photographic work from the past several years.

After their troubles in Egypt, Marion and Lee were due a vacation. They stayed in Greece relaxing for some time, and then Lee was offered an interesting job heading up a State Department-sponsored birth control program in India. Marion was quite happy about this. Her mother's years with Margaret Sanger's organization had given her strong feelings on the subject of a woman's right to limit the number of children she bore, and India was certainly a country with a major population problem as well as attitudes concerning women that she hoped would be challenged. Lee enjoyed India. The program that he was involved with was well financed with good back-up from the U.S. ambassador to India, Chester Bowles. It was a pleasure to run. Marion, however, picked up amoebic dysentery early in the trip and was sick for much of the first year.[21] Eventually she recovered enough to be able to enjoy travels through India and Sri Lanka. They stayed in India for about a year and a half and consider it one of their best overseas experiences.[22]

In 1968 the overseas wanderings came to an end. Lee decided that it was time to return to the United States. He was now sixty-three, and the years of hard work and travel had left him ready for a quieter life. The younger children were both out of college by now. There was nothing to keep the Wolcotts overseas, and so they came home.

But where is home for wanderers? Back in the States, the first order of business was a short visit to Lee's mother in Mill Valley, California. (Marion's mother had died in New York City while the Wolcotts were in California.) Southern California appealed to them, so they bought a house in Montecito, a village on the outskirts of Santa Barbara. When housing prices spiraled upward in the early 1970s, the Wolcotts realized that they could make a very good profit by selling the house and moving into something smaller and simpler, and so they did, living, for a while, in a small house near the Santa Barbara Mission. The first house in Santa Barbara proved less than satisfactory, however, and they moved again. Between 1970 and 1975 the Wolcotts moved three times within the Santa Barbara area.[23] Marion found much of her time taken up with the process

of moving. She also found that she enjoyed the role of grandmother, babysitting for daughter Linda's two children who lived some two hours away. She also did volunteer work at the Santa Barbara Art Museum where she was put in the museum shop behind the counter, selling prints and art-related items to visitors. No one had any idea of her significance, and it never occurred to Marion to mention her work for the Farm Security Administration. It had been a long time ago and very few people would have even known what she was talking about.

Yet, despite all these distractions, her creative urges with the camera began to reassert themselves at Santa Barbara. Marion had been interested in color during her later years with the FSA. Kodachrome had been a very new material in those days, and her experiments with the medium had excited her. During her years abroad, she made color slides in Iran, Pakistan, and India, but these generally functional images, designed to be used in schools or health programs, had either been destroyed in Egypt or left in the various countries for the use of the local people. On short trips from Santa Barbara she began to do some landscapes and seascapes—the sort of thing she had done well in the earlier years but had been self-conscious about and had labeled "FSA cheesecake." The landscape work broadened her interest, and other photographic possibilities began to suggest themselves. Lee was interested in collecting fine art prints, and this had led to his involvement with the Art Museum of the University of California at Santa Barbara. During one of his meetings Marion drove to the nearby student village of Isla Vista for a general look around. What she saw interested her. Isla Vista was an almost perfect capsule of California in the 1970s. The student counterculture was strong there, and Marion sensed a degree of social commitment that reminded her of her student days in Europe. The area was colorful, especially the graffiti. Marion got out her 35-mm cameras, and for several months she photographed the community, its streets and its people, using some black-and-white and quite a lot of color film. It had been a long time since she had worked in a documentary mode, and she found it enjoyable. Her timing began to return. Sometimes she would catch the precise moment in which moving people and changing situations organized themselves into a picture that said exactly what she wanted to say. Occasionally she could hear the flat, midwestern twang of Roy Stryker in her ear, "Now Marion, why did you take that particular shot? How about a close-up of that? Get those field notes, Miss Post. Remember you've got to get all your captions written by the end of next week." Marion was glad to be working again. The color provided new challenges,

and her sense of humor reasserted itself.[24] Taken thirty-two years after she had last used the camera as a social documentarian, the Isla Vista series is astonishingly good. The series might have been continued had not the old urge to wander reasserted itself.

In 1974, on a trip into the Northwest, Marion and Lee saw Mendocino and fell in love with that area. Lee wanted to move and Marion was also enthusiastic. She could still see her grandchildren, and she was ready for a change. The Wolcotts sold their condominium in Santa Barbara, applying the money from that sale to the purchase of a beautiful old house overlooking the Pacific on the outskirts of Mendocino. It was a sprawling, loosely built place in the old California manner; Marion loved it dearly, except in the winter, when the cold drafts from the Pacific were impossible to exclude. On pretty days, she and Lee could sit in their breakfast room and drink their coffee while watching the whales swim slowly by on their stately migrations north and south with the seasons.[25] Except for the cold rains of winter, the five years that the Wolcotts spent at Mendocino were very good ones.

During the Mendocino years Marion began to reestablish her connection with photography in a serious way. Through Christmas cards and very occasional visits she had kept in touch with old friends such as the Lees, who were living in Austin, Texas, and Ben and Bernarda Shahn in New Jersey. Arthur and Grace Rothstein had kept in touch, and on one or two trips to the East Coast, Marion and Lee had enjoyed short visits with them, but all these contacts had been strictly social and very occasional. Now, however, national interest in photography as an art form, along with increased interest in the art and photography of the depression, were becoming almost irresistible forces. Sooner or later, Marion was bound to be drawn into the "thirties revival." For the time being, however, she was happy to concentrate her cameras on the physical beauties of the Mendocino area. For the first time in their married life, Marion had a darkroom. She had not printed her own pictures since her days at the *Philadelphia Bulletin*, and the emphasis there had been on speed, not quality. Now she and Lee began to learn to print. They read Ansel Adams's books; they enlisted the help of a local Mendocino commercial photographer; and they wasted a great deal of paper, but gradually the prints improved and both became competent technicians.[26]

In the spring of 1975 the late Lee Witkin, owner of the Witkin Gallery in New York and good friend to all who loved photography, learned that Marion was living in Mendocino. He was gathering material for an exhibition on the work of the Farm Security Admin-

Protest meeting, Grey Panthers and other groups. San Francisco, California, c. 1984.

istration, which was to be a major feature of the opening of his new gallery, and wrote to ask if he could come out for a visit. Marion and Lee agreed to see him. On his way up to Mendocino, he stopped in San Francisco to see some old friends. Having heard that Marion was shy, Witkin decided that his interview with her might be helped if he took along some people who were serious, working photographers and who also knew her work. He invited his hosts, Jack Welpott and Judy Dater, to come along. Both were familiar with the FSA photographs and eager to meet Marion Post Wolcott. Lee Witkin, Jack Welpott, and Judy Dater came to Mendocino. For all concerned it was a magical day. Marion was amazed and unabashedly

pleased at having been sought out. It had been a long time since she had talked seriously about photography to people of very high talent, and she found it wonderfully stimulating. Lee Wolcott enjoyed himself too and saw a side of his wife that he had seldom seen before. When Judy Dater predicted that Marion might well become a "cult figure," he was pleased and supportive. Marion was not sure that she wanted to be a "cult figure," whatever that meant, but she did enjoy the company. When the day was over, Lee Witkin left with some beautiful prints that Marion had carefully saved from the FSA years and managed to keep through all their travels, and Jack Welpott left with a new friend.[27] Since that meeting Welpott has played a major part in encouraging Marion to take a larger role in photography. He has loaned Marion and Lee the use of his excellent darkroom; he has encouraged her to take her own work seriously and helped her to find exhibition space. Marion considers Jack Welpott a mentor in her return to photography.[28]

The pace of her creative life began to pick up. The FSA exhibition at Lee Witkin's gallery opened in 1976 and was a tremendous success. People began to notice Marion's ability with subject matter and her sense of light and composition. There was also a feeling that the problems she had photographed in the late 1930s had not disappeared but had only changed. Some looked to the FSA file for insight into current national problems. Requests for prints began to pour in. A Library of Congress traveling exhibition entitled "Women Look at Women" presented her work along with that of Dorothea Lange and others. Her photographs were featured in exhibitions in Germany in 1976, in France in 1979, and in Australia in 1980.[29] They had also been appearing in books and collections for some time, but now the pace of that quickened. One of the first of the FSA revival books (so called to distinguish them from publications that were contemporaneous with the project) that featured a good selection of Marion's pictures was Thomas H. Garver's small but highly influential *Just Before The War* published in 1968. My own *Portrait of a Decade* featured several Wolcotts in 1972, as did Roy Stryker and Nancy Wood's *In this Proud Land* published the next year.[30] Since the mid-seventies, however, the number of books and magazine articles devoted to the FSA has proliferated as more and more researchers have discovered the great photography file in Washington.[31] As a result, Marion has found herself the subject of a great deal of attention, and she has had to learn to cope with all this new interest. In 1979 all the surviving FSA photographers were invited to a conference in Amarillo, Texas. Marion and Lee attended, and, although she was intensely uncomfortable, she participated fully,

talking in detail about her years with the agency and what she had tried to accomplish. It was great fun to see Russ and Jean Lee, John Collier, Jr., Arthur Rothstein, and Jack Delano.[32] Other conferences followed, and the contacts which had been so tenuous during the 1950s and 1960s were renewed and strengthened. At Daytona Beach, Florida, she was able to get together with "the group" in the summer of 1985.[33] It was the last such meeting, for Arthur Rothstein died within a few months, and Russell Lee died in 1986. For Marion, however, the recent years have brought her recognition. In 1985 she received the Dorothea Lange Award from the Oakland Museum and the following year the Distinguished Photographer Award from the Women Photographers of America, an honor given to women whose lives have made a difference in the field.[34] In 1986 she was the featured speaker at a conference, "Women in Photography: Making Connections," held at the University of Syracuse. She was given a one-woman show, and her keynote address was received with respect and pleasure. Marion could enjoy the satisfaction of knowing that her work had earned a permanent place in the canon of serious photography in America.

For Marion, however, the photograph has never been an end in itself. Recognition by the art world is gratifying, but the important thing about a photograph is what it can say about the world we live in. In her speech to the "Women in Photography" conference, Marion made it clear she still believes that the photographer has a responsibility to take a stand, to use the camera to clarify issues, and to uphold the cause of humanity. After addressing the problems of women in the arts and the difficulties inherent in trying to carry on a creative life while also meeting the demands of wifehood and motherhood, she moved on to what were for her larger and more important issues. "My principal concern," she said, "is to challenge photographers to document, in mixed media if they wish, or even just record, in still photographs as well as film and video, our present quality of life, the causes of malaise in our society—and the world—the evidences of it."

> World-wide and in this country, and in this dark, "zone I and II world," these are signs of our times. These issues will affect your lives, your work, and your careers.
> The rise of anti-semitism and fascism: the Ku Klux Klan is on the march again. In Pulaski, Tennessee recently the Klan marched and demonstrated in protest of the first national observance of Martin Luther King, Jr.'s birthday. It proclaimed "the Klan is the answer, the watchdog, the salvation of America."
> Other reactionism: the appointment of Rehnquist as Chief Justice

of the United States, efforts of the Reagan Administration to erode women's rights by actively supporting "right to life" groups, denying support for affirmative action, providing inadequate funding for cleanup of toxic wastes.

Increasing power of ultra-conservative groups in religion, spilling over into the political arena. The frightening influence of the Jerry Falwells, Jesse Helmses and TV evangelist Robertson, now considering a run for President.[35]

Marion's litany continued, including the erosion of first and fourth amendment rights, the attacks of censors on all types of art, joblessness, farm foreclosures, and the widening gap between rich and poor in this country. Finally, she emphasized the point that photographers could make a difference. Quoting Estelle Jussim's statement in *Observations*, she endorsed Jussim's words and made them her own.

Long-term goals undoubtedly require continuous exposure of social wrongs and a vocabulary of change that can provide the basis of a new ideology. In that struggle, photography has much to contribute—if the photographer can develop not only patience but an uncanny sense of timing for the influential image.[36]

The influential image is certainly a phrase that sums up much of what Marion Post Wolcott has aimed for in her career. It is also a phrase that explains much that is at the heart of the documentary tradition. Finally, Marion returned to women in photography and the arts in general, ending her speech with these words.

Women are tough, supportive, sensitive, intelligent, and creative. They are survivors. Women have come a long way, but not far enough. Ahead still are formidable hurdles. Speak with your images from your heart and soul. Give of yourselves. Trust your gut reactions. Suck out the juices—the essence of your life experiences. Get on with it. It may not be too late.[37]

In recent years the Wolcotts have returned to Santa Barbara where the climate suits them both better. As Marion has become aware that her work for the FSA constitutes a significant corpus, she has recognized a responsibility to allow serious students access to her, although she remains a very private person. She has cooperated in several studies of herself, a process that is agonizingly difficult for her, yet there have also been benefits. In the difficult process of talking about her life with various researchers, she has, to a degree, rediscovered herself.

In March 1986 I visited the Wolcotts in Santa Barbara. We were already thinking about a book, and both Marion and Lee were generous with their time and gave detailed and intimate interviews. Lee Wolcott, at eighty-one, is still, as Jack Welpott has described him, a "handsome devil," and Marion is still obviously in love with him. It is also clear that he is accustomed to making the decisions in the family and Marion is accustomed to deferring. Even so, as we talked, I could sense subtle changes in the relationship. Marion Post Wolcott, seasoned professional, was there, just below the surface, and now and then the spark would leap.

On the last morning of my visit we had been working hard, and Marion was tired and ready for a break when the doorbell rang. It was a young woman with a clipboard who was checking facts for the local telephone directory. She noted the street address to make sure it was correct. "Let's see," she said, "we have _____ East Pedregosa? Is that right"

Marion nodded.

"And that number is _____-_____?" She recited the phone number.

"That's right."

"And that's Mr. and Mrs. Lee Wolcott?"

Marion thought for a second and shot a sharp, humorous, knowing glance back at me.

"Maybe you'd better make that Lee and Marion Post Wolcott," she said.[38]

It was a small moment but an important one. Marion Post Wolcott now has her own name in the Santa Barbara telephone directory. It is a part of a much larger process of reestablishing her own identity. It is not a rebellion against Lee, whom she loves dearly, but an assertion of her own selfhood, an assertion that Lee has come to understand and approve in recent years.

"What a time you've had!" Roy Stryker wrote Marion after she had emerged from the mountains of eastern Kentucky. His phrase aptly describes a life of tremendous variety. From the small New Jersey town to the streets of New York; from Berlin to Vienna; from Philadelphia to Washington to a hundred towns and a thousand farms in the American South, New England, and the West; from the Catoctin Valley to New Mexico to Iran, Pakistan, Egypt, and India; from untried girl to seasoned professional to wife and mother to internationally recognized documentary photographer—what a time you've had.

Plates

Winter visitors picnic on running board of car on
beach. Sarasota, Florida, 1941.
LC-USF 34-56952-D

Spectators at horse races. Hialeah Park, Florida, 1939.
LC-USF 33-30473-M2

Sulky races. Shelbyville County Fair, Kentucky, 1940.
LC-USF 34-55137-D

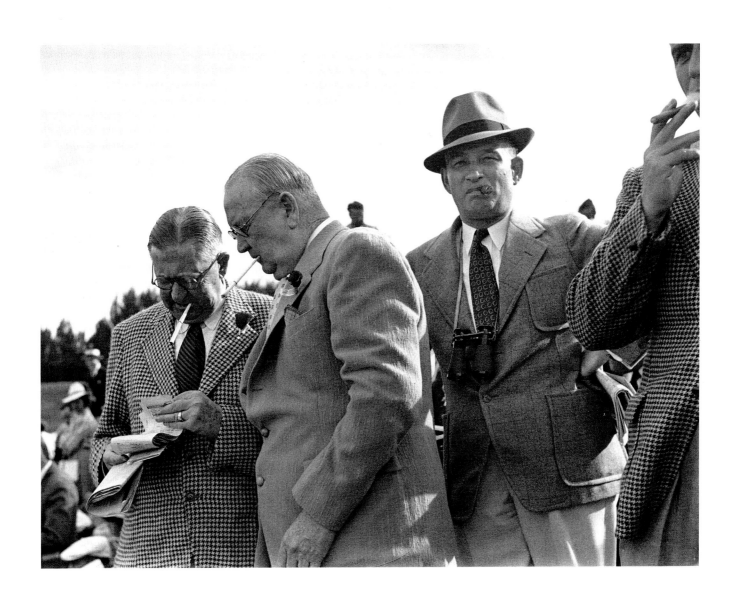

Men at horse races. Hialeah Park, Florida, 1939.
LC-USF 33-30469-M4

Mr. Whitley in his general store. He also owns a
bank, cotton exchange, and real estate. He was
the first man to settle in town; he cut down trees
and pulled out stumps for "main" street.
Wendell, North Carolina, 1940.
LC-USF 34-52710-D

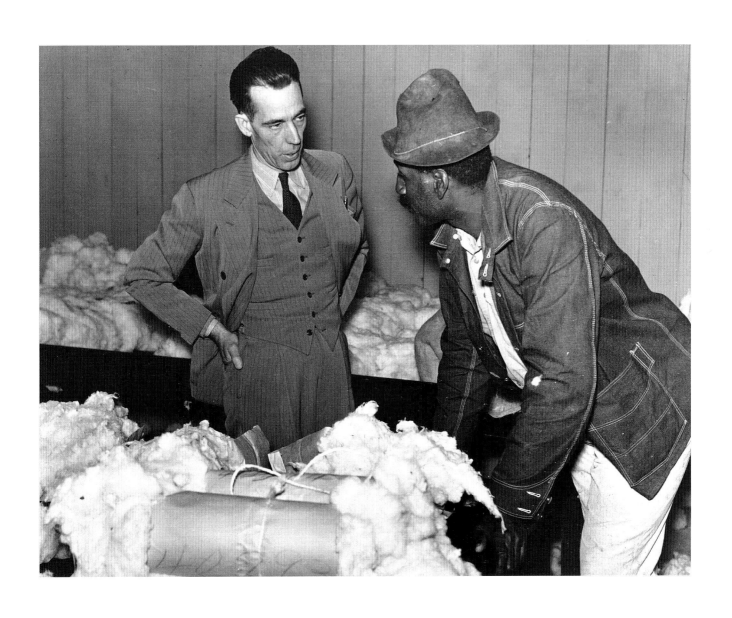

Tenant farmer brings his cotton sample to buyer/
broker to discuss price. Clarksdale, Mississippi, 1939.
LC-USF 34-52429-D

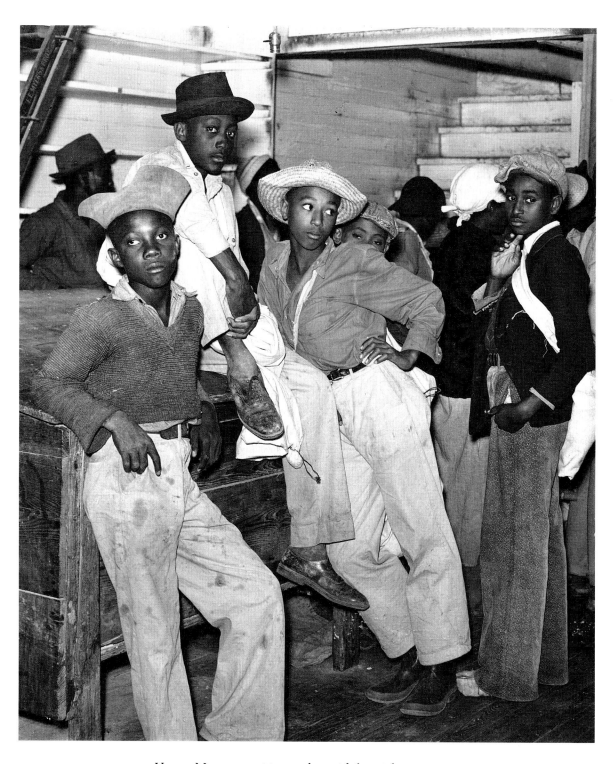

Young Negroes waiting to be paid for picking cotton, inside plantation store, Marcella Plantation. Mileston, Mississippi, 1939.
LC-USF 34-52250-D

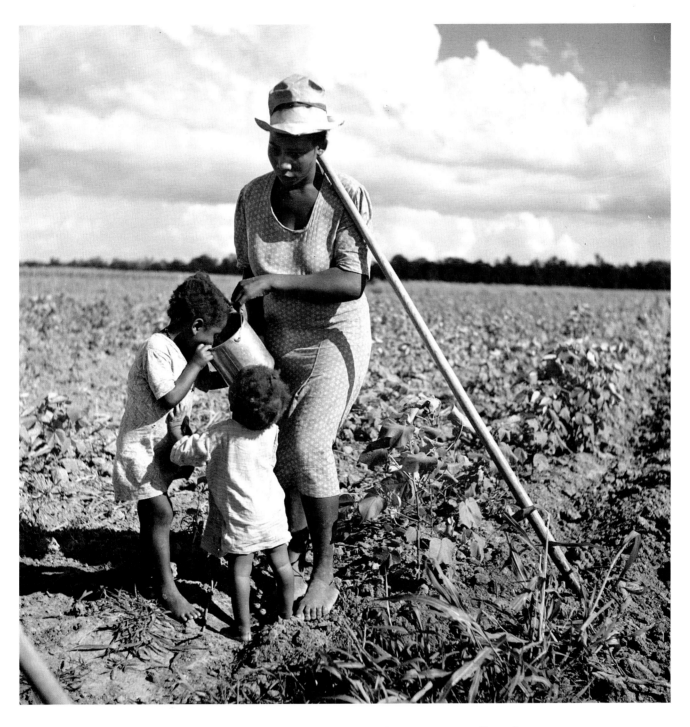

Taking a drink and resting from hoeing cotton, Allen Plantation,
an FSA project. Natchitoches, Louisiana, 1941.
LC-USF 34-54481-E

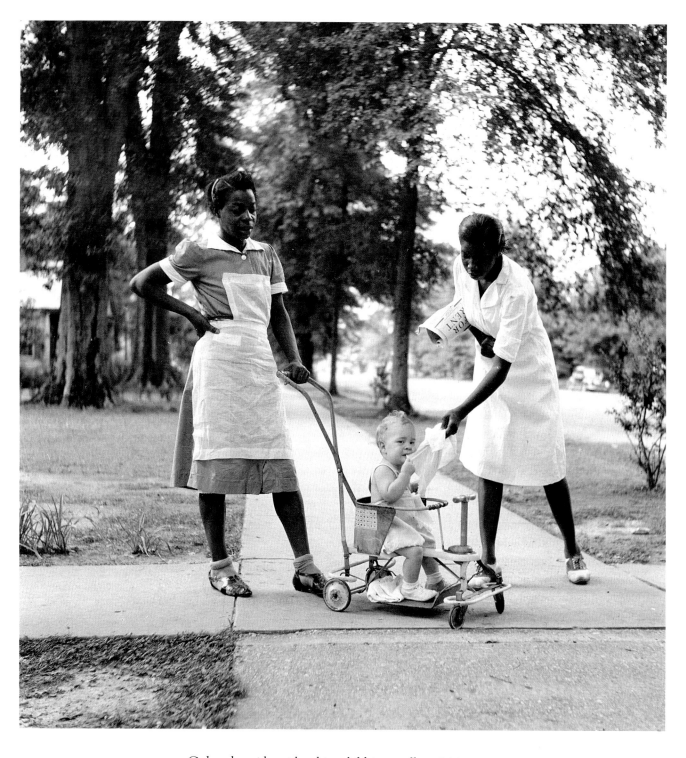

*Colored maids with white child in stroller visiting
together on street corner. Gibson, Mississippi, 1940.*
LC-USF 34-54985-E

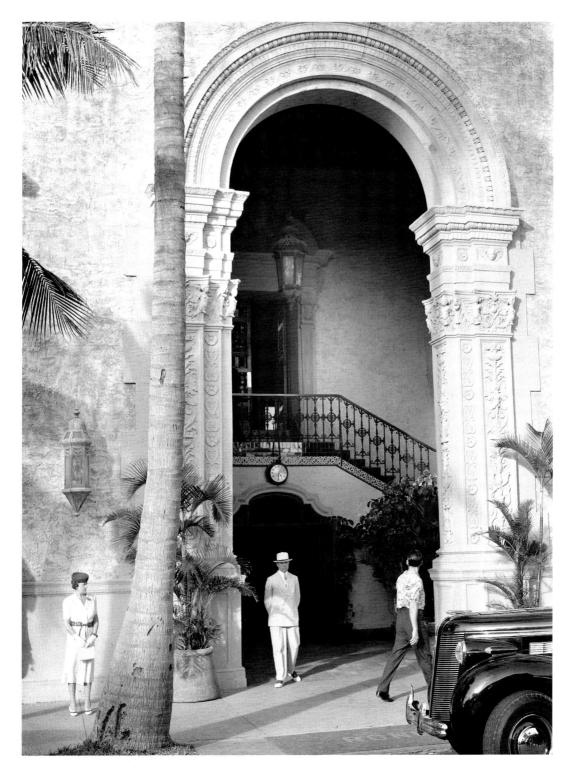

Entrance to Roney Plaza Hotel. Miami, Florida, 1939.
LC-USF 34-51215-D

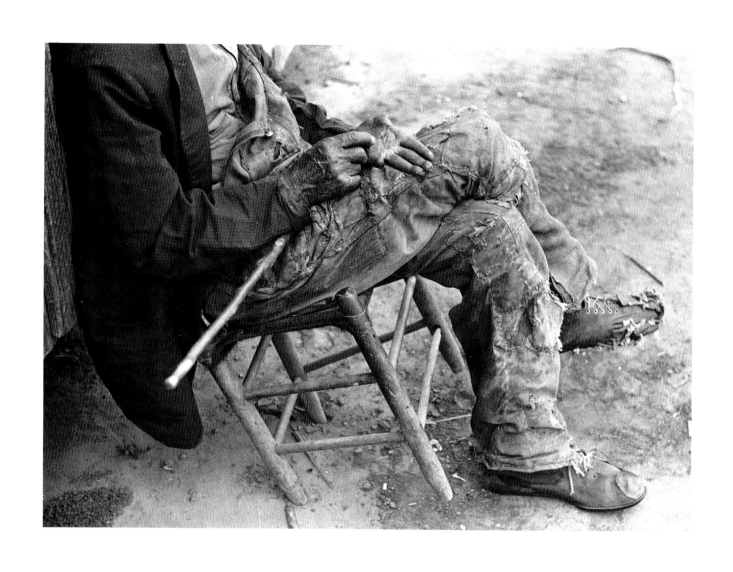

"The Whittler," an old Negro man (ex-slave).
Camden, Alabama, 1939.
LC-USF 33-30350-M4

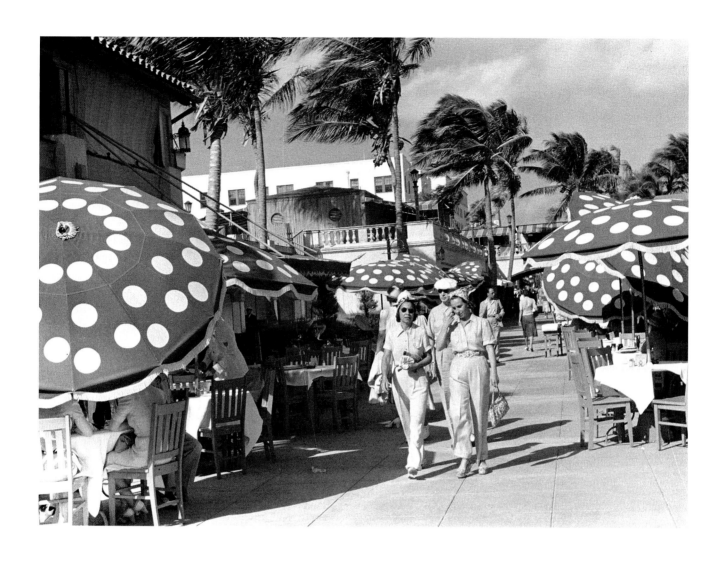

Typical scene, private beach club boardwalk.
Miami, Florida, 1939.
LC-USF 33-30438-M1

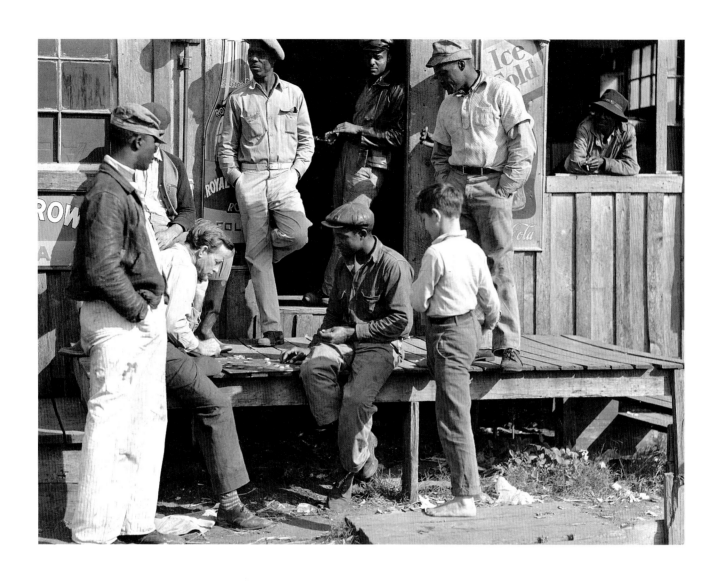

Migrants playing checkers (with bottle caps), on
a juke joint porch after a "freeze-out" of
vegetable crops. Near Okeechobee, Florida, 1939.
LC-USF 34-57106-D

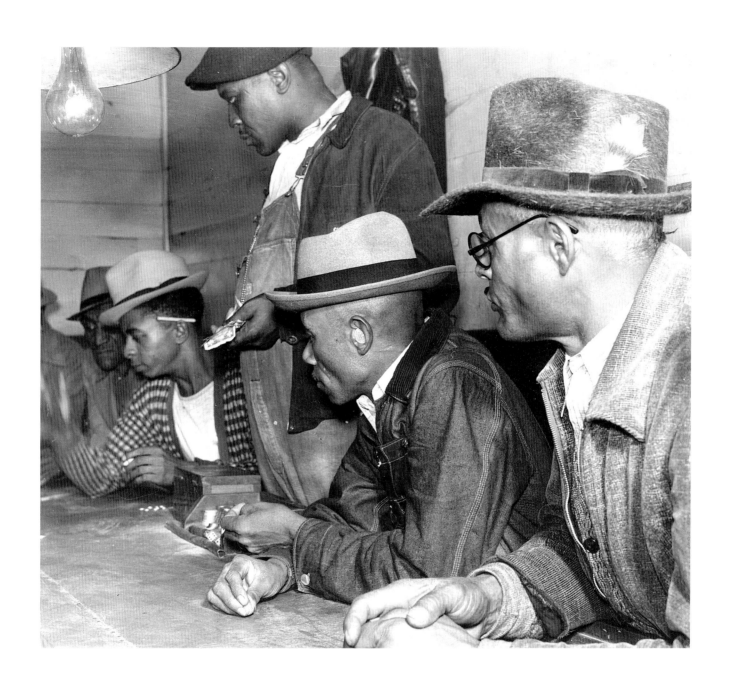

Gambling with their "cotton money" in back of a juke joint.
Clarksdale, Mississippi, 1939.
LC-USF 34-52487-D

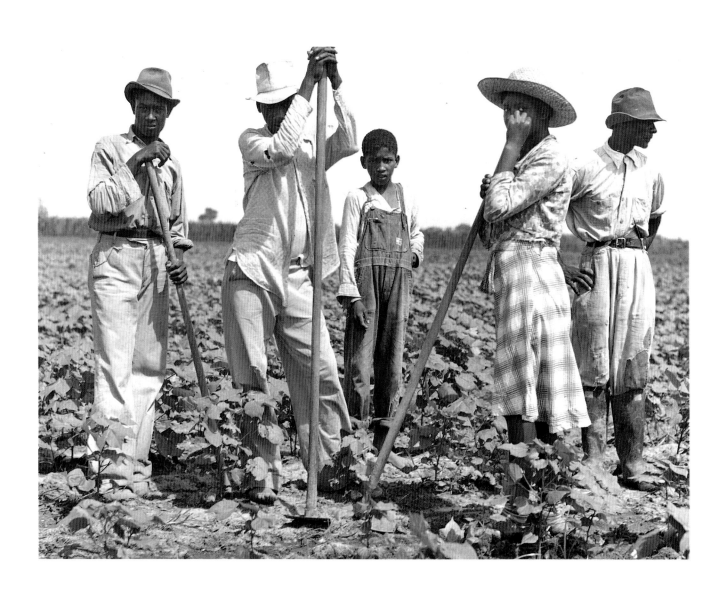

*Negro men and women working in a field, Bayou
Bourbeaux Plantation. Natchitoches, Louisiana, 1940.*
LC-USF 34-54416-D

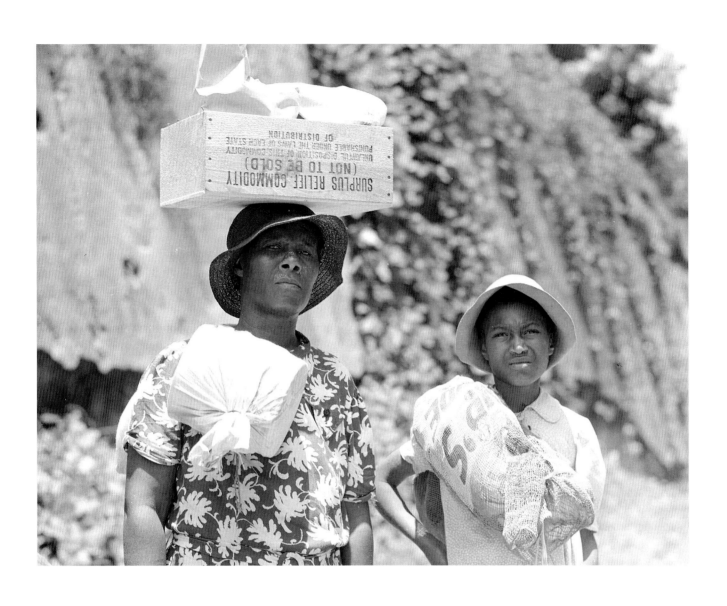

*Two Negro women carrying packages, one has a
box of surplus relief commodities on her head.
Natchez, Mississippi, 1940.*
LC-USF 34-54731-D

167

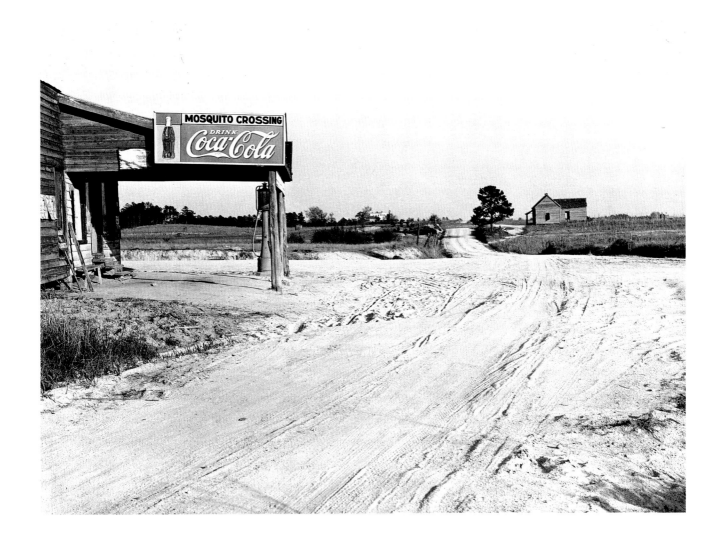

Mosquito Crossing. Near Greensboro, Georgia, 1939.
LC-USF 34-51279-D

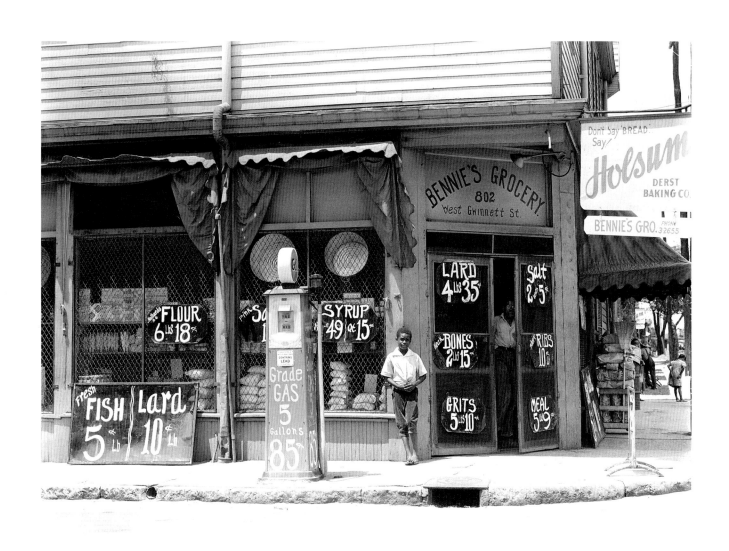

Bennie's grocery store. Sylvania, Georgia, 1939.
LC-USF 34-51905-D

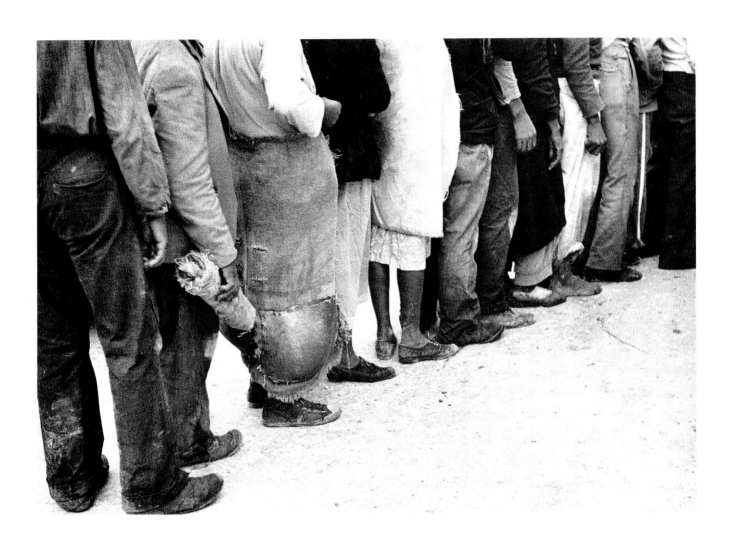

*Migrant agricultural workers waiting in line behind
truck in the field, for pay for day's work. Near
Belle Glade, Florida, 1939.*
LC-USF 33-30491-M5

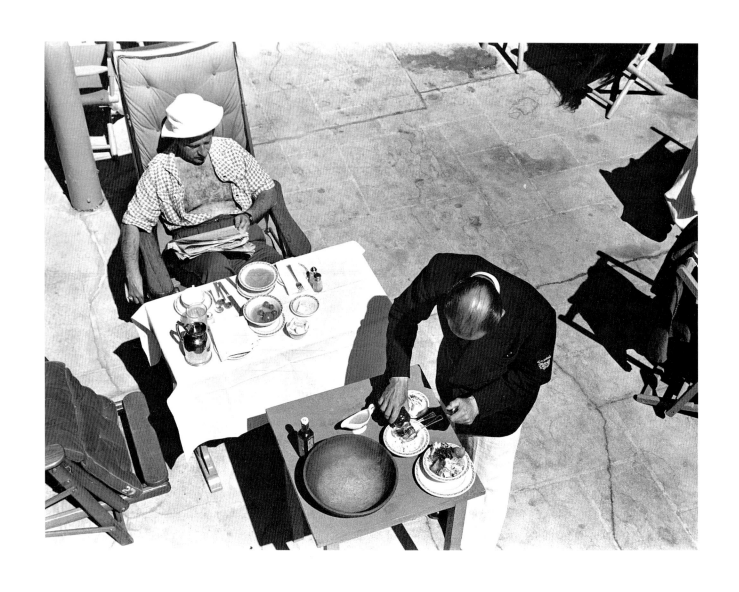

Winter visitor being served brunch in a private
beach club. Miami, Florida, 1939.
LC-USF 33-30493-M2

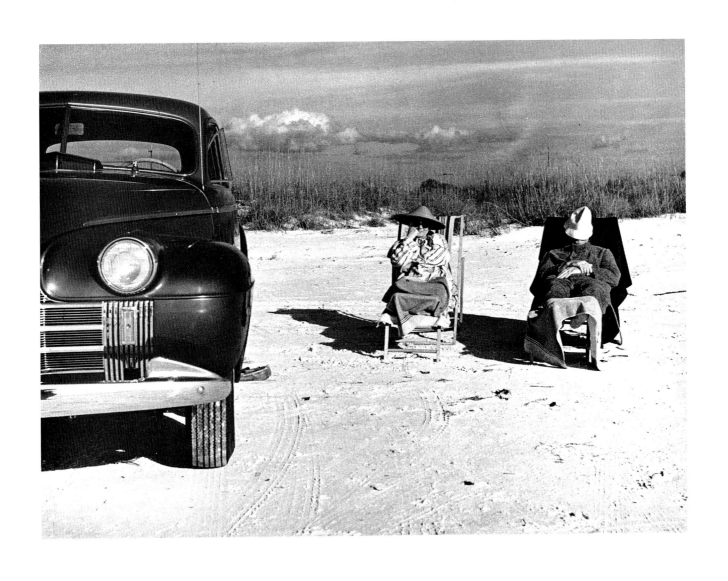

*Winter visitors relaxing on the beach beside their
car near a trailer park. Sarasota, Florida, 1939.*
LC-USF 34-56924-E

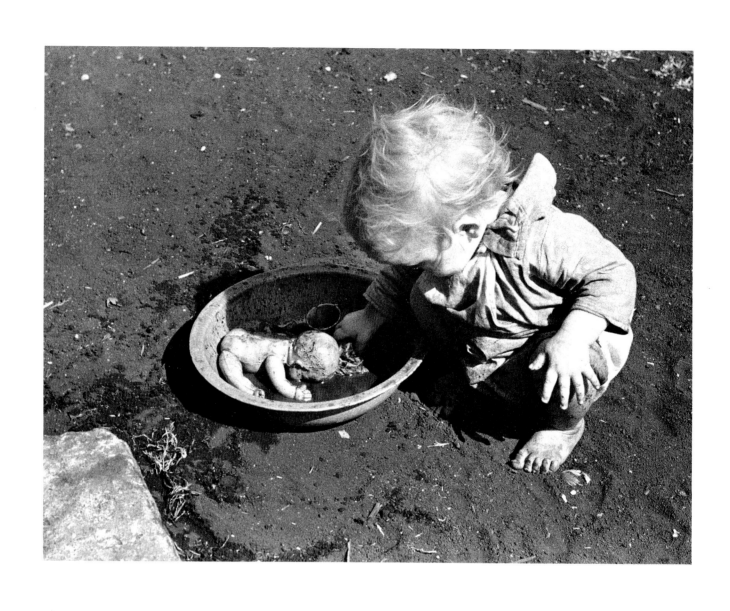

A child of migratory packing-house workers washing her doll. Belle Glade, Florida, 1939.
LC-USF 33-30480-M3

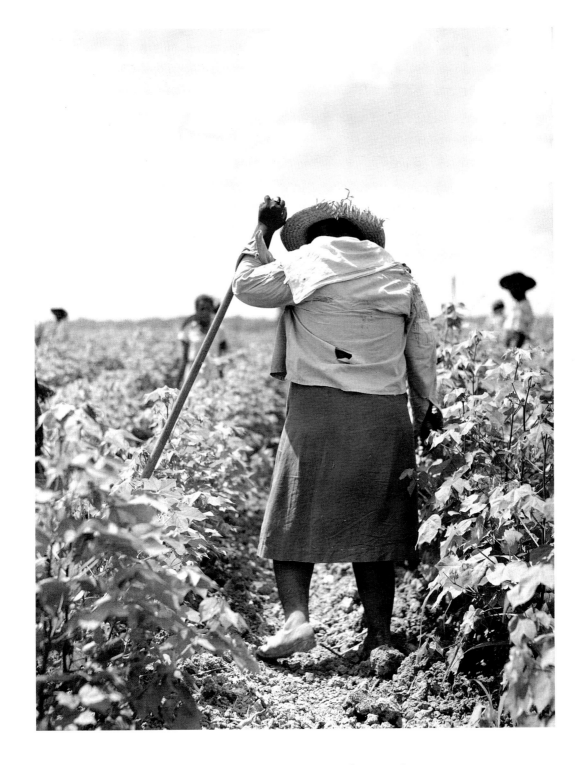

*A day laborer chopping cotton on the Knowlton
Plantation. Perthshire, Mississippi, 1940.*
LC-USF 34-55256-D

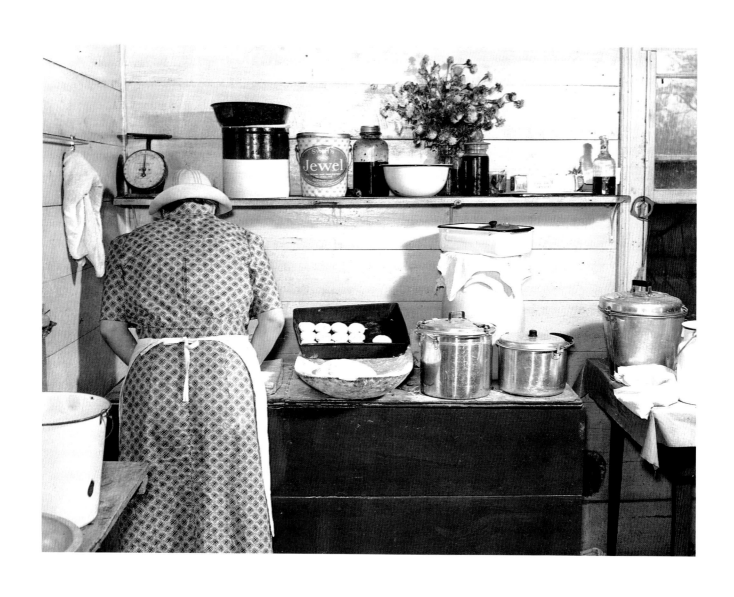

A member of the Wilkins family making biscuits for dinner on corn-shucking day at the home of Mrs. Fred Wilkins. Stem, North Carolina, 1939.
LC-USF 34-52728-D

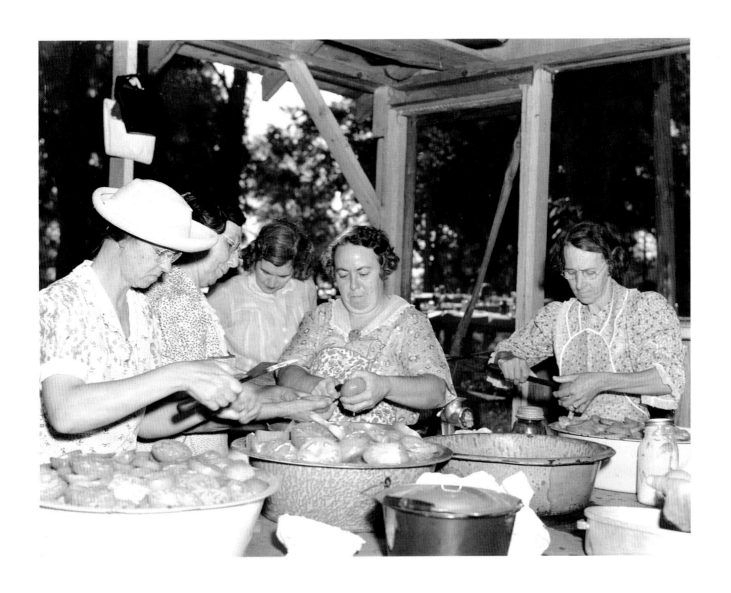

Parishioners peeling tomatoes for a church benefit supper. Bardstown, Kentucky, 1940.
LC-USF 34-55253-D

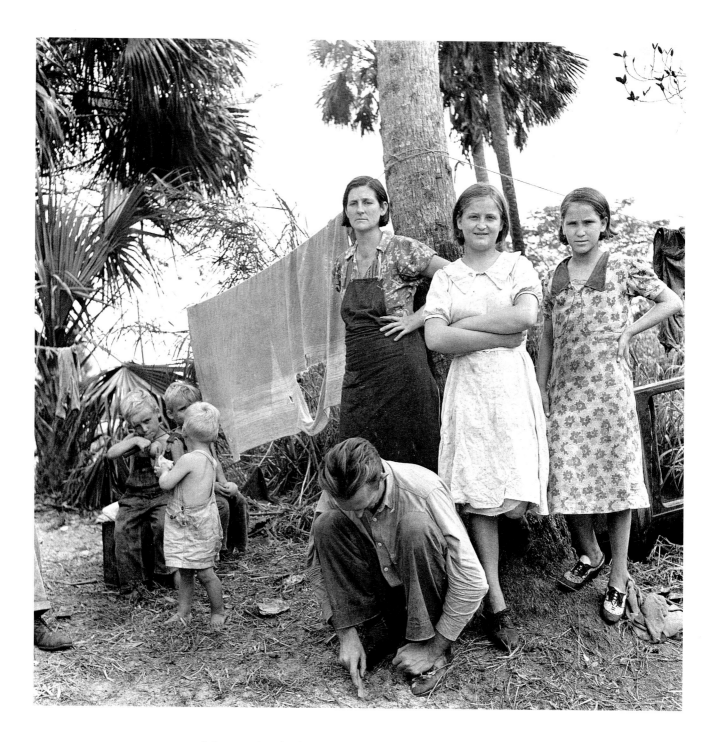

Migrant family from Missouri camping out in cane brush.
One woman said, "We ain't never lived like hogs before,
but we sure does now." Canal Point, Florida, 1939.
LC-USF 34-51185-E

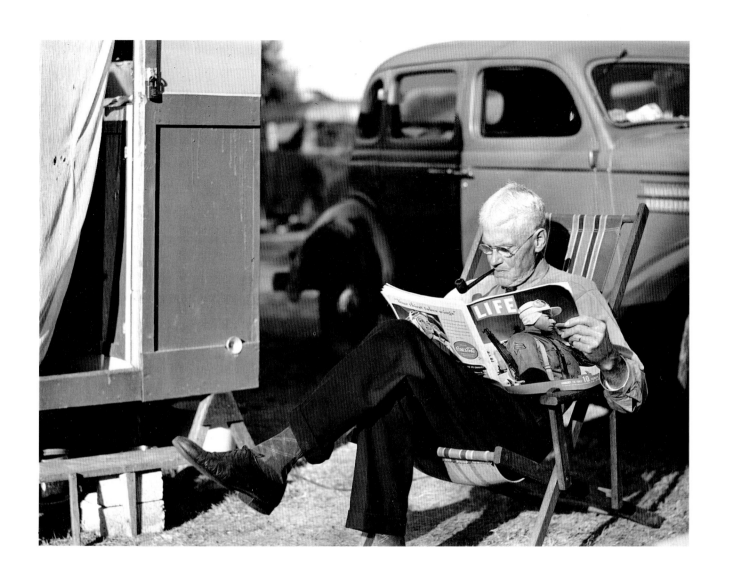

Man reading Life magazine in trailer park.
Sarasota, Florida, 1941.
LC-USF 34-57057-D

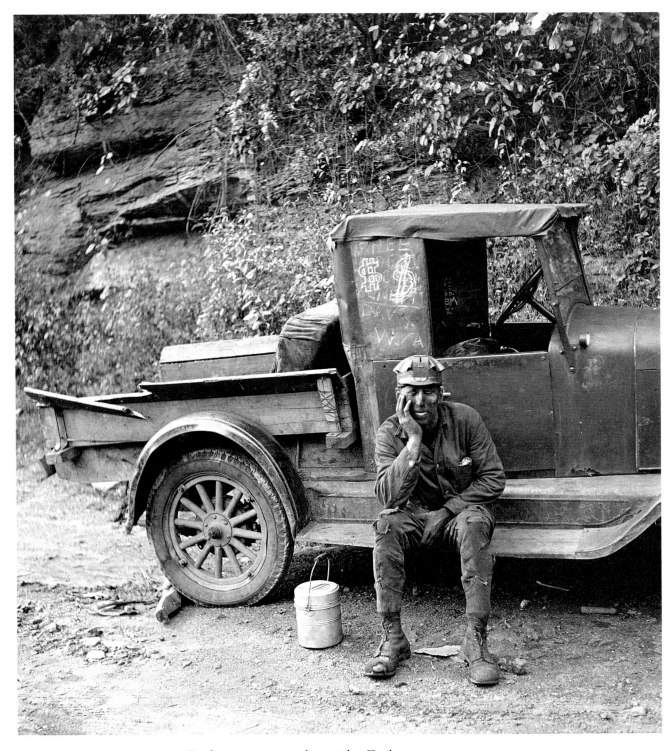

Coal miner waiting for a ride. Each pays twenty-
five cents a week to the owner of the car. Caples,
West Virginia, 1938.
LC-USF 34-50185-E

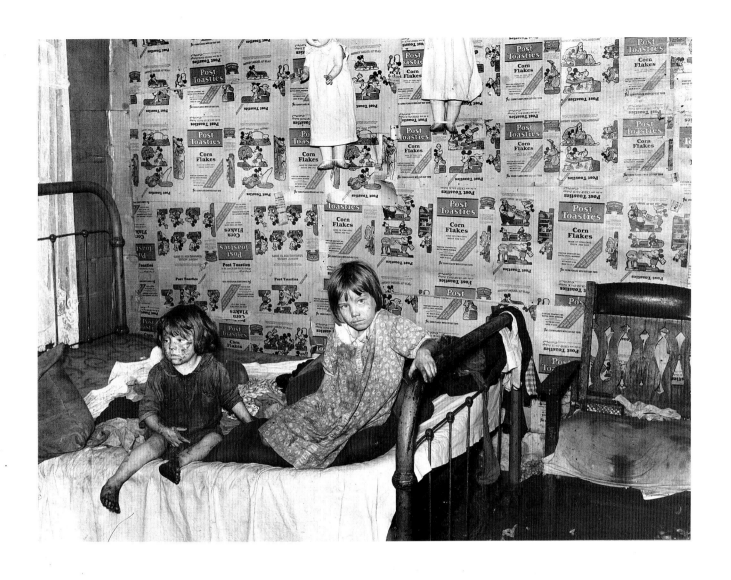

Coal miner's children. Charleston, West Virginia, 1938.
LC-USF 34-50119-D

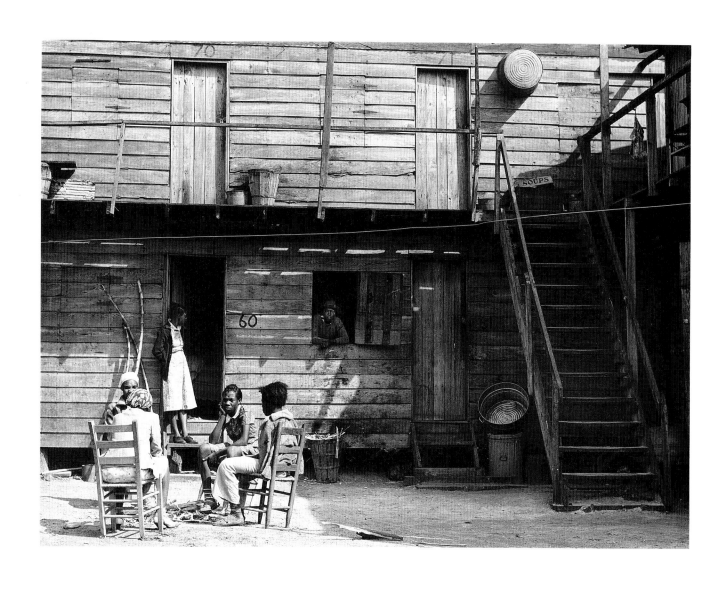

"Pahokee Hotel," migrant vegetable pickers'
quarters. Near Homestead, Florida, 1941.
LC-USF 34-57103-D

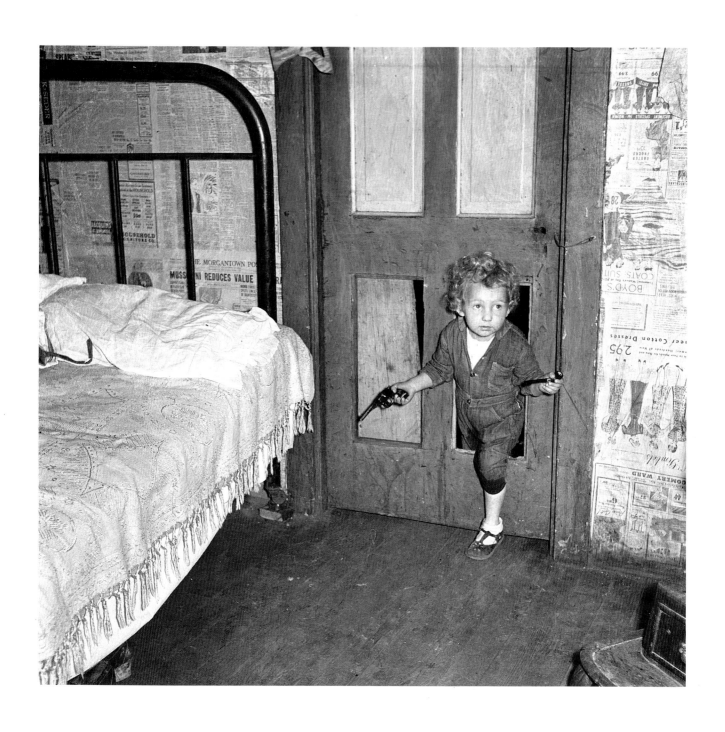

Coal miner's child using the "cathole." Bertha Hill,
Scott's Run, West Virginia, 1938.
LC-USF 34-50348-E

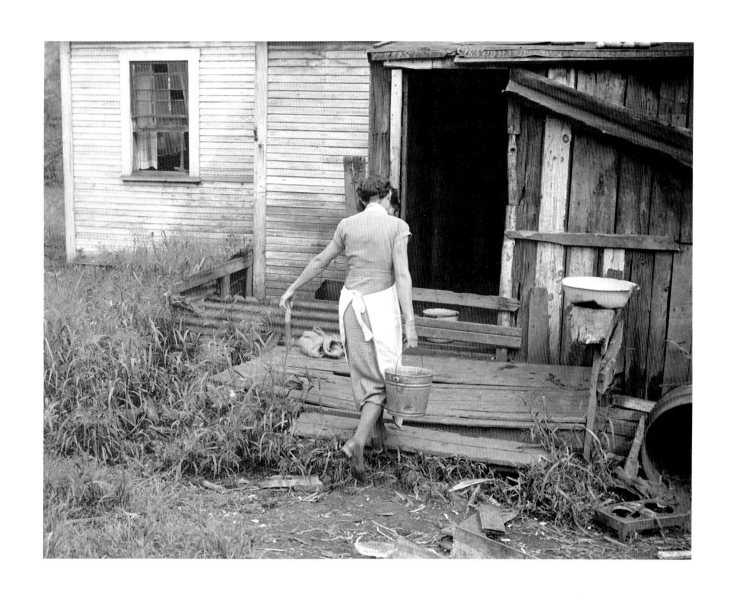

Coal miner's wife carrying water from the hill.
Bertha Hill, Scott's Run, West Virginia, 1938.
LC-USF 33-30237-M3

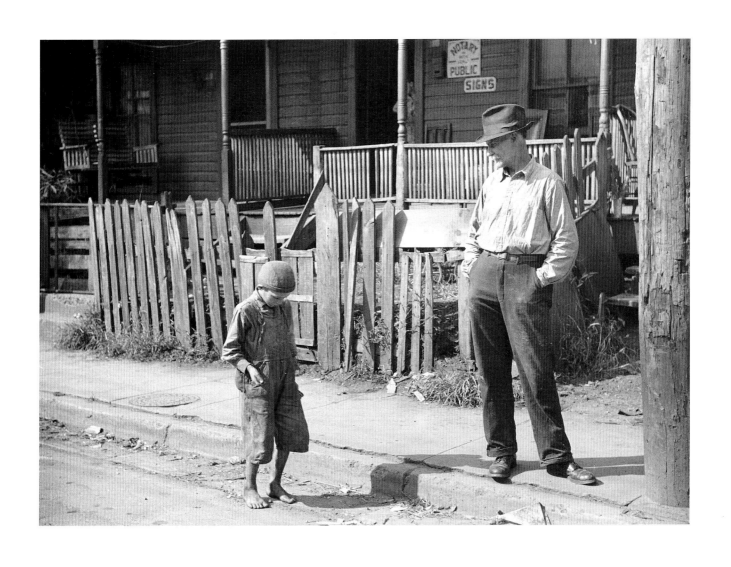

A street in Charleston, West Virginia, 1938.
LC-USF 33-30106-M4

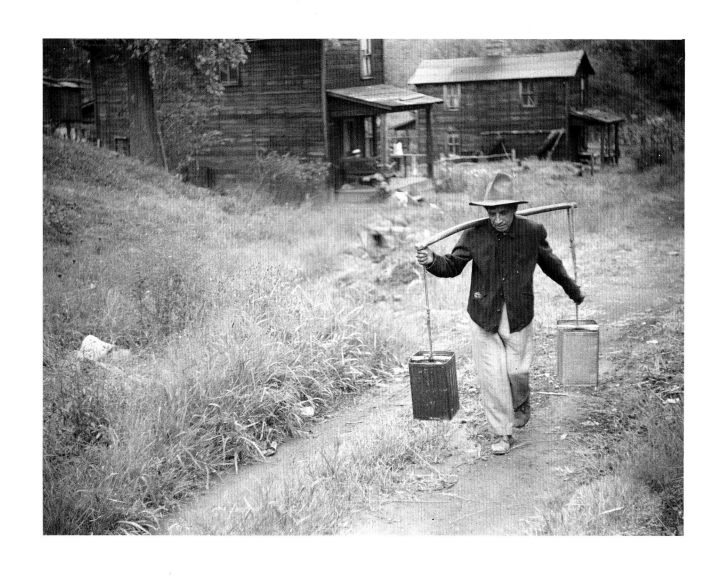

Mexican miner carrying water up a hill to his home, which is about two miles distant. Bertha Hill, Scott's Run, West Virginia, 1938.
LC-USF 33-30246-M2

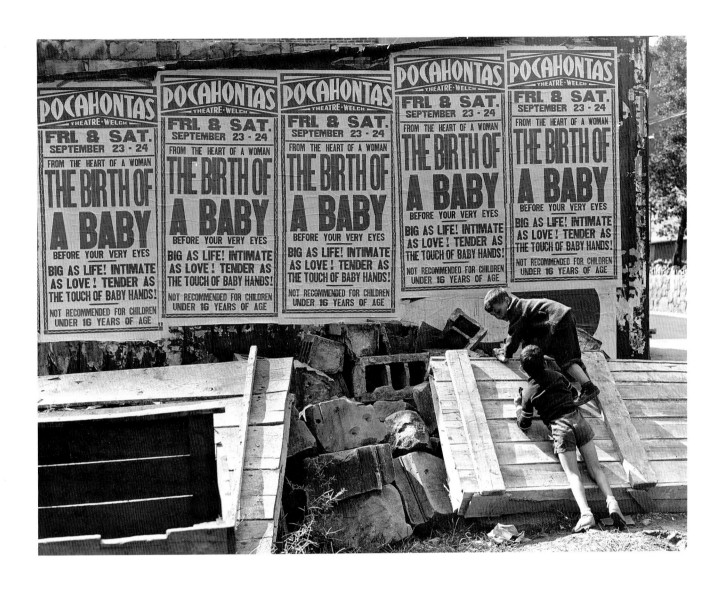

Movie advertisement on the side of a building,
"Birth of a Baby." Welch, West Virginia, 1938.
LC-USF 34-50084-D

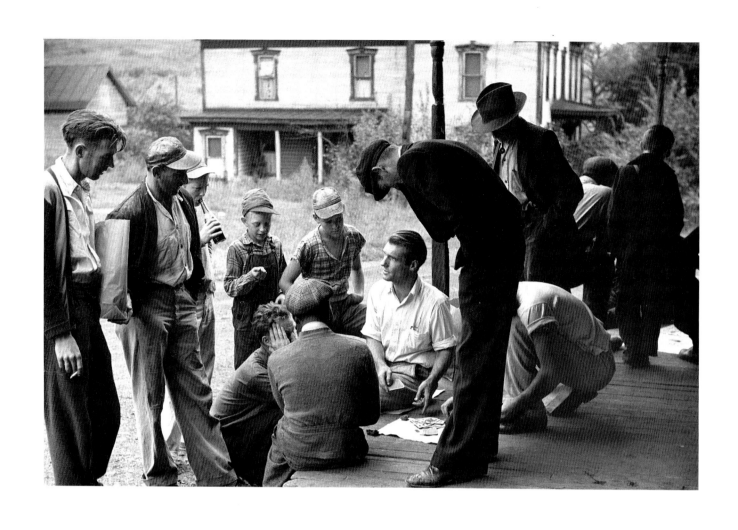

Coal miners' card game on the porch. Chaplin,
West Virginia, 1938.
LC-USF 33-30142-M4

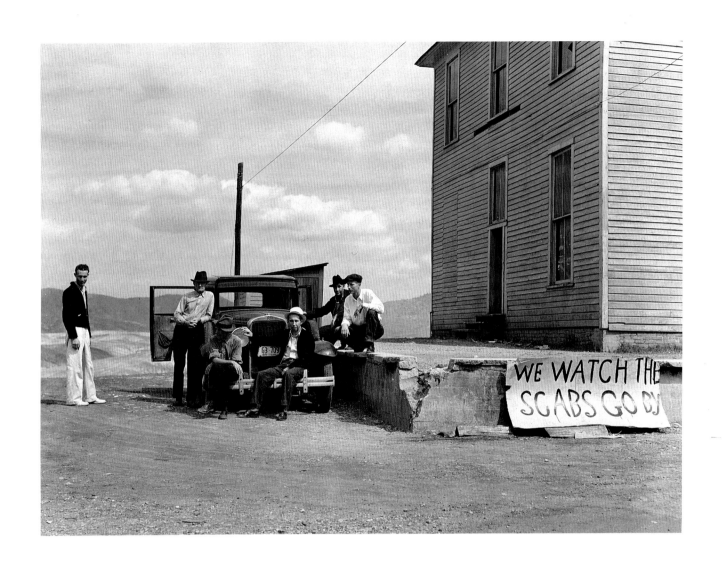

*Picketing copper miners on strike waiting for the
"scabs" (strike breakers) to come out of the mine.
Ducktown, Tennessee, 1939.*
LC-USF 34-52142-D

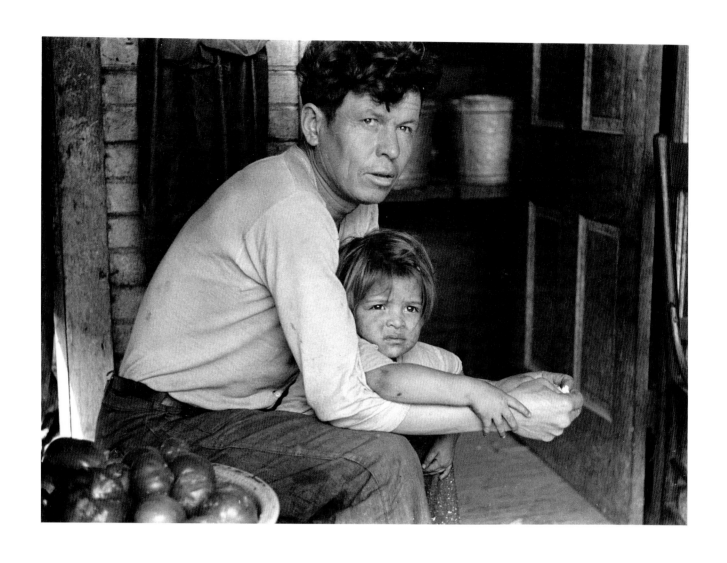

*Mexican miner and child. Bertha Hill, Scott's Run,
West Virginia, 1938.*
LC-USF 33-30196-M2

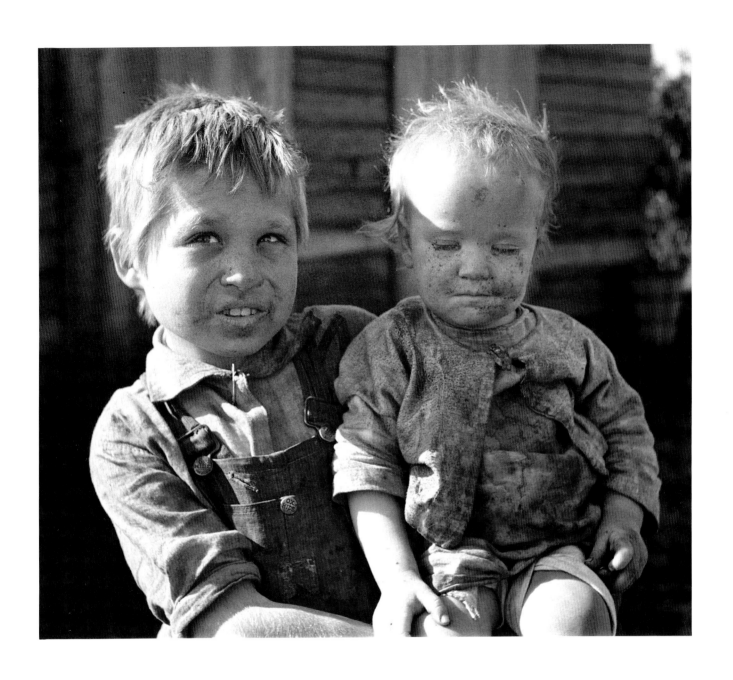

*Migrant vegetable picker's children. Baby's eyes are
sore from caustic soil. Near Belle Glade, Florida, 1939.*
LC-USF 34-51187-E

Barn and silos on rich farmland. Bucks County,
Pennsylvania, 1939.
LC-USF 34-51995-D

*Board and split rail fences around fields of shocked
corn. Near Marion, Virginia, 1940.*
LC-USF 34-56105-D

Farmers sleeping in a "white" camp room in a warehouse.
They often must remain several days before their
tobacco is sold. Durham, North Carolina, 1939.
LC-USF 34-52785-D

Pie and box supper, benefit for Quicksand School.
Near Jackson, Kentucky, 1940.
LC-USF 34-55786-D

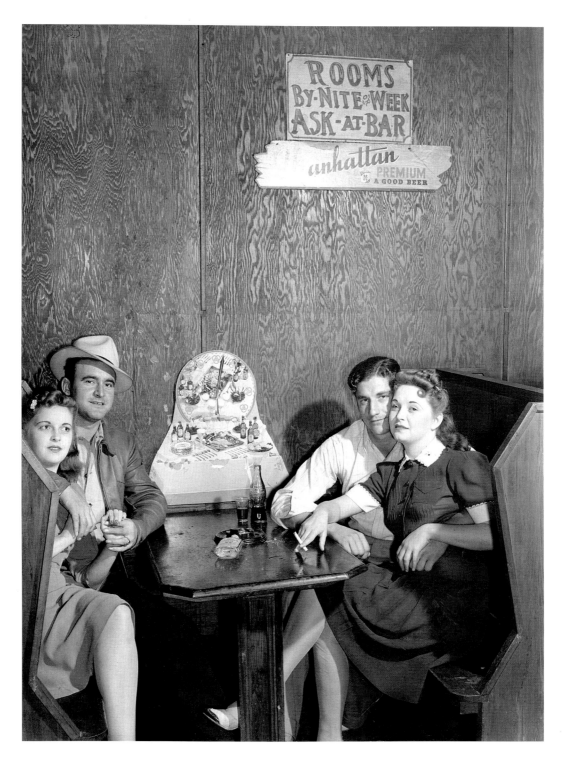

*Two couples in a booth in a juke joint. Near
Moorehaven, Florida, 1939.*
LC-USF 34-57094-D

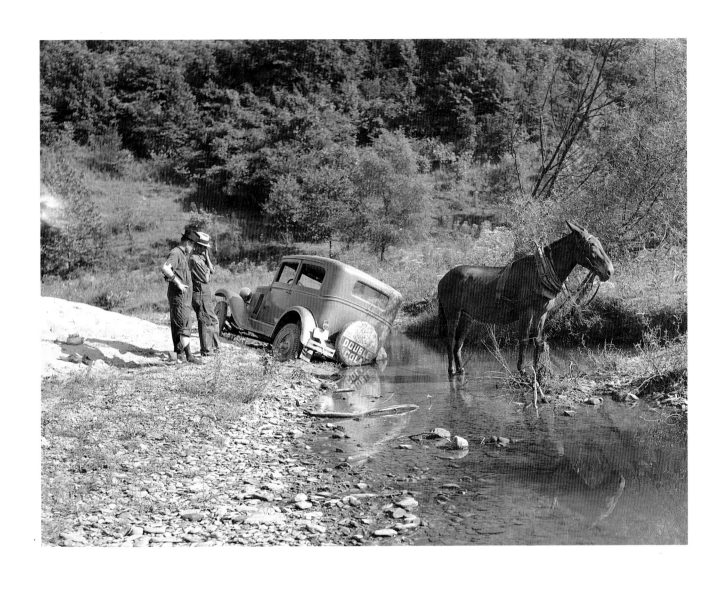

*On assignment in a borrowed car and stuck in a
creek bed road. Breathitt County, Kentucky, 1940.*
LC-USF 34-55773-D

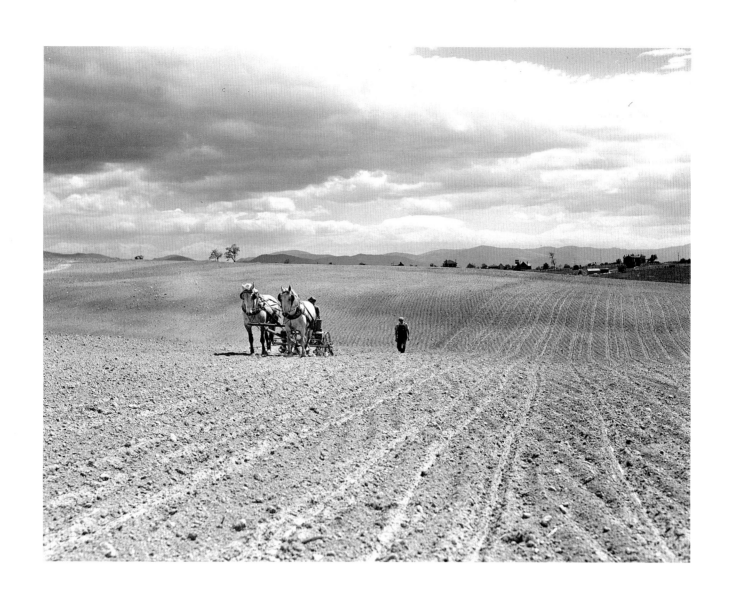

*Planting corn before the storm in the fertile
Shenandoah Valley. Near Luray, Virginia, 1941.*
LC-USF 34-57514-D

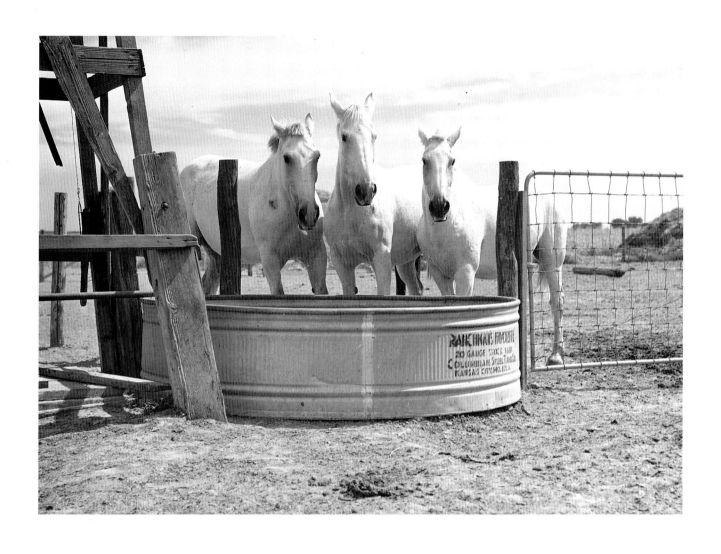

Work horses on a Farm Security Administration project. Scott's Bluff, Nebraska, 1941.
LC-USF 34-59209-D

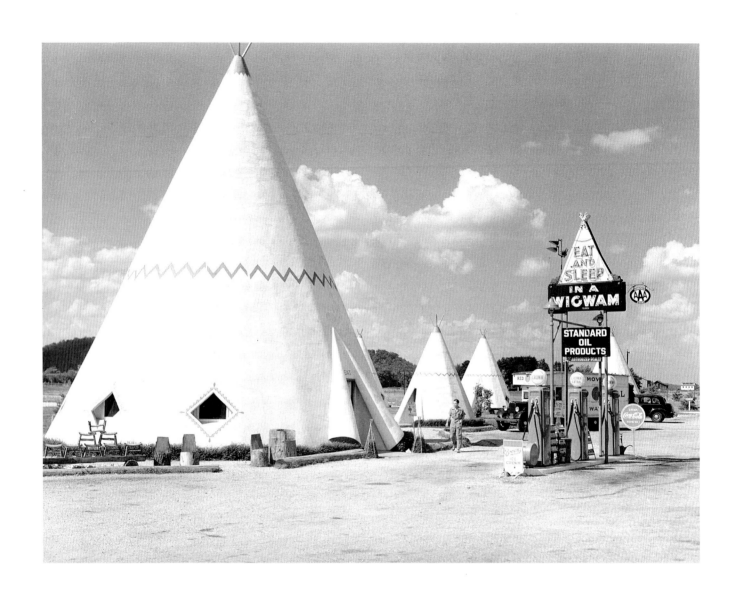

Wigwam Motel. Bardstown, Kentucky, 1940.
LC-USF 34-55240-D

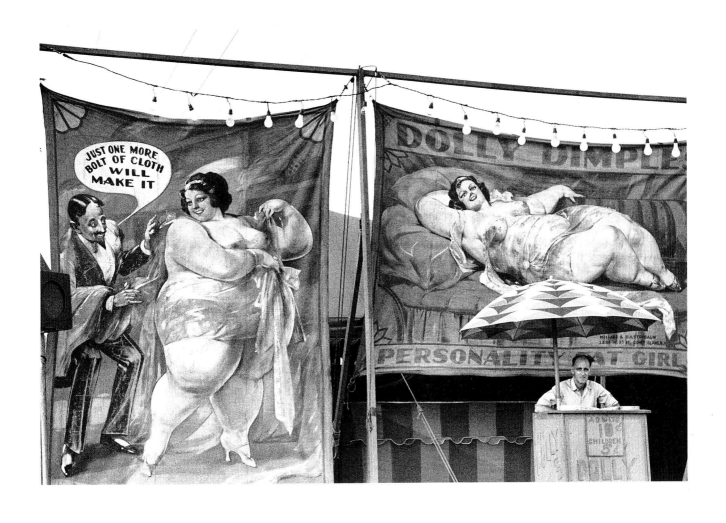

Carnival signs, Strawberry Festival. Plant City, Florida, 1939.
LC-USF 33-30477-M4

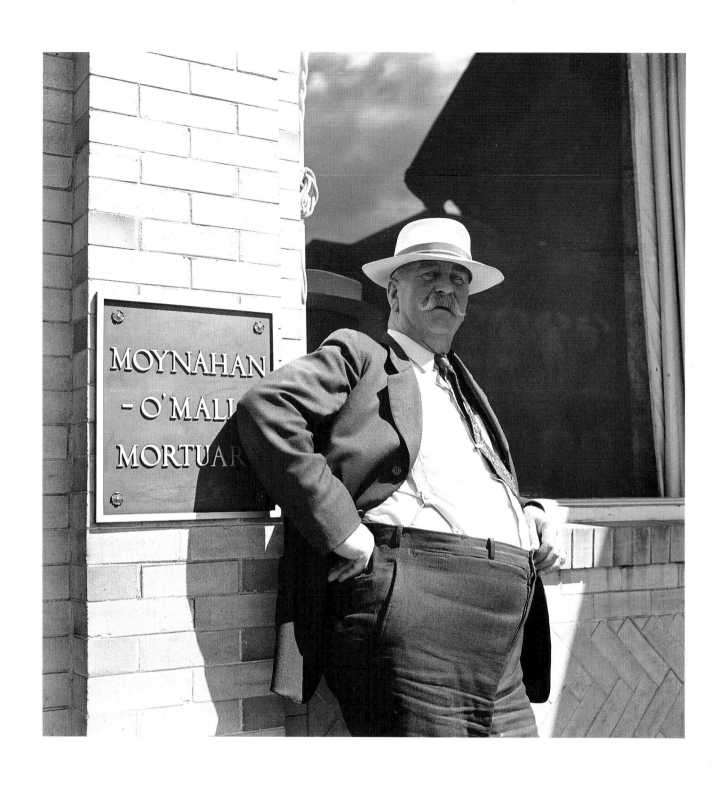

County judge on the main street, Leadville, Colorado, 1941.
LC-USF 34-58965-E

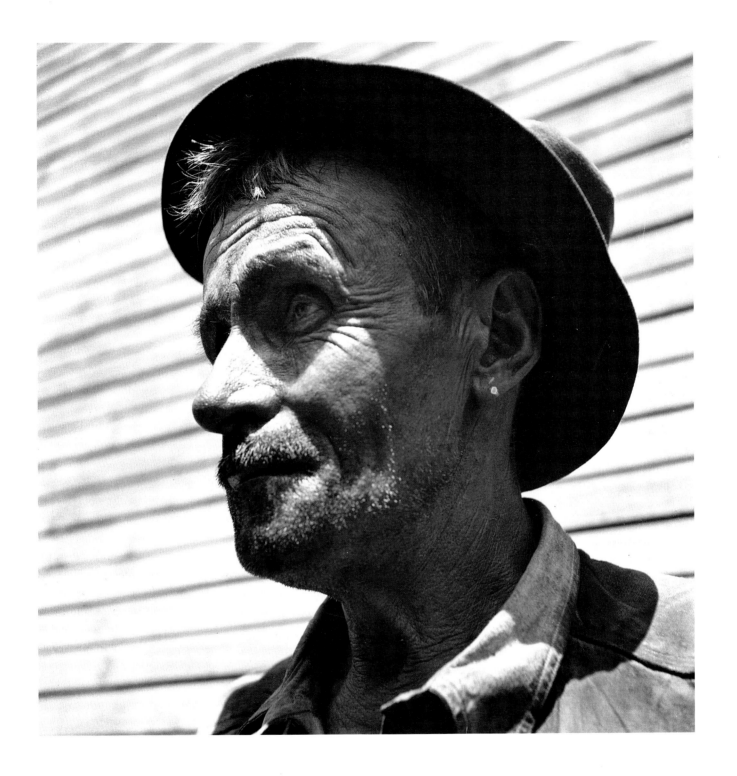

Steel worker. Pittsburgh, Pennsylvania, 1935.

Dudes watching rodeo, Crow Agency fair.
Montana, 1941.
LC-USF 34-58898-E

Mulatto worker on John Henry cotton plantation.
He was talented in crafts and weaving.
Natchitoches, Louisiana, 1939.
LC-USF 34-54276-D

Man playing guitar with his two children on porch.
Natchitoches, Louisiana, 1940.
LC-USF 34-54368-D

Daughter of a Cajun family returning home after fishing in Cane River. Melrose, Louisiana, 1940.
LC-USF 34-54625-D

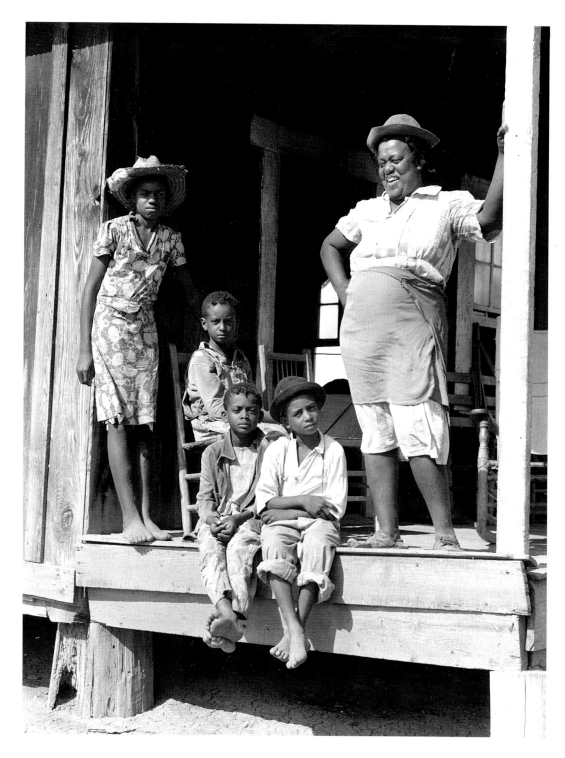

A Negro family on the porch of their home.
Natchitoches, Louisiana, 1940.
LC-USF 34-54405-D

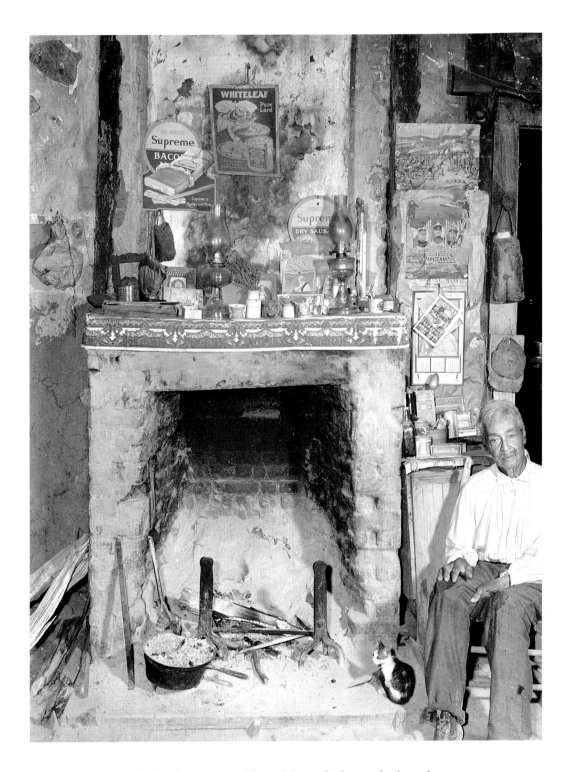

A fireplace in an old mud hut which was built and
is still lived in by a French-mulatto family, near the
John Henry plantation. Melrose, Louisiana, 1940.
LC-USF 34-54654-D

Proprietor of a poolhall playing cards. Woodstock, Vermont, 1939.
LC-USF 34-53121-D

After a blizzard, center of town. Woodstock, Vermont, 1940.
LC-USF 34-53307-D

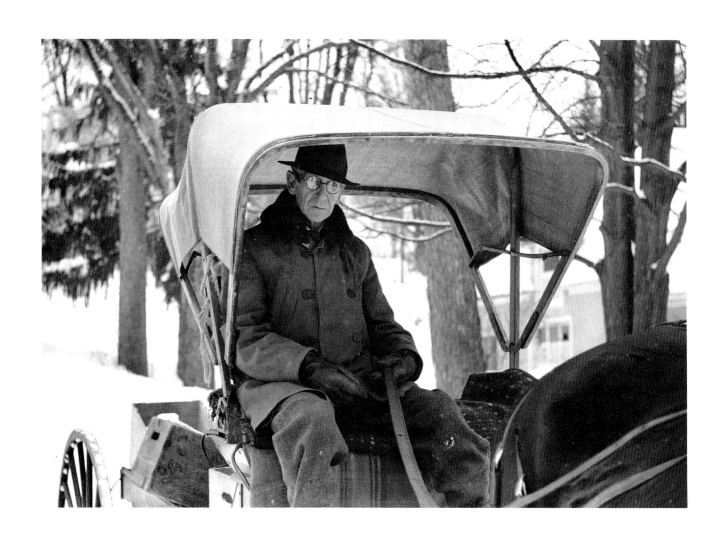

*Peddler who goes from door to door, selling hardware
and groceries. Woodstock, Vermont, 1940.*
LC-USF 33-30839-M4

Farmhouse and attached shed in snow.
Putney, Vermont, 1939.
LC-USF 34-53059-D

Sunset Village, a Farm Security Administration
project for defense workers. Radford, Virginia, 1941
LC-USF 34-91091-D

*Boy Scouts inspecting and learning about army
equipment. Washington, D.C., 1941.*
LC-USF 34-57739-D

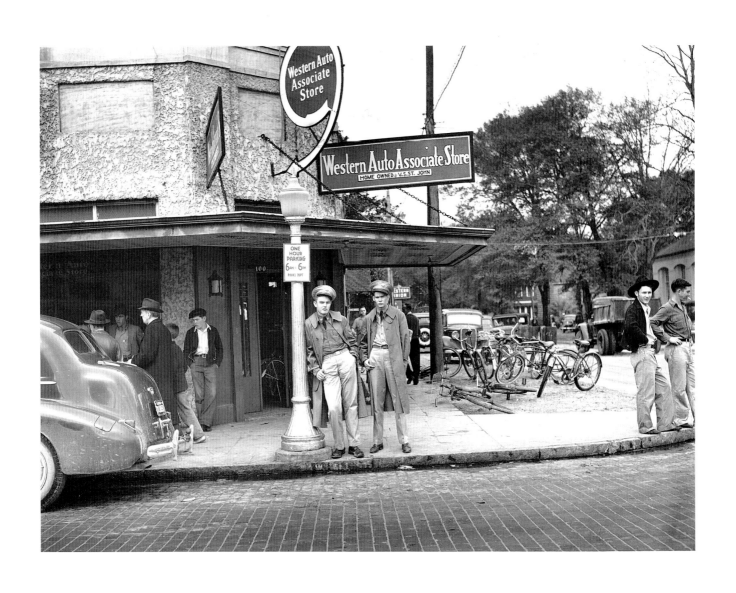

Soldiers on a street corner. Starke, Florida, 1940.
LC-USF 34-56720-D

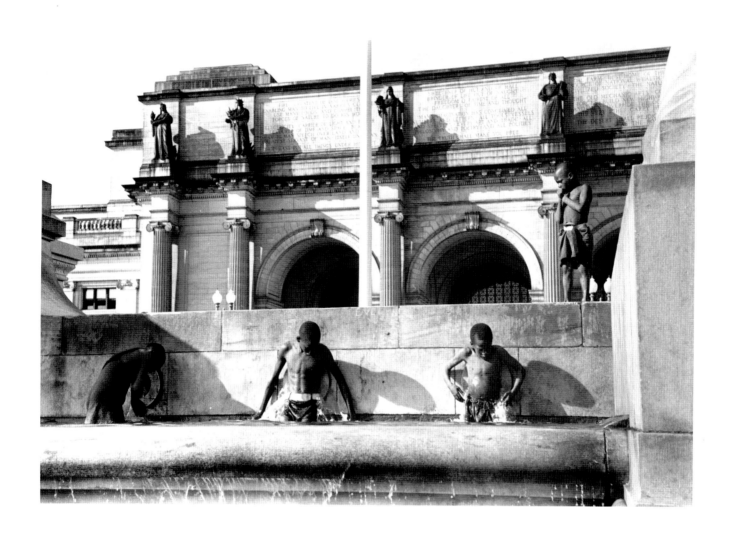

Swimming in the fountain across from Union Station. Washington, D.C., 1938.
LC-USF 33-30043-M5

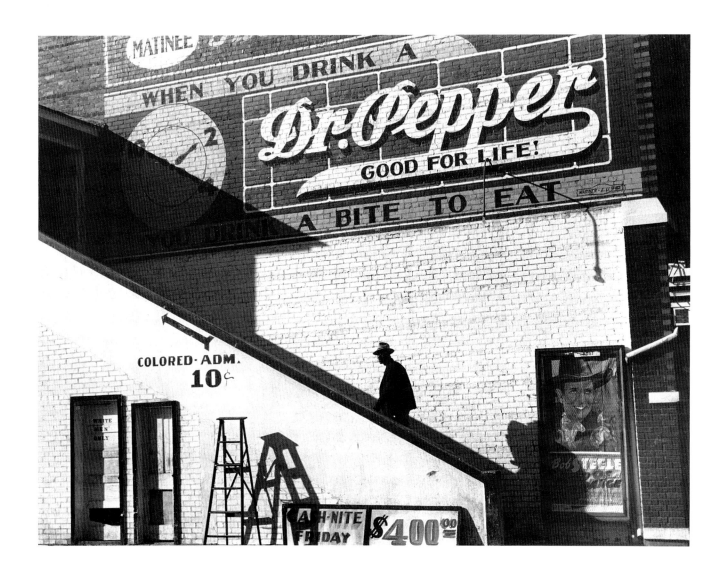

*Negro using outside stairway for "colored" to enter
movie theatre. Belzoni, Mississippi, 1939.*
LC-USF 33-30577-M2

Satterfield tobacco warehouse, Liberty Cafe.
Durham, North Carolina, 1939.
LC-USF 34-52415-D

NOTES

INTRODUCTION

1. F. Jack Hurley, *Portrait of a Decade: Roy Stryker and the Development of Documentary Photography in the Thirties* (Baton Rouge: Louisiana State University Press, 1972), p. 110.

CHAPTER ONE

1. Interview, Marion Post Wolcott with F. Jack Hurley, March 15, 1985, at Santa Barbara, California. Untranscribed, in possession of the author. Hereafter cited as Wolcott/Hurley Interviews, Series I. Reel 1.

2. Peter Modley, "Biography of Helen Post," in *Photo Metro*, a monthly journal of photography published in San Francisco, February 1986, pp. 20–21.

3. Wolcott/Hurley Interviews, Series I, Reel 4.

4. Marion Post Wolcott, "Keynote Address," Women in Photography Conference, Syracuse, N.Y., October 10–12, 1986. Enlarging on this point, Marion noted, "I am certain that Reasie's loving care and devotion to me—thru my 19th year—and her talks re. her life and the lives of black people in the South was one of the most important influences of my life. It explains my ability to understand, communicate with, and *photograph* them for the F.S.A." Notes in possession of the author.

5. Wolcott/Hurley Interviews, Series I, Reel 1. Additional details of the breakup of her parents and Marion's relations with her mother were provided in a second series of interviews conducted at Santa Barbara, California, November 15 and 16, 1986, hereafter cited as Wolcott/Hurley Interview, Series II. Reel 1.

6. Modley, *op. cit.*

7. Wolcott/Hurley Interviews, Series I, Reel 1.

8. *Ibid.*

9. Paul Raedeke, "Interview With Marion Post Wolcott," *Photo-Metro*, February 1986, p. 3.

10. Wolcott/Hurley Interview, Series I, Reel 1. See also Julie M. Boddy, "The Farm Security Administration Photographs of Marion Post Wolcott: A Cultural History," Ph.D. dissertation, State University of New York at Buffalo, 1982, pp. 83–85.

11. Wolcott/Hurley Interview, Series I, Reel 1.

12. *Ibid.*

13. *Ibid.*

14. Boddy, p.85.

15. Wolcott/Hurley Interview, Series I, Reel 2.

16. *Ibid.*

17. *Ibid.*

18. *Ibid.*

19. *Ibid.* For years the worker's councils of Vienna and its suburbs had provided a center for socialist activities. In Floridsdorf, a worker's village on the outskirts of the city, workers attempted to make an armed stand against further encroachments of Naziism. The government brought in artillery and shelled the area, reducing two famous major buildings providing housing for workers, the Marxhof and the Goethehof, to rubble. See Boddy, pp. 133–35.

20. *Ibid.*

21. *Ibid.*

22. Modley, p. 21.

23. Raedeke, p. 4.

24. Wolcott/Hurley Interviews, Series I, Reel 2. See also Boddy, p. 153.

25. Wolcott/Hurley Interviews, Series I, Reel 2.

26. Raedeke, p. 4.

27. Wolcott/Hurley Interviews, Series I, Reel 2.

28. Modley, p. 29. Helen Post's fine collection of photographs of American Indians has been given to the Amon Carter Museum in Fort Worth, Texas.

29. *Ibid.* p. 5.

30. *Ibid.*

31. *Roy Stryker Papers, 1912– 1972*, edited by David Horvath for the University of Louisville Photographic Archives. Microfilm Edition published by Chadwick-Healey, Alexandria, Va. Reel 1.

CHAPTER TWO

1. Jonathan Green, *American Photography: A Critical History from*

1945 to the Present (New York: Harry N. Abrams, 1985), p. 42.

2. In addition to the study mentioned above, see Charles Alan Watkins, "The Blurred Image: Documentary Photography and the Depression South," Ph.D. dissertation, University of Delaware, 1982.

3. Paul V. Maris, "Farm Tenancy," Yearbook of Agriculture, 1940 (Washington, D.C.: U.S. Government Printing Office, 1940), p. 889.

4. By far the best discussion of all these problems is to be found in Sidney Baldwin's Poverty and Politics: The Rise and Decline of the Farm Security Administration (Chapel Hill: University of North Carolina Press, 1968).

5. Ibid.

6. Stryker to D. Harry Carmen, October 11, 1935. Stryker Papers, Reel 1.

7. Matthew Baigell, The American Scene: American Painting of the 1930s (New York: Praeger, 1974), p. 23.

8. Ibid., p. 38.

9. Stryker to Post, July 14, 1938, Stryker Papers, Reel 1.

10. Interview, Ben Shahn with Dr. Harlan Phillips, Roosevelt, N.J., October 3, 1965, Archives of American Art, Washington, D.C. Transcribed, pp. 38—39. For a discussion of difficult local administrators in the South, see the same resource, p. 40.

11. Stryker to Post, op. cit.

12. Post to Clara Dean Wakeham, December 23, 1938, Stryker Papers, Reel 1.

13. Post to Stryker, December ?, 1938, Stryker Papers, Reel 1.

14. Post to Stryker, December ?, 1938, Stryker Papers, Reel 1. In the early days, Post did not date her letters, thus two letters may have similar citations, as is here the case.

15. Stryker to Post, January 13, 1939, Stryker Papers, Reel 1.

16. Post to Stryker, January ?, 1939, Stryker Papers, Reel 1.

17. Post to Stryker, January ?, 1939, Stryker Papers, Reel 1.

18. Post to Stryker, January ?, 1939, Stryker Papers, Reel 1.

19. Post to Stryker, January ?, 1939, Stryker Papers, Reel 1.

20. Stryker to Post, January 26, 1939, Stryker Papers, Reel 1.

21. Post to Stryker, January ?, 1939, Stryker Papers, Reel 1.

22. Stryker to Post, February 10, 1939, Stryker Papers, Reel 1.

23. See especially Sally Stein, "Marion Post Wolcott: Thoughts on Some Lesser Known FSA Photographs," in Marion Post Wolcott: FSA Photographs (Carmel, Cal.: Friends of Photography, 1983), p. 9.

24. Post to Stryker, January ?, 1939, Stryker Papers, Reel 1.

25. Stein, op. cit., p. 4.

26. Stryker to Post, March 16, 1939, Stryker Papers, Reel 1.

27. Ibid.

28. Stryker first mentioned Raper and his book, Preface to Peasantry, in a letter to Post dated January 11, 1939. Instructions to contact Raper came in the March 16 letter, Stryker Papers, Reel 1.

29. Stryker to Post, March 18, 1939, Stryker Papers, Reel 1.

30. Stryker to Post, February 24, 1939. Also Post to Stryker, February ?, 1939, Stryker Papers, Reel 1.

31. Stryker to Post, February 24, 1939.

32. Stryker to Post, April 14, 1939, Stryker Papers, Reel 2.

33. Wolcott/Hurley Interview, Series I, Reel 4.

34. Post to Stryker, May 8, 1939, Stryker Papers, Reel 2.

35. Ibid.

36. Stryker to Post, May 10, 1939, Stryker Papers, Reel 2.

37. Post to Stryker, July 5, 1939, Stryker Papers, Reel 2.

CHAPTER THREE

1. Wolcott and Arthur Rothstein in conversation with the author, July 8, 1985, at a meeting at Daytona Beach, Fla., titled "The Farm Security Administration: A Fifty Year Symposium," sponsored by the Daytona Beach Community College Gallery of Fine Arts and the Southeast Center for Photographic Studies. Notes in possession of the author. Clarified and enlarged in Wolcott/Hurley Interview, Series II, Reel 2.

2. Stryker to Jonathan Daniels, September 13, 1943, Stryker Papers, Reel 2.

3. Stryker's desire for academic legitimacy can be seen in his letter to Harry Carmen quoted in Chapter two (Stryker to Carmen, October 11, 1935, Stryker Papers, Reel 1). Much later, Stryker wrote to Carmen to tell him abour a conversation reported to him by Dr. Will Alexander, the Director of the FSA. Alexander had been in a meeting with Gunnar Myrdal, the Swedish sociologist and later author of An American Dilemma and T. J. Woofter, an American rural sociologist and author of Landlord and Tenant on the

Cotton Plantation. Stryker, with obvious pleasure reported:

> Woofter suggested to Myrdal that a survey of the F.S.A. files might be more valuable to their study than most of the statistics they could supply. That pleased Dr. Will no end and he remarked that he thought we have a better proposition here than we realize, and it is, after all, a research job that we are doing.

(Stryker to Carmen, March 2, 1939, *Stryker Papers,* Reel 2.) With his background as an instructor in economics at Columbia, such evidence of academic legitimacy was to be cherished by Stryker.

4. Wolcott/Hurley Interview, Series I, Reel 2.

5. *Ibid.*

6. *Ibid.*

7. *Ibid.*

8. Federal Writers Project, *These Are, Our Lives,* Chapel Hill, University of North Carolina Press, 1939.

9. Charles Allen Watkins, *The Blurred Image: Documentary Photography and the Depression South,* Ph.D. dissertation, University of Delaware, 1982.

10. See, for example, George Talbot, *At Home: Domestic Life in the Post-Centennial Era, 1876–1920* (Madison: University of Wisconsin Press, 1976). See also, The Photographers' Gallery and Jonathan Bayer, *Reading Photographs: Understanding the Aesthetics of Photography* (New York: Pantheon, 1977). Also Alan Trachtenberg, editor and intro., *The American Image: Photographs from the National Archives, 1860–1960,* (New York: Random House, 1979).

11. Both Dorothea Lange and Jack Delano took pictures for the North Carolina Study, but Marion Post Wolcott spent more time in the area and took far more pictures than either other photographer.

12. Post to Stryker, October 2, 1939, *Stryker Papers,* Reel 2.

13. *Ibid.*

14. Stryker to Post, October 17, 1939, *Stryker Papers,* Reel 2

15. Margaret Jarman Hagood to Edwin Rosskam, April 26, 1940, Section B., Odum Papers, Southern Historical Collection, University of North Carolina. Quoted in Watkins, *op. cit.,* p. 134.

16. Watkins, p. 136. Watkins's study contains much valuable and new information. Unfortunately, it is so concerned with proving its thesis, that the FSA file is totally untrustworthy, that all evidence to the contrary is ignored.

17. John D. Stoeckle, M.D., and George Abbott White, *Plain Pictures of Plain Doctoring: Vernacular Expression in New Deal Medicine and Photography* (Cambridge: Mass.: MIT Press, 1985).

18. Wolcott/Hurley Interview, Series I, Reel 4.

19. Sally Stein, "Marion Post Wolcott: Thoughts on Some Lesser Known FSA Photographs," introduction to *Marion Post Wolcott: FSA Photographs* (Carmel, Cal.: The Friends of Photography, 1983), p.8.

20. For good examples of magazines' use of FSA photographs, see "Caravans of Hunger," *Look,* May 25, 1937, pp. 18–19; "Children of the Forgotten Man," *Look,* March 1937, pp. 18–19; "Pictures from the F.S.A.," *U.S. Camera Annual,* 1938, pp. 43–75. Typical books of the period include Rupert B. Vance, *How the Other Half is Housed* (Chapel Hill, 1936); Arthur F. Raper and Ira DeA. Reid, *Sharecroppers All* (Chapel Hill, 1941); and H. C. Nixon, *Forty Acres and Steel Mules* (Chapel Hill, 1938).

21. Interview, F. J. Hurley with Robert J. Doherty, February 25, 1988. Notes in posession of the author. For similar statements, see Milton Meltzer, *Dorothea Lange: A Photographer's Life* (New York: 1978), p. 136.

22. Stryker to Post, January 29, 1940, *Stryker Papers,* Reel 2.

23. Post to Stryker, February 20, 1940, *Stryker Papers,* Reel 2. Quoted out of context in *Marion Post Wolcott: FSA Photographs,* p. 46.

24. Post to Stryker, February 24, 1940, *Stryker Papers,* Reel 2.

25. Stryker to Post, February 27, 1940, *Stryker Papers,* Reel 2

26. Post to Stryker, March 2, 1940, *Stryker Papers,* Reel 2.

27. Stryker to Post, March 4, 1940, *Stryker Papers,* Reel 2.

28. Stryker to Post, September 21, 1940, *Stryker Papers,* Reel 2.

29. *Ibid.*

30. Post to Stryker, March 24, 1940, *Stryker Papers,* Reel 2.

31. Post to Stryker, May 15, 1940, *Stryker Papers,* Reel 2.

32. *Ibid.*

33. *Ibid.*

CHAPTER FOUR

1. Fragment of contemporary writing [circa 1940] in posession of Marion Post Wolcott. Pages 5 through 13 extant. Quotes from pages 5, 7, and 8.

2. Post to Stryker, May 30, 1940, *Stryker Papers*, Reel 2.

3. Post to Stryker, June 19, 1940, *Stryker Papers*, Reel 2.

4. *Ibid.*

5. *Ibid.*

6. Post to Stryker, July ?, 1940, *Stryker Papers*, Reel 2.

7. *Ibid.*

8. Post to Stryker, July 28 and 29, 1940, *Stryker Papers, Reel* 2.

9. *Ibid.*

10. *Ibid.*

11. Post to Clara Dean Wakeham, August 16, 1940, *Stryker Papers*, Reel 2.

12. Post to Stryker, September 19, 1940, *Stryker Papers*, Reel 2.

13. *Ibid.*

14. *Ibid.*

15. Stryker to Post, September 21, 1940, *Stryker Papers*, Reel 2.

16. Post to Stryker, September 25, 1940, *Stryker Papers*, Reel 2.

17. Stryker to Post, September 27, 2940, *Stryker Papers*, Reel 2.

18. Wolcott/Hurley Interview, Series II, Reel 3.

19. Post to Stryker, October 2, 1940, *Stryker Papers*, Reel 2.

20. Stryker to Post, October 16, 1940, *Stryker Papers*, Reel 2.

21. Post to Stryker, October 2, 1940, *Stryker Papers*, Reel 2.

22. Wakeham to Post, October 24, 1940, *Stryker Papers*, Reel 2.

23. Post to Stryker, November 4, 1940, *Stryker Papers*, Reel 2.

24. Post to F.S.A. Historical Section Office, March 14, 1940, *Stryker Papers*, Reel 2.

25. Wolcott/Hurley Interview, Series I, Reel 5. Also recounted in telephone conversation with the author, September 9, 1986. Notes in possession of the author.

26. Holographic manuscript by Marion Post Wolcott in possession of Ms. Wolcott, written during the 1970s. "My husband never wanted me to continue in it [photography]. He never thought it feasible in our circumstances at that time."

27. Wolcott/Hurley Interview, Series I, Reel 4.

28. Wolcott/Hurley Interview, Series I, Reel 4.

29. Wolcott to Stryker, August 2, 1941 (note that Marion was by now signing herself Marion Post Wolcott). Wolcott to Stryker, August 6, 1941, *Stryker Papers*, Reel 3.

30. *Stryker Papers*, Series II, Part C, contains all the surviving shooting scripts, a very useful series of papers which needs much more analysis.

31. Wolcott to Stryker, August 21, 1941, *Stryker Papers*, Reel 3.

32. *Ibid.*

33. Fragment of contemporary writing (circa 1940) in possession of Ms. Wolcott, p. 12.

34. Stryker to Wolcott, September 19, 1941. Private letter, not included in microfilm collection, in possession of Marion Post Wolcott.

35. Wolcott/Hurley Interview, Series I, Reel 4.

36. Wolcott to Stryker, August 21, 1941, *Stryker Papers*, Reel 3.

37. Wolcott to Stryker, September 9, 1941: "Lee finally met me for a few days on his return from San Francisco. . . . He insisted on just traveling with me—instead of my taking leave and vacationing—so as not to delay my trip any and keep me away longer than necessary." *Stryker Papers*, Reel 3.

38. *Ibid.*

39. Wolcott to Stryker, September 2?, 1941, *Stryker Papers*, Reel 3.

40. *Ibid.*

41. Stryker to Wolcott, September 19, 1941. Private letter, not in microfilm collection, in possession of Marion Post Wolcott.

42. *Ibid.* The quoted material is annotated on the margin of the letter in Lee Wolcott's handwriting.

43. Wolcott/Hurley Interview, Series I, Reel 4. Copy of the memorandum also in possession of Marion Post Wolcott.

CHAPTER FIVE

1. Wolcott/Hurley Interview, Series II, Reel 2.

2. Ruth Schwartz Cowan, *More Work for Mother* (New York: 1983), pp. 203–10. For a more complete analysis, see Betty Friedan, *The Feminine Mystique* (New York: 1963).

3. Wolcott/Hurley Interview, Series II, Reel 1.

4. *Ibid.*

5. *Ibid.*

6. Wolcott/Hurley Interview, Series II, Reel 2.

7. Wolcott/Hurley Interview, Series I, Reel 2.

8. Wolcott/Hurley Interview, Series 1, Reel 3.

9. *Ibid.*

10. Wolcott/Hurley Interview, Series II, Reel 2.

11. *Ibid.*

12. Wolcott/Hurley Interview, Series II, Reel 1. On this subject, Marion stated, "Perhaps he had a concern underneath, which he didn't express, that it might interfere with the marriage or the care of the children. He didn't object if I took the kids down to the creek and photographed them, or when I would photograph on the farm or other nearby farms. And I think he didn't object to my photographing other people's children because I usually did it on our farm. He realized that I had to have *some* free time and I think he was pleased when other people liked the photographs. There wasn't any objection to that. There wasn't any encouragement either. Now, of course, he is very proud of it and very supportive. He has turned around completely."

13. Telephone Interview, Marion Post Wolcott with F. J. Hurley, October 15, 1986. Notes in possession of the author.

14. Wolcott/Hurley Interview, Series I, Reel 3.

15. Wolcott/Hurley Interview, Series 1, Reel 4.

16. *Ibid.*

17. *Ibid.*, also Reel 3.

18. Resume—Marion Post Wolcott, manuscript document in M.P.W.'s handwriting, Marion Post Wolcott personal papers, five pages. Internal evidence indicates that this was written during the mid-1970s at Mendocino, p. 2.

19. Wolcott/Hurley Interview I, Reel 4.

20. Resume, p. 3.

21. Telephone Interview, *op. cit.*, notes in possession of author.

22. Telephone Interview, Jean Lee with F. Jack Hurley, October 15, 1986, notes in possession of the author.

23. Wolcott/Hurley Interview, Series II, Reel 3.

24. Resume, p. 3.

25. Wolcott/Hurley Interview, Series I, Reel 4.

26. Resume, p. 3.

27. Wolcott/Hurley Interview, Series I, Reel 4.

28. *Ibid.*

29. *Ibid.*

30. Jack Welpott, "Trip the Light," introduction to an exhibition catalogue, *Marion Post Wolcott*, Robert B. Menschel Photography Gallery, an affiliate of Syracuse University, Syracuse, N.Y., 1986.

31. Wolcott/Hurley Interview I, Reel 4.

32. "U.S.A. 1935–1943—Photographien Fur Die FSA Von: Walker Evans, Russell Lee, Marion Post Wolcott," Gallery Taube, Berlin, exhibition catalogue, 1976. "Images de l 'Amerique en Crise: Photos de la FSA," Centre de George Pompidou, Paris, 1979. "American Photography and Social Conscience," Victoria, Australia, 1980.

33. Thomas H. Garver, *Just Before the War* (Balboa, Cal.: Newport Harbor Art Museum, 1968). F. Jack Hurley, *Portrait of a Decade.* Roy Emerson Stryker and Nancy Wood, *In This Proud Land* (Greenwich, Conn.: New York Graphic Society, 1973).

34. Sally Stein, "F.S.A. Color: The Forgotten Document," *Modern Photography*, January 1979. Joan Murray, "Marion Post Wolcott: A Forgotten Photographer from the FSA Picks Up Her Camera Again," *American Photographer*, March 1980. Edwin Rosskam, "Not Intended for Framing: The FSA Archive," *Afterimage*, March 1980.

35. Symposium, "F.S.A. Photographs: A Re-Examination," Amarillo Art Center, Amarillo, Tex., January 25–26, 1979.

36. "The Farm Security Administration: A Fifty Year Commemorative Symposium," DBCC Gallery of Fine Arts, Daytona Beach Community College, July 8–9, 1985.

37. Wolcott/Hurley Interview, Series II, Reel 3.

38. Symposium, "Women in Photography: Making Connections," Syracuse University, Syracuse, N.Y., October 10, 11, and 12, 1986. Ms. Wolcott's keynote address was on the evening of October 11.

39. Estelle Jussim, "Propaganda and Persuasion," *Observations: Essays on Documentary Photography* (Carmel, Cal.: Friends of Photography, 1984), p. 114.

40. Notes in possession of the author.

BIBLIOGRAPHY

SOURCE MATERIALS

America, 1935–1946, Microfiche edition of the FSA-OWI Collections of the Prints and Photographs Division, Library of Congress, 87,000 photographs on 1506 fiche. Teaneck, N.J., 1984, Chadwyck-Healey.

Boddy, Julie M., "The Farm Security Administration Photographs of Marion Post Wolcott: A Cultural History," Ph.D. dissertation, State University of New York, 1982.

Howard Odum Papers, Southern Historical Collection, University of North Carolina.

Roy Stryker Papers, 1912–1972. Microfilm edition, edited by David Horvath for the University of Louisville Photographic Archives. Teaneck, N.J., 1982, Chadwyck-Healey.

Interview, Ben Shahn with Dr. Harlan Phillips, October 3, 1965, Archives of American Art, Washington, D.C.

Watkins, Charles Alan, "The Blurred Image: Documentary Photography in the Depression South," Ph.D. dissertation, University of Delaware, 1982.

Wolcott, Marion Post, "Keynote Address," Women in Photography Conference, Syracuse, N.Y., October 10–12, 1986. Notes in possession of Marion Post Wolcott.

Interview, Marion Post Wolcott with Richard K. Doud, August 17, 1963, Archives of American Art, Washington, D.C.

Interview, Marion Post Wolcott with F. Jack Hurley, March 15 and 16, 1985. Six reels, untranscribed, in possession of the author. Cited in text as Series I.

Interview, Marion Post Wolcott with F. Jack Hurley, November 15 and 16, 1986. Four reels, untranscribed, Notes in possession of the author. Cited in text as Series II.

BOOKS CONTEMPORARY WITH THE DEPRESSION

Anderson, Sherwood. *Hometown.* New York: Alliance Publications, 1940.

Chamberlain, Samuel, ed. *Fair Is Our Land.* New York: Hastings House, 1942.

Dollard, John, *Caste and Class in a Southern Town.* New Haven: Yale University Press, 1937. Reprinted 1957 by Anchor Books, New York.

Federal Writers' Project. *These Are Our Lives.* Chapel Hill: University of North Carolina Press, 1939.

Hagood, Margaret. *Mothers of the South: Portraiture of the White Tenant Farm Woman.* Chapel Hill: University of North Carolina Press, 1939. Reprinted 1977 by W. W. Norton Co., New York, with a new introduction by Anne Firor Scott.

Nixon, Herman, C. *Forty Acres and Steel Mules.* Chapel Hill: University of North Carolina Press, 1938.

Odum, Howard. *Southern Regions of the United States.* Chapel Hill: University of North Carolina Press, 1936.

Powdermaker, Hortense. *After Freedom: A Cultural Study in the Deep South.* New York: Viking Press, 1939.

Raper, Arthur. *Preface to Peasantry.* Chapel Hill: University of North Carolina Press, 1936.

Raper, Arthur, and Ira DeA. Reid. *Sharecroppers All.* Chapel Hill: University of North Carolina Press, 1941.

Rosskam, Edwin. *Washington.* New York: Alliance Publications, 1939.

Wright, Richard. *Twelve Million Black Voices.* New York: Alliance Publications, 1940.

Vance, Rupert V. *How the Other Half is Housed.* Chapel Hill: University of North Carolina Press, 1936.

The Yearbook of Agriculture, 1940. Washington, D.C.: U.S. Government Printing Office.

RECENT BOOKS

Alinder, James, ed. Introductory essay by Sally Stein. *Marion Post Wolcott: FSA Photographs.* Carmel, Cal.: Friends of Photography, 1983.

Anderson, James C., ed. Introductory essays by Robert Doherty and Calvin Kytle. *Roy Stryker: The Humane Propagandist.* Louisville: The University of Louisville Photographic Archives, 1977.

Appel, Alfred, Jr. *Signs of Life.* New York: Alfred A. Knopf, 1983.

Baigell, Matthew. *The American Scene: American Painting of the 1930s.* New York: Praeger, 1974.

Baldwin, Sidney. *Poverty and Politics: The Rise and Decline of the Farm Security Administration.* Chapel Hill: University of North Carolina Press, 1968.

Brannan, Beverly W., and David Horvath, eds. *A Kentucky Album: Farm Security Photographs.* Lexington: University of Kentucky Press, 1986.

Conrad, David E. *The Forgotten Farmers: The Story of Sharecroppers in the New Deal.* Urbana: University of Illinois Press, 1965.

Cowan, Ruth Schwartz. *More Work For Mother.* New York: Basic Books, 1983.

Daniel, Pete, et al. *Official Images: New Deal Photography.* Washington, D.C.: Smithsonian Press, 1987.

Elliott, James, and Marla Westover. *Marion Post Wolcott—FSA Photographs.* Berkeley: University of California Art Museum, 1978.

Fisher, Andrea. *Let Us Now Praise Famous Women: Women Photographers for the U.S. Government 1935–1944.* London: Pandore Press, 1987.

Friedan, Betty. *The Feminine Mystique.* New York: W. W. Norton, 1963.

Garner, Gretchen. *Reclaiming Paradise: American Women Photograph the Land.* Duluth: Tweed Museum of Art and the University of Minnesota Press, 1987.

Garver, Thomas R. *Just Before the War.* Exhibition catalogue, New York: Newport House, 1968.

Green, Jonathan. *American Photography: A Critical History from 1945 to the Present.* New York: Harry N. Abrams, 1985.

Higgins, Chester, and Orde Coombs. *Some Time Ago.* New York: Anchor Press, 1980.

Hurley, F. Jack. *Portrait of a Decade: Roy Stryker and the Development of Documentary Photography in the Thirties.* Baton Rouge: Louisiana State University Press, 1972.

———. *Russell Lee, Photographer.* Dobbs Ferry, N.Y.: Morgan and Morgan, 1978.

Jay, Bill. *Negative/Positive: A Philosophy of Photography.* Dubuque, Iowa: Kendall-Hunt Publishing Co., 1979.

Jussim, Estelle, et al. *Observations: Essays on Documentary Photography.* Carmel, Cal.: Friends of Photography, 1984.

Meltzer, Milton. *Dorothea Lange: A Photographer's Life.* New York: Farrar, Straus and Giroux, 1978.

Newhall, Beaumont. *History of Photography.* New York: Museum of Modern Art, 1964.

Ohrn, Karin Becker. *Dorothea Lange and the Documentary Tradition.* Baton Rouge: Louisiana State University Press, 1980.

O'Neal, Hank. *A Vision Shared: A Classic Portrait of America and Its People.* New York: St. Martin's Press, 1976.

Sontag, Susan. *On Photography.* New York: Farrar, Straus and Giroux, 1977.

Steichen, Edward, ed. *The Bitter Years: 1935–1941: Rural America as Seen by the Photographers of the FSA.* New York: Museum of Modern Art, 1962.

———, ed. *The Family of Man.* New York: Museum of Modern Art, 1955.

Stoeckle, John D., and George Abbott White. *Plain Pictures of Plain Doctoring: Vernacular Expression in New Deal Medicine and Photography.* Cambridge, Mass.: Massachusetts Institute of Technology Press, 1985.

Stott, William. *Documentary Expression in Thirties America.* New York: Oxford University Press, 1973.

Stryker, Roy E., and Nancy Wood. *In This Proud Land: America 1935–1943 As Seen in the FSA Photographs.* Greenwich, Conn.: New York Graphic Society, 1973.

Terrill, Tom E., and Jerrold Hirsch, eds. *Such As Us: Southern Voices of the Thirties.* Chapel Hill: University of North Carolina Press, 1978.

Turner, David. *Marion Post Wolcott—FSA Photographs and Recent Work.* Amarillo, Tex.: Amarillo Art Center, 1979.

USA, 1935–43, Photographien Fur Die FSA, Von: Walker Evans, Russell Lee, Marion Post Wolcott. Catalogue for exhibition. Berlin: Galerie Taube, 1976.

Witkin, Lee, and Barbara London. *The Photograph Collector's Guide.* Boston: New York: Graphic Society, 1979.

Women Look at Women. Exhibition catalogue. Washington, D.C.: Smithsonian Institution, 1977.

Szarkowski, John. *The Photographer's Eye.* Greenwich, Conn.: New York Graphic Society and the Museum of Modern Art, 1966.

227

ARTICLES CONTEMPORARY WITH THE DEPRESSION

"Caravans of Hunger." *Look* (May 25, 1937): 18–19.

"Children of the Forgotten Man." *Look* (March 1937): 18–19. [Note, at this point, *Look* was still a monthly publication. By May 1937 it was weekly.]

Howe, Hartly. "You Have Seen Their Pictures." *Survey Graphic* (April 1940: 236–38.

Maris, Paul V. "Farm Tenancy." *The Yearbook of Agriculture, 1940.* (Washington, D.C., 1940): 887–906. ·

"Pictures from the FSA." *U.S. Camera Annual: 1938:* 43–75.

Stanley, Edward. "Roy Stryker, Photographic Historian." *Popular Photography* (July 1941): 28–29, 100.

Edward Steichen, ed. "FSA Pictures." *U.S. Camera Annual: 1939:* 43–47.

Walker, Charles R. "Homesteads—New Style." *Survey Graphic* (June 1939): 377–81, 408.

RECENT ARTICLES

Brumfield, John. "America's Depression Years." *Artweek* (June 4, 1988).

Chahroudi, Martha. "From the FSA to Today." *Afterimage* (November 1978).

Contemporary Photographers, 2d ed. Chicago and London: St. James Press, 1988.

Curtis, Cathy. "Photographs of Hope in Troubled Times." *Los Angeles Times* (May 5, 1988).

Doherty, Robert J. "Farm Security Administration Photographs of The Depression Era." *Camera* (October 1962): 9–51.

Fisher, Hal. "Marion Post Wolcott's Spectrum of the Depression." *Artweek* (May 27, 1978).

Hendrickson, Paul. "Double Exposure. *The Washington Post Magazine* (January 31, 1988): 12–25, 36–38.

Modley, Peter. "Biography of Helen Post." *Photo Metro* (San Francisco, February 1986): 20–21.

Murray, Joan. "Marion Post Wolcott: FSA Veteran Gets Back To Work." *American Photographer* (March 1980).

"Prevailing Images." *Esquire* (January 1980): 82.

Raedeke, Paul. "Interview with Marion Post Wolcott." *Photo Metro* (San Francisco, February 1986): 3–17.

———. "Marion Post Wolcott: Photographs for the Farm Security Administration documenting rural American life in the 1930s and 1940s." *Arrival* (Berkeley, Cal., Summer, 1987): 16–27.

Severin, Werner J. "Cameras With A Purpose." *Journalism Quarterly* (Spring 1964): 191–200.

Stein, Sally. "FSA Color: The Forgotten Document." *Modern Photography* (January 1979): 90–99, 162–64, 166.